How to Start a
Professional Photography Business

How to Start a
Professional Photography Business

Ted Schwarz

Contemporary Books, Inc.
Chicago

Published by Contemporary Books, Inc.
180 North Michigan Avenue, Chicago, Illinois 60601
Manufactured in the United States of America
Library of Congress Catalog Card Number: 77-81920
International Standard Book Number: 0-8092-8134-1 (cloth)
0-8092-8070-1 (paper)

Published simultaneously in Canada by
Beaverbooks
953 Dillingham Road
Pickering, Ontario L1W 1Z7
Canada

Contents

Introduction

We live in a world of images. Whether we watch a program on television, look at a pretty girl smiling down from a billboard advertisement, or study the illustrations in a textbook, photographs are an integral part of our lives. When a company has a new product to sell, the management uses pictures to excite the buying public. When a hospital needs to raise several million dollars for an expansion and research program, photographs tell of its current problems. And when a couple gets married, their special wedding photograph album is a cherished family heirloom long after they're old and grey.

The photographer is the person who records the images our lives are so intimately involved with. In portrait, wedding, advertising, and general commercial studios, photographers are a part of an ever-expanding, multi-million-dollar profession, one in which it's possible to earn a far better than average income. A few professionals, generally those working for major clients in New York, Chicago, and other large cities, become quite wealthy—but almost every photographer finds his or her career immensely rewarding on a personal basis.

But how does one go about becoming a professional pho-

tographer? What do you need to know about business methods, equipment, sales, insurance, and the myriad other details that contribute to success? And if you're already working in this field, how do you go about expanding into new and different aspects of professional photography?

This book should provide the answers. If you're an advanced amateur, it will tell you how to become a professional. If you're already professional, but working as a staff photographer in industry, on a newspaper, or as part of someone else's studio, this book will tell you how to go out on your own. And if you already have your own studio, it will teach you how to expand your business, improve your promotions, and increase your profits.

1

Starting Into Business

Professional photography might be considered a service which provides a client with the visual means to a desired end. In advertising, the client uses a photograph to sell a product, service, or business. In public relations, the photograph tells the story behind a company or organization. Even the wedding photographer is offering a service: wedding pictures provide a way for married people to relive one of the most important moments in their lives, and then become historical documents as they're passed on to the next generation.

Unfortunately, since photography is a service, every potential client is going to want to see why you, as a photographer, feel you can satisfy his or her needs. Young couples will want to see how you've recorded other weddings so they can decide if your approach fits their conception of what a wedding album should be. Advertising account executives will want to see product and model photography. And the portrait customer wants to see how you've handled other men and women who have posed for your camera.

This attitude on the part of potential clients is quite reasonable, you will agree. But how can you be expected to show exam-

ples of past assignments if you're just taking your first plunge into the field of professional photography? A portfolio of samples is essential, but how do you build one when you have yet to gain your first customer?

Assembling a Portfolio

The answer is that, in fact, no one expects you to have a portfolio of earlier assignments when you're just starting into business. What is expected is that you have a portfolio which shows your versatility, one that relates to the needs of your potential client.

The Portrait Portfolio

The ideal portrait portfolio has prints showing everything from formal head photographs, carefully posed and lighted, to full-length portraits, to candid photographs of families and/or children at play. Your samples can be made by photographing your spouse, friends, neighbors, or anyone else you know. The examples need not be of paying customers.

The first step in preparing a portfolio for portrait sales is to decide just what types of portraits you'll offer. Many photographers lack the space or the understanding family necessary for converting a corner of their homes into a small portrait operation; this means they must rely on location settings. They use parks and, perhaps, interestingly designed shopping malls, museums, and similar public areas for their "studios." They also take photographs in their clients' homes.

If you're going to work on location, your portfolio must reflect your versatility in this area. Family photographs, both outdoors and in the home, must be specially arranged. You'll have to find a cooperative group of relatives or neighbors who will pose for you in exchange for a couple of free prints.

Record your subjects in a variety of settings, using color negative film for all the work. This film is best because it can be used to make both black-and-white and color prints at low cost. You don't have to go to the expense of making internegatives or Cibachrome prints, as you would with transparencies, and you don't have the processing cost of an additional roll of film, as you would with black-and-white.

You'll find that it's a good practice always to handle portraits with color negative film unless there's a special reason for using transparencies or black-and-white. Even when the client wants a monochrome print, showing color proofs of everything you take will help boost your business. A client who just wants a black-and-white publicity photo for the local newspaper, for example, may decide to order a framed 11 × 14 color portrait as well. As a professional, you must always think about both the assignment for which you've been hired and the potential future sales you can make from the negatives.

Be certain your subjects are attractive. People looking at a portfolio of portraits tend to imagine themselves in the pictures. If the subjects you select for samples each have two heads, one eye, and giant warts on the tips of their noses, you'll never get a customer, even if the pictures are technically and artistically flawless. The people viewing the work will *not* say to themselves, "What masterful photographs! It's too bad the photographer couldn't find better-looking clients." They'll say, "Is this photographer ever lousy! Look how ugly he made these people! If I pose for him, the final print will probably show me with three heads!"

Candid photographs of children are easy to get. One approach is to work with friends' or neighbors' children. However, it's just as easy to go to the nearest park or schoolyard on a weekend and photograph children playing there. At first you'll be swamped with questions—"What are you doing?" "Can I hold your camera?" "When can I see my picture?" "Where's the bathroom?" After a few minutes the kids will lose interest in you, and you'll be able to photograph to your heart's content while they completely ignore you.

If the weather is bad, photograph children at play indoors. The easiest method is to record them when they're absorbed in some activity like playing a board game or building a model. Take close-ups of their faces, full-figure photos, and group pictures. You may need to stay with a high-speed black-and-white film like Tri-X for these indoor photographs.

Flash photography is difficult because of the need for multiple units to provide adequate light without harsh shadows. Flood-

lighting might be impossible because of the danger of active children knocking over your stands. The candid approach is always best, even if you have to settle for black-and-white pictures only.

Portfolio and sample prints should never be smaller than 8 × 10, and loose samples should go as large as the greatest size you plan to offer. For example, you might have an album containing twenty 8 × 10 color and black-and-white photographs, as well as loose dry-mounted and framed prints in sizes 11 × 14 through 20 × 30 or whatever the maximum will be. Or you might keep your portfolio filled with impressive 11 × 14 prints while your loose samples start at 8 × 10.

The album you select for your portfolio need not be expensive, but it should be good enough to take some abuse. Each photograph should be protected with a clear plastic sheet. The photographs should be slipped inside these envelopes, rather than pasted, so they can be changed from time to time as you increase your clients and have a better range of negatives from which to choose.

The Wedding Portfolio

The wedding portfolio is perhaps the most difficult to obtain. A wedding is one of the most important days in people's lives, and they're not likely to want to entrust the photography to someone whose work they haven't seen.

Ideally, you can obtain your sample wedding portfolio by recording a friend or family member's wedding. Someone who knows you well and is aware of the general quality of your photography is likely to be receptive to the idea of having you record his or her wedding. The next best approach is to ask your friends to check with any of their acquaintances who might be getting married. A referral from someone who knows you can be a big help.

If all else fails, you're going to have to approach strangers in much the same way you'll seek clients when you have your own wedding business, to be discussed fully in a later chapter. Talk with the clergyman of your church or temple; talk with people you know from PTA meetings; contact couples whose engage-

ment announcements appear in the newpaper. Then, when you finally find someone willing to discuss wedding photography with you, be completely candid about your plans and experience.

When I was first starting out I found that I was able to convince couples to use my photographic services by showing them general samples of my photography. I had a double appeal for them. The first was the fact that my past work, though unrelated to weddings, showed that I was competent with a camera. They felt that though I certainly might not prove to be the greatest wedding photographer in the business, I would at least not ruin the pictures of their wedding.

Secondly, the two weddings I eventually handled to gain a wedding portfolio were done on the basis of cost plus a small hourly rate, with the understanding that the prints would be used in the promotion of my business. I was careful to make certain that these clients understood that my regular rates would be considerably higher than what I was charging them. They were not to tell friends who were interested in my services what they paid for their wedding photographs. The low price was a special arrangement because they were taking a chance on me and I planned to utilize the results for my own ends. I did not and do not consider such an arrangement to be an unfair business practice. It is a one-time necessity meant to help establish you in business, and will in no way affect your future competition with other professionals.

Once you have a willing couple, photograph their wedding as if it were the most important news event in history. Take as many high-quality photographs as possible, calling upon every ounce of creativity and skill as possible. Plan on carrying triple the film you would normally expect to use so you don't become nervous about running out.

You shouldn't be working wildly, firing your camera like a machine gun, hoping that at least some of the results will be good. Instead, carefully compose each photograph, working quickly but with thought going into each image. Take a great many photographs, but take each one with thought towards its potential salability. Thus, when you're finished, you'll have an extensive assortment from which to make the selection for your

first wedding portfolio. You will also delight the bride and groom, who are quite likely to be so overwhelmed by what you've done that they buy all the photographs instead of the ten to twenty prints they may have planned to purchase.

Most wedding albums are 8 × 8 or 8 × 10; depending on the film format used to take the pictures. However, you will eventually want to have three different sample albums for display.

One album will be the standard 8 × 10. A second will be 11 × 11 or 11 × 14, a dramatic size that often sells even more than the quality of your work. Somehow large wedding photographs invariably have a special dramatic appeal, regardless of the quality of the images (assuming they are professionally done.) The third album will be proof size—generally 4 × 4 or 4 × 5. Such albums are shown not so much to sell the bride and groom but because they make ideal gifts for their families to send to relatives and friends. Knowing that such albums are available can increase the amount of money the parents eventually put aside for photographs. You might even suggest them as gifts for the bridesmaids, ushers, and best man.

Once again all photographs should be taken with color negative film. This should be your standard working policy even when the wedding couple is on a limited budget and can only afford black-and-white prints. Replacing the black-and-white prints with color is an ideal way for the family to remember the couple on their first wedding anniversary. The purchase of prints from negatives taken long ago can be a major source of income in the years ahead.

The Commercial Portfolio

Photographs of business and industry are easier to obtain than you might think. If you're currently working in a place that's visually interesting, like a steel mill or a manufacturing plant, then you already have an in. Talk with your supervisor, the head of public relations, the editor of your employee newsletter, or anyone else in a position of authority. Explain that you would like to photograph the plant to obtain photographs for use as samples for a part-time photography business you're thinking of operating during your off hours.

If you're afraid of the consequences of letting your boss know about your second business, or if your current place of employment is visually dull, you'll have to contact some other company in your community. To get prints for my first portfolio, I went to the advertising agency handling a number of industrial accounts. I made an appointment with the director and explained what I was trying to do. I requested permission to take photographs of the operation of one of their clients, at my own risk and expense, for use as samples to show potential customers. I said that if, by chance, the firm wanted any of my work, it would be available at standard rates. However, I was not expecting to sell any of the samples.

The agency arranged for me to photograph one of their clients, the manufacturer of electric lift trucks for industry. One of the plant executives took me on a tour of the building, letting me photograph as we went along. I had to work rapidly and many of my negatives had to be improved by a skilled darkroom expert—named, oddly enough, Hope. However, in the end I had my industrial samples. They never did sell to the agency, but they helped me get numerous other assignments from their competitors.

Hospitals are often quite willing to let you photograph their facilities for your sample portfolio. The Public Relations Director, Community Relations Director, or, in smaller hospitals, the Executive Director, is the person to see. Hospitals lack the budget to hire expensive professionals more than occasionally and are delighted to have access to professional quality work.

Professionals I know who started in this manner invariably sold some of their prints from the sessions at full price. The hospital saved in not having to pay the photographer's hourly rate, and the professional covered the expense of his portfolio with the sale of individual prints. The photographers were hired in the future, whenever the hospitals had the budgets to pay for both time and prints. In fact, in one case the pro who got his start this way was placed on retainer with a handsome monthly guarantee.

Hotels are also receptive to the sample shooter, and a fairly expensive facility with elaborate lobby and rooms can result in

impressive photographs. The only problem is that you will generally be required to do the lobby photography at odd times, such as 4:00 A.M., when your equipment will not endanger guests. However, this is a small price to pay for gaining samples.

The Advertising Portfolio

When it comes to landing advertising agency accounts, there are two approaches that can be used by beginning professionals. Some photographers go to the trouble of preparing sample product photographs, using cereal boxes, linen, canned goods, or almost anything else they feel they can record in a dramatically different manner. Sometimes they go so far as to hire professional models from local agencies to enhance their pictures. Such an approach is often prohibitively expensive, and seldom results in work that's sufficiently unusual to warrant the effort.

The second approach is to include as many different types of photographs as you possibly can. They should be technically excellent and visually dramatic, but their subject matter can be a little of everything. For example, my first advertising photographic portfolio consisted of several industrial area scenes taken from bridges and overpasses near railroad tracks and factory districts. I had several photos of pretty girls, using both straight portrait approaches and unusual backlighted special effects. I had dramatic exterior views of buildings with unusual architecture, some candid street scenes that I felt were particularly moving or humorous, and a few unusual scenics. The photographs were selected to show my versatility. I was quite open about my lack of professional experience when talking with account executives, and was frequently given an assignment to prove what I could do.

Keep in mind that it's a freak happening when you can walk into the office of a large advertising agency and be handed an assignment for a major account. Normally you'll be handed what many full-time studios consider busy work. The job is small, not very expensive, and not very involved. If you succeed, the account executive will give you a slightly more elaborate project the next time around, steadily increasing his demands on your skills until you're handling major accounts. If you fail, it costs very

little to have some other photographer redo your work. You may or may not get paid for the failure, but that's the risk you take with every assignment.

Since it's likely that you'll be starting small, there is little sense in going to great expense making sample photographs similar to ads you've seen in magazines. If your portfolio just shows your versatility, it will provide the account executive with enough information to decide whether he wants to give you a break.

For both advertising and public relations agencies, your portfolio should be either 8×10 or 11×14; it must include both color and black-and-white. The color work must be of high quality and appropriate to the subject matter. Many agencies let their art directors hire photographers, and art directors are trained to recognize subtle aspects of color photographs the average person may miss. There must be a reason for you to use color; the images must be enhanced by the approach you take. Black-and-white is most appropriate when recording shapes and forms. Color has a special impact, but that impact must be warranted.

With art directors, you'll face another problem you must plan for. An art director generally recognizes the quality of a photographic print. The color differences between a machine-made print and a hand-made print that's been carefully dodged and burned-in are quite obvious. Unless your original negative was flawless and the machine print excellent, it will pay you to have more expensive, custom-made prints for the color section of your portfolio. I realize there is a difference of as much as $6 between the cost of a good machine print and a custom-made photograph. But if the better photographs land you just one more assignment than you would have had without them, they're worth the money.

Some photographers like to overwhelm potential clients by having a giant portfolio of 16×20 or even 20×24 photographs specially dry-mounted on carefully selected boards. They carry their heavy work in special cases often sold by art supply houses. You can see them walking the streets of a city's business district, their bodies bent under the strain of carrying such a heavy weight, their faces set with determination.

Unusually large portfolios can be impressive. Size can often

turn an average photograph into something special. But what good does it do to have a dramatically large print if the potential client's office is too small to accommodate the work? Account executives, even with many of the larger agencies, don't have the giant offices you might think. Often they work in tiny cubicles that barely hold their desk and a couple of chairs. When the recession began hitting advertising budgets, ad agencies had to tighten their belts by eliminating waste, and one of the first expenses to be cut was rent. By moving into offices that were purely functional, they eliminated a large part of their overhead.

If you walk into a small office with your oversized portfolio, you're going to overwhelm the potential client. If the photographs are put against one wall, they'll be too close for proper viewing. Taking them into the hall to get an adequate distance away can be awkward. Your 8 × 10 prints will fit nicely on desks and even the larger 11 × 14 size can be appreciated in close quarters, but any bigger prints are liable to work against you.

There is another psychological aspect working against you with large-format photographs. Most of the pictures taken for advertising are reproduced in sizes no greater than 8 × 10. When you show a client a portfolio of oversized prints, he or she may start to think that your work is effective only when made quite large. The potential client will assume that your work loses its impact when printed a normal size, that you will be unable to provide a picture that can fill a corner of a magazine page and still grab the reader's attention. The assignments that might have been yours will be given to somebody else. That oversized portfolio can cost you employment.

The Photographer's Image

This brings us to the problem of image. The initial impression you and your work make on potential clients will mean the difference between success and failure in professional photography.

It's very easy to say, "I am a unique individual. How I choose to live, the length of my hair, and the clothes I wear all reflect my personal lifestyle. If someone can't take me for what I am, if a

person is going to be turned off by my physical appearance, then I don't need him. I will not compromise for anyone." Unfortunately, that attitude is best maintained by someone who is independently wealthy.

Like it or not, in most cities a photographer's success is determined in part by his or her appearance. When a person dresses in a manner that doesn't reflect the contemporary standards of the business community, there's a good chance of being turned away by the receptionist. For example, if you're going to see an account executive for Caesar, Brutus, and Nero Advertising Unlimited, in the city of Dead-At-Night, Kansas, it's important that you dress in a manner that's the community norm. If you're male, this probably means a clean, pressed shirt, slacks, tie, and jacket. It might be a sports coat or a full suit. Shoes are conservative, and might even be polished.

If you're female, a well-tailored pantsuit or a reasonably conservative skirt and blouse or dress might be appropriate. Neither denims nor a dress with a low neckline and a high hemline would get you the kind of reception that results in assignments.

Slightly long hair, neatly combed and clean, and/or a well-trimmed beard would probably be acceptable for a male. But the general appearance, male or female, should be reasonably conservative.

If you're really concerned about expressing your individuality and unique approach to life, do it with your portfolio. Your photographs are your vehicle for indicating that you "march to the beat of a different drummer." Like it or not, you could be the greatest genius of all time when you pick up your camera, but if you don't play the account executive's game by dressing in a style to which he is accustomed, you'll never have your chance to show what you can do. There are enough photographers who are willing to subvert their taste in dress to the community standards to keep the "individualist" from ever getting a job.

I consider myself unique, and I think that much of my work is both avant-garde and better than the competition. But I've learned through bitter experience that the only way I'm going to have a chance to prove myself to a potential client is to first get in

to see him. And that means a day-to-day appearance similar to the people with whom I am dealing. I intend to "blow their minds," but I do it with my camera, not my clothing.

Telephone Answering Services

Image is reflected in other ways. From the moment you start going after assignments, everything about you must scream "PROFESSIONAL!" If you'll be receiving telephone calls from prospective clients, there must be someone available to answer that telephone whenever a call comes through. This might mean a spouse, assuming he or she can always be home during whatever hours you conduct your business. More likely, this means the use of either a telephone answering service or a telephone answering machine. I've used both, and there are advantages and disadvantages to each.

The Real Thing. A telephone answering service is nothing more than a switchboard manned by one or more operators for periods ranging from the typical forty-hour week to twenty-four hours a day, every day, year-round. There are usually two ways they work with you. One is to have your telephone number connected to the switchboard so that it rings both in your home or studio and in the answering service's office. The operator is instructed to answer it only after a certain number of rings, perhaps five, to give you time to take the call if you're home. Because of the nature of the telephone system, it's necessary to find a service in your immediate area if you want both numbers, home and service, to be the same.

The answering service operator always answers the telephone with whatever message you request. Generally she responds with the studio name, but this is something for you to decide. In theory, she gives the impression of being a member of your staff, explaining that you're not in the office at the moment and asking if she can take a message. However, I have yet to talk with an answering service that didn't sound like an answering service when I called.

I think the problem is that answering service employees are generally former telephone company operators who have been trained for working with the telephone. The average office

receptionist doesn't have such training. He or she tends to answer the telephone in a more casual manner. The difference is readily apparent.

The second method answering services use is to provide you with their own telephone number for you to give your clients. This number is not connected with your studio. The operator answers that line by repeating the telephone number rather than your name; this enables the answering service to use that one line for everyone from a salesman of left-handed widgets to a deranged Russian revolutionary still trying to raise funds to overthrow the czar. This arrangement is the least expensive, and I feel it's the best way to go. If you're like me and can usually spot an answering service when you hear it, why bother with the pretension and expense of a private line?

The Machines. Answering machines come in all shapes and sizes, and cost from less than $100 to around $1,000. Some have a special remote control device which enables you to call your answering machine from anywhere in the world, sound a signal, and hear all your messages played back to you. Some of the machines plug directly into the wall phone jack; others fit onto your telephone, raising the receiver when a call comes through, delivering your message, recording the incoming call, and then replacing the receiver on the hook. This is the style preferred by the Bell System.

According to the phone company, many answering machines that plug directly into the telephone jack can cause damage to the lines. The electronic components of such units are poorly made, according to the phone company, and do not operate in a manner compatible with the phone lines. This charge was confirmed by a friend of mine, an electronics expert who at one time was an instructor for Western Electric, a manufacturer of telephone equipment.

For these reasons, the phone company is insistent that you either rent a "proper" answering machine from them or that you have your equipment modified by one of their repair people so it is compatible with the lines. There are numerous fees involved with any of these "services," most of which are high enough to

discourage you from using a machine. After all, one of the reasons for an answering machine is so that you have a one-time expense rather than having to pay a regular monthly charge for an answering service. If the phone company places an additional charge on your bill, you might as well stick with human answerers.

There are two alternatives. One is to buy the answering machine of your choice, plug it into the wall, and decide that what the telephone company doesn't know won't hurt them. Many people feel this way and, admittedly, only a very few ever get caught. However, since some of the machines can damage the lines, this is not always the best approach.

A better solution is to buy the type of unit that attaches to the telephone itself, raising the receiver when a call comes through. Such units start at under $250 and are just as dependable as those which plug into the wall. More important, they will work with a permanently installed telephone; you won't have to have your outlets changed to the plug-in jack type by the phone company.

There are actually two price ranges for answering machines —under $500 and over $500. Over $500 you gain the highest quality electronics and the most versatile units. Most have the facility for calling in to get messages, for example. The best units under $500 are the ones with the fewest features. The ones that come with the call-in feature aren't as well made as the more expensive units, and might cause problems.

Basically, your machine should have a fifteen- to thirty-second prerecorded message that you can customize any way you like. It should also be able to record incoming calls, allowing at least a minute of recording time for each caller. Expensive units are generally voice-activated, and run as long as someone is talking. My inexpensive machine will record messages up to 1½ minutes maximum.

The machine should operate silently so you aren't disturbed when you're working in the same room while it's on. But it should have a monitor device of some sort so you can be either in or out to certain callers. It should work on AC rather than batteries, as this is cheaper for you in the long run.

Since the machines are constantly changing, I won't attempt to discuss the different models. Look around to see what's available within your price range, in your area. Then check with electronic repair shops to find out which tend to break down. Most likely you'll find a serviceable unit in the $250 price range, less than the cost for ten months of most answering services.

Business Forms and Stationery

Once you have someone or something taking your telephone calls, you'll need to have some basic business supplies printed. Business cards are a must. They should include your name, your studio's name, and your telephone number at the very least. An address is optional but preferred. You might want to see if the printer can provide a design of some sort that seems appropriate for a photography studio to enhance the card's appearance. When you're ready for a full-time operation, it will pay you to talk with a commercial art studio about a custom-designed logo.

You'll also need bill forms, which are available from most printers. Any style is fine. You can have your name and studio address custom-printed or you can type in the information each time. Don't use a rubber stamp for billing or letterheads, though. It looks amateurish and doesn't leave a good impression.

Whether or not you have letterheads made up will depend upon whether you're going to be writing letters. Some photographers send follow-up letters to agency executives shortly after their initial contact. If this idea appeals to you, you should get extremely high-quality stationery attractively printed with your name, studio name, and, if you wish, your street address. Some photographers do so much moving while still freelancers that they're better off typing in their current address just below their closing signature; otherwise, reams of letterheads could become outdated each move.

Generally a twenty-pound paper, preferably one that's 25 percent rag or cotton, is best. The imprint can be in color, such as gold, or two-toned. Plain black is the least expensive but may not be very dramatic. Once again the addition of a design would be effective.

Be certain to get competitive quotes for all your printing, and

make certain you're shown samples of similarly priced jobs each firm has handled for others. Often the least expensive printer also takes the least pride in his work. You want someone who will treat your order with care and respect, producing consistently high-quality material. Your letterhead represents your studio, regardless of whether it's a corner of your basement or in a custom-built building. You should never settle for anything but the highest quality from your printer.

Once a design is prepared and set into type, ask to see a sample of the finished work before authorizing the full order to proceed. This is just an extra precaution to make certain you're satisfied with the agreed-upon design. It can save you a lot of grief.

Envelopes can be plain or carry the same information as your letterhead. If they will be plain, plan on typing the return address rather than rubber-stamping it. This is time-consuming but, again, more professional.

Getting Business Started

Now that you have your basic tools, let's examine how you will go about finding your clients. Perhaps the hardest people to approach are the ad agency and public relations account executives, so we'll look at them first.

Start your sales effort with the Yellow Pages, making a list of the firms doing advertising and/or P.R. work in your community. Make note of their addresses and telephone numbers. All the business guides I've seen suggest calling firms for an appointment. I disagree. It's very easy to give someone the run-around over the telephone, and I have seldom had much luck with this "sensible" approach. I prefer to use the walk-in method.

To prepare my portfolio—actually a photo album that's attractive and doesn't seem to show wear—I select a wide range of photographs, regardless of who the clients of the agency might be. Generally I take a minimum of ten prints and a maximum of twenty for that first visit. I make them as varied as possible, so I will not only attract a potential client's interest for hiring me for current projects but also be given consideration for future projects that might be far afield from the work he's presently handling.

Next I decide which part of town I want to cover first. I then locate the agencies in that section and begin making the rounds. By covering as many places as possible without having to drive to a different area I save time, gas, and parking expenses—thus reducing overhead. When I first began in this business I used to park my car in a hotel parking lot and walk two miles to the heart of the advertising district in my city. The walk took a little time, but it saved me parking costs, which ran as high as $5 a day in some parts of the city. The hotel lot was the last free'location for parking before the start of the business district.

The best times to approach agency personnel are from around 1:00 P.M. Monday through 11:00 A.M. Friday. Monday morning means that many people will be cranky, hung over, or uninterested. Friday afternoon means that some of them will be slightly inebriated and the rest will be so busy thinking about their weekend activities that they won't give you and your work proper attention.

The First Contact

When you walk into the office, tell the receptionist that you dropped by *to make an appointment* to see one of the account executives about buying photography. You will find as you go along that you'll generally be able to see someone in a position to buy photographs whenever you drop in. However, always stress that you want to *make an appointment* for a later time and act somewhat surprised when you're shown into an executive's office.

Once inside, apologize for disturbing him or her, even if on your way to the office you noticed him using a rubber band to shoot paper clips into a wastebasket. Everyone likes to feel important, and your implying that the executive was hard at work is good for his or her ego. And what's good for an account executive's ego makes for points in your favor.

Explain to the account exec that you're a freelance photographer just entering the business. Show samples of your work and stress any specialties you might have. Ask for information concerning the needs of the firm's clients and see if there might be an assignment on which they could try you.

In the majority of cases there will be no work available. This

will be because the account exec doesn't like your work, because he or she is unwilling to risk part of his budget on an untried new professional, or simply because the firm really doesn't have any photographic needs. If this happens to you, thank the exec for his time, leave your business card, and return to the lobby. Check with the receptionist to see if anyone else in the firm buys photography, then make arrangements for appointments to see them as well. If the person you saw is the only buyer, go on to the next agency on your list.

Occasionally you'll get lucky the first time out. Sometimes an account executive will spot a print in your portfolio that happens to fill a special need. This happened to me once with a photograph of an elderly couple walking arm-in-arm past a deserted shopping area late at night. It wasn't a particularly great photograph, and the print even had a few tiny dust spots on it. However, it was exactly the type of print needed to fill a space on a pamphlet the agency was preparing for a firm that worked with the elderly. I received $10 for one-time use of the print. Today, several years later, I would probably receive triple that amount or more.

Other times you'll find someone with both a need for photographs and a willingness to give a newcomer a break. You'll be asked to quote a figure for handling the job and, if it is competitive, you will be given the assignment.

How to figure rates requires an explanation that fills an entire chapter of this book. For now you should keep in mind that when you begin making the rounds you must be prepared to give prices for whatever jobs are available. You do not need to make up a price list, and you should always stress that if the client has put the agency on a very strict budget you're willing to work with him. However, you should know what you intend to charge for an hourly rate, a day rate, for each print, and for color versus black-and-white.

The Follow-up

No matter how enthusiastically you've been greeted by an account exec, unless you're given an immediate assignment, your name will be forgotten five minutes after you leave the office.

Perhaps your business card will be thrown away. Perhaps it will be buried in a pile of other cards. Once I had an account executive tell me he wanted to be certain to have my card handy so he could call me when a job arose. He made a big show of carefully clipping it to the top page of his desk calendar. Of course, the next day, when he turned the page over, he also turned my card face down, forever erasing it from his memory.

"When I have need of a photographer, I tend to call the first person who comes to mind who I'm sure can handle the job," one account executive told me. "This almost always means somebody I've used frequently in the past. He may not be as good as a new photographer I saw a couple of days before. He's just familiar to me and I know he can do the work. It's rough on the person starting out, but that's the way I work."

The answer to the problem is follow-up. You have got to keep in contact with a potential client until the day you're given your first assignment. Then, if you handle it well, you will quickly become the tried-and-true professional who comes to mind when new work is being given out.

Perhaps the best approach is a short, businesslike letter written the same day you see the account exec. This should be typed on the quality letterhead paper already mentioned. It need not be long. You might say something to the effect of:

Dear Mr. or Ms. _____ ,

 It was a pleasure meeting you today; I appreciated the opportunity to show you my portfolio and remain ready to handle any of your photographic needs, large or small, as they arise. Thank you again for your time.

Sincerely,

The letter should be properly addressed, with the correct spelling of the executive's name. If you're uncertain, call the receptionist and ask for the spelling. This is a trivial detail, but many account executives are petty enough to feel that if you can't be bothered to get the correct spelling of their names, they can't be bothered to give you an assignment.

Roughly a week after you've mailed the letter, follow up with a

telephone call to the same account executive. Explain that you're just checking to see if there's a photographic need you might be able to handle for the agency. If there is, you have your first assignment. If not, graciously thank the executive and prepare for yet another follow-up.

Your next contact will be in another week or two. Once again it will be personal, and once again you should drop over to make an appointment. This time you must bring a few more photographs. These might be loose, in which case half a dozen prints of widely varying subjects will suffice, or in a portfolio. If you use a second portfolio you must have a minimum of ten new prints and a maximum of twenty. Don't include any of the photographs that were shown the first time around: you want the account exec to think of you as skilled, versatile, and experienced even if you are only starting your professional career. If you include any photographs he's already seen, the assumption will be that they're the only good ones you have. If that should prove true, then you probably are not skilled enough to handle an assignment.

Leave your business card when you make your second visit, regardless of the fact that you already left one. It's safe to assume that the earlier card was lost.

Once again, check back by telephone. This can be at any time from a few days after your visit to two weeks later. If no assignment comes your way, place another telephone call two weeks after that.

If you don't have an assignment two months after your first contact with a potential client, you haven't left the impression you thought you did, the client hates your work, or there's a business slump that has caused photographic budgets to be slashed. No matter what the circumstances, repeated follow-ups at regular intervals are probably going to prove a waste of time. Forget about the account exec for a while, not bothering to contact him for the next six to eight weeks.

After that interval, return to the office with a new portfolio of photographs and start the game all over again. If you go to a total of six months without work from a particular person, you can assume that it's personal for one reason or another, and forget about him. Further contact will probably be fruitless.

Finding the Right Contact

It's a good idea to make a card file of names of the people from whom you're attempting to get assignments. One system is to have a card for each individual as well as a card for each agency. The latter is especially important if more than one person within an agency buys photographs.

On each card, write the name of the person contacted, the dates contact took place, and the methods used for contact (letter, telephone, in person). You might also make note of any reaction to your work, such as: "No work now. Contact again in six weeks," or "He threw me out the office window after ripping my prints to shreds." After you've seen a great many people, such notes help to refresh your memory.

The cards can also be used for keeping track of assignments received. The exact way you set up your card file is a personal matter, but it's important to have some sort of system.

Agency personnel are notoriously unstable in their jobs. Sometimes the head of an agency fires an account exec after placing full blame on him or her for a campaign that failed, regardless of how many people okayed it originally. Other times a person leaves the job for one that pays more money. Some open their own agencies; others develop ulcers and leave the business. The reasons are numerous, but the important point is that the person holding a position today may be somewhere else tomorrow. Check with the receptionist about new personnel who are suddenly in a position to buy photographs. Even when you've been selling an agency for years, it is important that you make your sales pitch to each new person coming in. Most individuals starting a new job want to develop their own sources for photographs. They're apt to ignore you unless you make an effort to win their business.

You'll find as you make your rounds that receptionists and secretaries are the best friends you can have. They hold the key to entering a potential buyer's office. If they like you, they'll go out of their way to schedule an appointment, regardless of whether their employers are anxious to see a new photographer.

This doesn't mean you should romance a secretary just to get in to see her boss. Such tactics are occasionally tried by misguided—and self-centered—male photographers. There are

several reasons for not trying such a chauvinist tactic if you're a male photographer. The first is the moral one: it is simply a rotten approach to human relations, and is not respected by anyone in the business world.

Receptionists and secretaries are generally at the low end of the pay scale in the business world. A receptionist, especially, is liable to be newly employed, perhaps working her first job. She knows how hard it is to be without work, and will empathize with your efforts to see the boss. She will go out of her way to help you if you're sincerely friendly and polite, simply because she has been in your shoes and would have been grateful to have someone help her. Contrary to what the cynics may say, there are a great many nice people in the business world who will treat you with the same kindness and respect you show them.

Even in the most formal of offices there's a close relationship between an employer and his or her secretary. They have an interdependence that makes each somewhat concerned about the other's welfare. If you upset a secretary by your attitude and treatment of her, her boss is liable to refuse to see you on the principle that he would rather turn down the best photographer in the world than fail to support his secretary.

In an agency in which more than one person is responsible for buying photographs, it's a good idea to make the rounds of all the account executives and/or art directors after completing your first assignment. If one person has tried you, the work you did will sell your abilities to the others in the office. You'll suddenly be "one of the team," and the number of assignments will increase rapidly.

For example, I once spent a couple of months trying to sell my services to several public relations account executives in the same firm. Finally one of them gave me the chance to photograph a university for some brochures he was preparing for the school. My work was good and the account executive was pleased. I immediately showed examples to the others in the agency and picked up two additional assignments, as well as selling half a dozen prints from my files. It seemed that almost no one wanted to use his portion of the budget to see what I could do, but they liked my work enough to give me jobs as soon as I could convince someone to let me prove my ability.

Getting the Assignment

Occasionally an account executive will ask you to leave your portfolio for a day or two. The excuse may be that he or she wants to study it at leisure, or perhaps he wants to show it to others. Whatever the reason, and no matter how tempting the idea, don't do it.

As you have seen, you're going to need to have up to three different portfolios containing a total of as many as sixty different black-and-white and color prints to handle follow-up approaches. Even using inexpensive labs, this gets to be a hefty expense.

Several things can happen when you leave your portfolio behind. It can be lost or stolen, something that happens with greater frequency than agencies would like to admit. It can be damaged through careless handling. Or somebody can accidentally give it a bath in hot coffee followed by a dab of jelly doughnut. Even though you use sheet protector pages, which have plastic overlays guarding your prints, a few won't survive the coffee break.

If someone asks you to leave photographs, explain that the portfolio is the only one you have and that you'll be showing it elsewhere that week. Explain that you'll be happy to return at a more convenient time and will stay as long as necessary. Be polite but firm. Do not leave it behind.

No matter how eager you are for work, have the courage to turn down an assignment you aren't equipped to handle. Perhaps your first opportunity for work will be a request to photograph a ten-course dinner for a frozen food company. Or you might be asked to do microphotographs of printed circuits when you lack a bellows, extension tubes, and close-up lenses. Whatever the case, it may involve the use of equipment and/or studio facilities you neither own nor can reasonably rent.

When such an assignment comes along, say something like, "I'm sorry but I'm not currently equipped to handle such an assignment, though I appreciate your giving me first opportunity to do it." If by chance you happen to know an established professional who could do the job well, recommend that person to the account executive.

"What? Recommend someone else to do the job?" you're

probably saying to yourself. "Not only would I never do it, but if I did, I'd suggest an incompetent whose work would make me look brilliant by comparison."

Such an attitude is understandable, but could cost you the chance for any future business. When you not only admit your current limitations but also recommend someone who can handle the job, you are showing the client that you have his interests at heart. You're saying, in effect, "My concern is finding a way to satisfy your needs. I want your work, but more than that, I want to be of service. If I can't handle an assignment you offer me, I'll try to help you find someone who can do the job quickly and effectively so you are sure to retain the account." Invariably the account executive will be so pleased that he will automatically turn to you first to handle any new assignment that arises.

The Next Assignment

Once you've successfully completed your first assignment for an advertising or public relations account executive, your sales efforts are far from over. "When someone does a job for me, I type cast him in my mind," one executive candidly admitted to me. "If Joe Blow photographed a building, then my mind remembers Joe Blow as an architectural photographer. When I need someone to photograph a steel mill, I'm going to go to Pete Smith who took pictures of a different mill a month or two ago. Now Joe Blow might be a far better industrial photographer than Pete Smith, but I'm only going to think of him as handling architecture."

As soon as you've satisfactorily completed an assignment, begin making a small portfolio of no more than ten prints that show how you handle work other than the type you've just completed. Once again these should be prints that are new to the account executive rather than samples from an earlier portfolio.

Wait a few days, then drop by or call in advance for an appointment. Explain that you wanted to show some examples of photographs in different areas in case there was a need for a type other than the one just handled. If you don't have such prints, assemble them as soon as you can and then go to see the agency.

You have to be certain the account executive thinks of you for every aspect of photography you're capable of handling.

Fighting the Communication Gap

There is one problem that can arise when you work with an account exec or art director who knows a little about photography. He or she may use terms that are quite specific to the trained professional, giving the impression that the person knows what he is requesting when this is, indeed, not the case.

For example, I was once assigned to spend a night riding with the police department operated by a large university. The account exec stressed that I must work with "available light." He wanted nothing else. I was to take only "available light" photographs.

Being new to the field of professional photography, I didn't ask for any further explanation of his terms or desires. Available light means just one thing to the technically trained individual—high-speed film and whatever light would be provided by the moon, street lamps, and car headlights. I took along a flash in case I encountered a fast-paced chase or a sudden student riot, but the night was calm and the extra unit unnecessary. All my work was done with film exposed from ASA 800 to ASA 1600, and turned out excellent. I delivered the contacts before noon the next day and went home to get some much-needed sleep.

"What the hell is this mud?" the account exec roared into the other end of the telephone pressed against my ear. He had gotten me out of bed and I wasn't yet awake. "I told you I wanted available-light photos. This stuff is trash. It has to be reshot by someone who knows what he's doing. I'm certainly not going to pay for this!"

I naturally responded in the calm, cool manner of the beginning professional—I panicked! I had worked hard to build a good reputation with other account executives in the same agency. I had begun to get regular assignments because the men buying photographs always liked my work—until that moment. Suddenly everything was going down the drain. I grabbed the

negatives, found what I thought were the best, and had blow-ups made. Perhaps if he saw some enlargements. . . .

"Like I said, they're terrible," the account exec bellowed. We were standing in his office with the door open as he thumbed through the 8 ×10's. "The contrast is too harsh, there's too much grain, and the whole thing is just awful!"

Fortunately for me, the agency president chanced by at that moment. He asked what the problem was and the account exec was only too happy to fill him in. "I wanted available-light photographs and look what he gave me," he moaned.

The head of the agency, who understood photography, informed him that they were excellent available-light photos. Any of them would be perfect for use. He didn't understand the problem.

"I said I wanted available light," the account executive repeated. "Like these." He grabbed a handful of night photographs quite obviously taken with multiple electronic flash.

I was both numb and angry. The account executive had thrown out a technical term but had used it improperly. Had I had the foresight to question him further, I would have saved myself time, money, and aggravation.

In my case, the ending was neither particularly happy nor very costly. I received my hourly rate plus expenses, though I lost whatever profit would have been made from the sale of prints. The account exec who had hired me never used my services again, though he changed jobs roughly three months later. I never learned if he quit or was fired, but I continued my relationship with the agency for the several years that I worked in that city.

The moral of the story is to make certain that you're always speaking the same language as the person who hires you. Never assume that because the client is using a technical term he or she really knows what it means. It's better to sound a little foolish by asking a great many questions than to come to a false assumption and not be able to satisfy your client.

2

Moonlight Becomes You

Talk to a gathering of full-time professional photographers and you'll find that no subject is as controversial as that of the moonlighter. To many studio owners, this part-time professional is the scum of the earth. He's accused of stealing business, undercutting prices, being in league with the devil, and causing famine, pestilence, and general sorrow for all. Yet despite the low regard other full-time professionals may have for the moonlighter, I here boldly proclaim that unless you have enough money to survive for a year without income after setting up a studio, moonlighting is the key to success.

Let's look at the facts of professional photography. A photography studio requires a tremendous outlay of capital for even the smallest operation. Building rent is high. If you're going to be a portrait and/or wedding photographer who will have people coming to your place of business, you'll need a location that's near a major population center, such as a shopping mall. You'll need ample parking space in front, and enough room inside to include a reception area, dressing room, and studio space for taking photographs.

If you're going to handle advertising and product photography

27

you can eliminate most of the parking needs and the reception area. However, your studio space will have to be larger, you'll need multiple backdrops, and if you'll be using models, you'll still have to have the dressing area. A darkroom, if you have one, requires more space, plumbing, and a ventilation system. Then there's heat for the winter, air conditioning for the summer, lights, telephone, special business licenses, taxes, and so on.

Next comes the equipment. You must have cameras, a rather large supply of film always on hand, lighting equipment, a tripod, and facilities for backgrounds of one sort or another. You may also need an enlarger, a print washer and dryer, chemicals, paper, and related items if you're going to do your own darkroom work.

Then there's your desk and bookkeeping system, negative files, print and transparency files, bill forms, and numerous other items that go into the operation of a small business. Some of these items are unavoidable, regardless of whether you're working part-time or full-time. But others affect only the studio owner, a fact that means the full-time professional must make a great many more sales than the moonlighter, just to meet overhead.

Most experts feel that the odds against any new, full-time, small business succeeding are quite poor. The situation is even worse in the case of a photography studio. Unlike many companies, a photography studio does not sell a product for which there is a ready market. It's only through the constant showing of photographs, the daily pounding on the doors of advertising agencies to drum-up business, that a studio becomes successful. The market for one's work *must be created,* and this takes time. While the photographer is spending this time, no money is coming in, and basic expenses of rent, heat, and so on must still be met.

The only way you can safely start a full-time studio without working into the profession gradually as a moonlighter is to have a year's income in the bank, beyond the cost of equipment, rent, and related business expenses, or to have money for rent and equipment coupled with a working spouse. It's highly unlikely that you can take the plunge any other way without going bank-

rupt. *Undercapitalization has been the cause of failure for almost every new photography studio that has had to close its doors after being in business for one year or less.*

But how can you be a professional photographer without a studio? Can you really approach big-time clients when you're working only part-time from a corner of your home? The answer is yes. I worked this way at one time, and I know numerous professionals now operating large and highly profitable studios who also got their start this way.

The key to working from home on a part-time basis is to go after only those assignments you have the time and equipment to handle. If all you own is a 35mm single-lens reflex, with normal lens, you must not try to get a job doing architectural studies of a twenty-story office building. Likewise, if you must be on the job from nine to five, five days a week, you can't accept assignments that will require time other than nights or your days off. If you go after only the work you can definitely handle, you will begin building a list of satisfied clients whose regular, repeat business will one day be the backbone of your full-time studio operation.

Professional Rates

Before I go any further with this discussion, there is one point I must make. The moment you turn professional, even if you're working part-time, you must begin to charge rates that are competitive with the full-time studios in your area. The fact that your operating expenses are considerably lower will mean that you conceivably could cut prices and still make a substantial profit. However, this should not be done for two reasons.

The first reason is that trying to get business by grossly undercutting your competition is unfair, and will only gain you the hostility of competing professionals. If the quality of your work is competitive, and I assume you feel it is or you wouldn't be reading this book, then you should get the fair market price for your skills.

A second reason is that it's extremely difficult to raise your rates once you've established them. If you charge rates based on your current overhead and then find you have enough business to open a studio, when your overhead increases, you may find

that your clients are unwilling to pay the higher prices you're forced to charge. If your rates are based on the cost of operating a full-time studio, any future cost increases can be absorbed. You'll make a higher than normal profit for your moonlighting, of course, but you'll also be able to retain your customers when you go to work full-time.

Admittedly, a low price can boost sales. However, if you want to undercut your competition, it's better to do it with a periodic, low-price promotion, such as most studios offer from time to time. Keep your rates at a level that reflects your professional status and compares closely with the charges of your full-time competitors.

Professional Equipment

When it comes to equipment, I assume that you wouldn't be reading this if you didn't already own a camera capable of taking salable photographs. This might be anything from a 35mm rangefinder or single-lens reflex camera to an 8 × 10 view camera. It doesn't have to be new or expensive.

I began my career with a thirty-year-old Leica and two lenses. The camera didn't even have flash synchronization, and the price for everything was slightly over $100. Later I added a model with flash that was ten years younger. Both were battered and bruised, but they worked, and, optically, they produced photographs that could have been made by the latest model four-on-the-floor, ermine-covered, diamond-studded Money-flex Camera with its 20-1000mm zoom lens. I was extremely limited in the type of work I could handle, but I stressed location shooting, and, at first, available-light assignments. I handled only those jobs I knew I could do well, and I built a reputation for quality work. When I could afford more versatile equipment, I increased the range of my assignments. But I was careful to never accept anything I couldn't handle effectively.

Specifically, the minimum equipment needed for professional work is a camera, preferably with interchangeable lens ability, and an electronic flash unit. Neither needs to be new or very expensive. High-quality optics are essential, but these are not necessarily costly. The lens-making art has advanced to the point where an independent lens maker's inexpensive wide-angle or

telephoto lens is every bit as good for taking many photographs as the "name" lens costing several hundred dollars. The difference is often in mechanical construction—a factor affecting the life of the lens, not the kind of photographs it takes. The optics vary somewhat, but all lenses now are superior to the "top of the line" available from major manufacturers a few years ago.

The only other requirement is that the camera look somewhat professional. You won't want to use an Instamatic for professional assignments, though, in some cases, it could be done. Image is an important part of salesmanship, so you don't want anything that seems amateurish to your client. Generally everything from 35mm to such large formats as 8 ×10 view cameras can be used when you first turn professional. You'll just have to tailor your assignments to what you own.

Let's take a moment to briefly look at what you can do with different types of equipment. This is discussed in depth later on, but I want to give you an idea of what you can handle.

The 35mm and roll film cameras are ideal for wedding work. Hundreds of thousands of weddings have been covered with such basic equipment as the non-interchangeable lens Rolleiflex Twin Lens Reflex and an electronic flash. As long as you follow the approaches mentioned in the chapter on wedding photography, you can use any camera that's fairly quiet and easy to handle.

Similar equipment can be used for public relations photography, which usually is somewhat like the fast, candid work required of a newspaper photographer. This is also true for some advertising and fashion work.

Product photography generally must be handled with 2¼ × 2¼ and larger formats if the client wants transparencies. This seldom has anything to do with reproduction quality, though some magazine printers still balk at 35mm. The main reason is that the larger transparency is easier for the client to study, and so it is generally demanded.

A view camera, offering major corrections for distortion, is a value for both product and architectural photography, but is useless for weddings and other fast-paced assignments. These cameras can be used for portraits as well; the large format is ideal for retouching negatives.

Each camera has its strengths and its weaknesses. As long as you go after assignments you know you can handle without having to spend money for an additional piece of equipment, your business will prosper.

There are two other items which are essential, and which must be purchased if you don't already own them. One is a heavy-duty tripod, which will cost you between $50 and $100 if bought new. This must be sturdy and capable of holding quite a bit of weight.

The second item is a set of floodlights, which can be purchased quite cheaply. You might buy clamp lights capable of holding 500-watt bulbs. These cost less than $5 for even the best, and can often be purchased in the lighting section of large hardware stores. You might also buy inexpensive stand lights. I have some kits consisting of two lights on an adjustable stand and one "bullet"-shaped clamp light in each kit. The cost was roughly $17, total. More expensive units will take more abuse and last longer, but so far my inexpensive lights have lasted more than six years with frequent use.

Floodlights are essential for everything from portraits, including those done on location, to products, to supplemental lighting of building interiors. You can obtain an adequate number, including several long (twenty-five-foot, minimum), heavy-duty extension cords for $50 or less, total expense.

You'll also need a portfolio and various business supplies, but again, the cost is slight. These are discussed later.

3

What Kind of Photographer Are You?

Ask the typical photographer how he or she wants to earn his living with his camera and he'll probably give you a photographic version of his hobby or favorite sport. Unfortunately, this attitude is impractical. A photographer just going into business for him- or herself must combine personal interests with realistic job opportunities in the area where he or she will be working. In other words, you can specialize in advertising work in a city like New York, Chicago, or Los Angeles, but such assignments are few and far between in a small town like Kiss-And-Tell, Idaho.

In general, professional studio work can be broken down into a limited number of areas that are common to all communities, large and small. The first is wedding photography, the easiest area for the moonlighter to enter. All work can be done on location and equipment can be minimal. Unfortunately, the size of your income will depend on the number of people getting married, and in a city such as Kiss-And-Tell there might not be enough work for the photographer who wants to handle weddings exclusively. Such communities need a jack-of-all-trades who also does portraits and occasional commercial assignments for local businesses.

A second area is portrait photography. In this field there's more room for specialization. You can photograph adults only, children only, or cater to families. The work can be done in the home, in a park setting, or in the studio. In large communities you can even work exclusively with one sex or the other, though this is generally not done.

A third area is advertising and/or public relations photography. Advertising photography is generally associated with a product being sold. This requires working space either in your home or in a studio, and thus is generally avoided by the beginner. Public relations photography is generally meant to communicate the work being done by a hospital, business, or other organization. It is almost always location work, and this is the field I specialized in when first starting out.

All other areas are variations of one of the above. Food photography and fashion work fall into the advertising field. Pet photography is part of the portrait photographer's realm. School photography is a combination of portrait and public relations photography. It ranges from photographing students to preparing brochures showing what the school has to offer.

Architectural photography is unique in the equipment it requires, but is generally best fitted into the area of advertising. In some communities it can be a studio specialty, but there is seldom enough work to make it the photographer's full-time occupation.

When someone talks about a "commercial photography studio," the reference is usually to a studio that handles several different types of assignments. The work may range from fashion to public relations to school work, for example. The smaller the community in which you plan to work, the greater the likelihood that your studio will have to fall into this category.

Before you establish a photography business, it's important for you to decide what areas of professional photography interest you most and see how they might fit into the needs of your community. Remember that a photographer is offering a service as well as a product, and that there must be a demand for that service.

Next, examine your strengths and weaknesses, both as a photographer and as an individual. This is an extremely difficult

aspect of your preparations for becoming a full-time professional, but it's essential.

Take my own personality, for example. Although I enjoy children and delight in taking candid photographs of tham at play, I lack the patience necessary to produce successful studio portraits of them. Their constant fidgeting, their short attention span, and all the other problems that arise when trying to produce a formal child portrait upset me so much that I do less than my best work. For me to agree to handle such an assignment would be a foolish disservice.

I am equally unnerved by weddings. I feel pressured by the family and their endless demands. I lack patience with drunks at the reception. I am tense and nervous the entire time I am working. The quality of my work doesn't seem to suffer, but I don't have fun, and a job you don't enjoy isn't worth having. If I decided to make weddings a regular part of my work, I'd have an ulcer in a few months. As a result, the only weddings I now accept are weddings of models I've worked with extensively in the past. I work easily with them, don't feel pressured, and actually enjoy the assignment. Even better is the fact that I seldom handle more than one a year.

Surprisingly, even the most demanding advertising or public relations work is a delight. The work is harder than weddings and the pressure is theoretically greater. Yet I thrive on such assignments, greatly enjoying every moment behind the camera.

Think about what you enjoy doing and not doing. Could you stand to meet the public constantly throughout the day, always being friendly and cheerful? Could you laugh again and again at the "originality" of such tired jokes as, "You'd better be careful. My face may break the camera"? Do you have the "gift of gab" that enables you to make anyone feel at home? If you do, then portrait photography might be ideal for you.

Are you a creative individual who can see new ways to arrange familiar objects? Do you enjoy special effects work and image manipulation both in the camera and in the darkroom? Could you follow an art director's ideas in showing off a product as well as working on your own? Then perhaps advertising is your strong point.

Or do you like the thrill of news work? If you like to visually tell

the story of businesses and people, if you can produce not just images of a company but also visually convey the attitude it wants the public to feel, then public relations photography is a good area for you.

Certainly the smaller your community, the less freedom you'll have to pick and choose what your studio handles. However, if you can't spend the bulk of your time photographing the kind of assignments you truly enjoy, then perhaps full-time professional photography is not for you. You may wish to continue as a moonlighter the rest of your life, never going full-time but also never having to be plagued with the pressures of work you don't enjoy.

Once you know your strengths and weaknesses, your desires and hates, you're ready to make that first important step. You're ready to consider going into business for yourself.

4

Records and Financial Obligations of Your Studio

Forming Your Business

There are several ways in which your studio can be operated. When you first start out, working from home, this may not be something to consider. However, as you progress to forming a studio, you must decide how you'll do business.

Sole Proprietorship

This is the studio in which you're your own boss. You work when you please and are responsible to no one. In effect, you're operating this type of business when you're freelancing or working from home. Your business success is limited only by your ability as a professional photographer.

The disadvantage is that a sole proprietorship is not considered as good a financial risk for a business loan as are other forms of studio organization. Your own personal credit is subject to question, not the quality of the business you're running; with other forms of studio operations, the solvency of the business is more important than how the person running it handles personal finances. Should you have business reverses, your personal assets, home, car, and similar items, could be sold to meet your business debts.

General Partnership

This occurs when two people pool their talents and money to form a studio. You'll need a lawyer to put in writing how profits will be divided, and to define each partner's obligations to the other. Often this type of arrangement is entered into by photographers with differing specialties. A portrait specialist might work with an advertising and public relations specialist so their combined studio could handle almost any type of work.

The disadvantage is that the partners are still liable for the business's financial reverses. If one partner can't meet his obligations, the other partner's assets can be taken. There is also the problem that when one partner dies, it's possible that the business will be totally dissolved.

Incorporation

Forming your own corporation is an involved process that may not be suitable for the average studio owner. There are many considerations, not the least of which is how much money you're making. A lawyer is essential before you make any decision about incorporating.

The advantages to forming a corporation are several. The people who create it and hold stock in it are not subject to personal assessment for bad corporate debts. Your personal finances are never in danger, regardless of what happens with the business. The business is also self-perpetuating when it's a corporation. The death of a partner does not mark the end of the studio.

Incorporation also has its disadvantages: the taxes are higher than for other forms of doing business. Bookkeeping becomes more involved, and expansion may be limited according to the terms of the charter established at the time the corporation is formed.

Taxes

Before you can sell your first photograph, you're going to have to get tangled up in a lot of red tape. While it goes without saying that you hope to be successful, you may be surprised to learn that the government is also rooting for you. City, county, state, and

federal agencies are all planning to take a piece of the action, and woe to the professional photographer who doesn't cut them in.

The best approach to taxes is to take a day off and make the rounds of the government tax offices to learn what you must pay and when you must pay it. You'll probably be faced with a state income tax, and often a city income tax, in addition to the federal share. Self-employment taxes generally have to be estimated and paid on a quarterly basis rather than just the annual problem you have when you're someone's employee.

There are also sales tax requirements, a fact that upsets many photographers. There is a question as to whether photography is a service or a product. Are you selling your skills or the actual photographs? If it's a service, you should escape sales tax in some areas. If it's a product, you won't. Unfortunately, if you ask a government agency for a ruling, you can be certain it will be in favor of whatever gives them the most money.

Social Security tax can be quite a shocker. If you've never been self-employed you may be unprepared for the size of your tax. Remember that employees share the cost of Social Security with their employers. When you're in business for yourself, the total amount due is your responsibility.

Zoning and Other Restrictions

Once you begin photographing people in your home, or if you open a studio, you'll have to comply with a host of regulations. Zoning is one problem you'll face. Can you run a business in the area where you live? Generally no one cares if you use a portion of your home for a base while handling assignments that are done only on location; zoning concerns are primarily with businesses that have customers coming and going—as is the case with a portrait studio. Businesses create parking problems, and they can change the driving pattern for your neighborhood. If your area is strictly residential, you may not be allowed to have a studio in your home.

Your home may have to be inspected before you can use it for a studio. Fire safety checks, for example, are often mandatory. Some of the codes are nuisances meant to produce revenue; others are genuinely meant to protect you and your clients from

possible harm. After all, do you really know if your home wiring can handle the power drain of high-powered floodlights without causing a fire?

Billing

A second problem area that should be considered in advance is how to get your customers to pay you. It's essential that at the start you insist on cash payments whenever possible. If you're handling commercial assignments for major companies there will, of course, be billing procedures to follow. However, when you do portraits, weddings, and similar assignments, work on a cash basis.

The cost for carrying accounts is far greater than you might imagine. Let's say a customer's bill is $10. If that customer pays you immediately or within thirty days, you get the full benefit of that $10. However, if you aren't paid for sixty days, several factors work against you. You won't be able to meet some of your bills when the account is unpaid for two months, so you'll have to pay your creditors an additional percentage for carrying your account. And you won't earn interest on that money, as you would if it had been deposited in the bank. Because of these increased operating costs and lost interest benefits, $10 paid to you sixty days late is effectively the same as receiving just $9 for your work. The situation gets worse when a client waits six months to pay your bill; then the $10 is reduced to a value to you of just $6.70!

In case you think this isn't a serious problem, I once did some work for a major firm of architects. The bill was a relatively small one—$100. The architects were successful, quite wealthy, and, you would think, good for the money.

Thirty days passed after I submitted my initial bill and I had to go to the time and expense of a follow-up billing. Then it was sixty days and another reminder, then ninety days. When did I at last get paid? Twelve months from the time I did their work! Why did they wait so long? I'm still at a loss to understand it.

There are many ways you can handle late accounts, of course. If your community has a small claims court, you can always "tell it to the judge" and hope he decides in your favor. Or you can work

through a collection agency, which will take a substantial portion of whatever is collected. Or you can hire a couple of thugs to go after the delinquent debtor and hope the police don't arrest you for extortion, assault and battery, and several other charges.

Credit Cards

Actually, there's an even better method for ensuring that you get paid, and that's to honor bank credit cards. You don't have to be established in business long for Master Charge and Bank-Americard to set you up as a member business. They're happy to work with someone just beginning since they know your volume will be growing.

Bank credit cards are the same as cash for a businessman. When you accept a card, it's the same as being handed money; the bank will pay you the amount of the charge the moment you deposit the slip. It's the bank's problem if the customer fails to pay his credit card bill. It's the bank that has the collection problems, and the bank that takes the loss if the customer defaults. The business that accepts the card receives its money no matter what.

The cost for using bank credit cards seems high until you look at the facts. At this writing, participating businesses are charged a maximum of 5 percent of their gross charge receipts by the issuing bank. The charge is determined by the volume of business you do, and declines to 3 percent when your gross rises substantially. If this seems high, keep in mind that recent studies of small businesses indicate that the cost for carrying accounts and billing runs an average of 7 percent of gross receipts. Bank credit cards save you 2 percent even when you pay the maximum percentage.

Your obligations to the bank are limited too. You must check the expiration date of the card being presented to you. If the card has expired, you must not accept it. If you do, and if the customer defaults on his bill, the bank charges you with the loss. You must check any list of stolen cards issued by the credit card company. This takes a matter of seconds.

If the amount of purchase exceeds what is known as your "floor limit," you must call a central computer to be certain the

customer is allowed to make that high a charge. The "floor limit" is a dollar figure determined according to the average charges made by your business. For example, if your average bill is $25, that might be your floor limit. If a customer charges more than $25 on his credit card, you must call the computer for an okay. This takes thirty seconds, on the average. You also get to make friends with machines you might otherwise never have met.

Finally, you must compare the signature on the card with the signature on the receipt. You don't have to be a handwriting expert. You just have to be certain the signatures look similar. If there's an obvious discrepancy, you must assume that the card doesn't belong to the user, and refuse to accept it.

Credit card acceptance can be of multiple value to you. The first is the easing of the cash flow problem. You no longer carry accounts, so you're paid in full right away. You may occasionally encounter characters like my architects, but it is rare that large, established businesses delay paying you. The problem is with the smaller customer who wants portrait and wedding work, and this difficulty is solved with the credit card.

Your sales can increase with credit card acceptance, too. If someone has to pay by cash or check, he'll be extremely price-conscious, and will strictly limit his purchases. Yet somehow $100 charged to a credit card never seems to be as much money as $25 in cash. When your customers realize you accept bank cards, they'll yield to impulse buying.

For example, one studio near my home sells picture frames as a sideline. The frames start at $15. Before the studio accepted charge cards, only one in twenty portrait sales resulted in the additional sale of a picture frame. When the studio added the charge card acceptance, one in five portrait sales resulted in the additional purchase of a frame. More important was the fact that the average amount of money spent for each frame rose from $20 to $35.

Another area where credit cards are a blessing comes when you're handling weddings. When the family of the bride or groom pays cash, their purchase is often limited to the basic album and perhaps one or two single enlargements suitable for framing. With the credit card, they're liable to buy small, proof-

size albums for gifts to bridal attendants, the best man, rich Aunt Harriet, grandparents, and close friends. They're also likely to order all the photographs you took of the wedding, rather than just your basic album containing a limited selection of perhaps twenty photographs.

Payment Methods

At first, your best approach to billing is to insist on payment on delivery of your work. For portrait customers this means cash, check, or credit card when the prints are completed, as well as a modest sitting fee the day you take the photographs. This latter charge will be discussed later.

When you photograph a wedding you'll actually collect from the family in three installments: one payment at the reception after you've handled full coverage of the marriage, a second payment the day the proof albums are delivered, and the third when the final order is delivered. Full details as to what to charge and how to handle the various payments are discussed in the chapters on weddings and pricing.

When you're doing work for advertising agencies, public relations firms, large businesses, and so on, you won't be paid immediately unless you're very lucky. Some companies pay at the end of each month, or in the first ten days of the month following receipt of your bill. Others pay only after receiving their money from their client. Still others pay only upon threat of immense bodily harm, public scandal, or extensive pleading and picketing. Hopefully you won't encounter this latter type of business when you're just beginning. Such an experience is most upsetting, though, sadly, stories are told of such clients by every commercial studio that's been in business for a few years.

Another disadvantage to accepting time accounts comes when you have to pressure your client to pay up. Even though you're within your rights when demanding money due you, the embarrassed client psychologically wants to save face. Rather than admitting to being in financial straits or just a deadbeat, he'll twist the situation in his mind so you become the villain. "That guy is so rich, he has no business hounding me like this," the customer thinks to himself. "He ought to know I'm good for the

money. Who does he think he is? Well, just to teach him a thing or two, I'm not going to pay!" And not only do you lose a client, you also lose business that might have come from his friends.

With cash accounts and the acceptance of bank credit cards you avoid all hassles. You get your money, and any bill collecting that must be done falls on the bank. There is never any resentment against your studio.

Record Keeping

In addition to planning your taxes and billing, you're going to have to keep records covering all phases of your business. You'll need to know how much money is coming in, how much is being spent, what supplies are used, and so on. Remember that there will be many items deductible from your taxes, but that these deductions can be made only if you have records to prove they are legitimate.

Income and Business Expenses

There are actually several sets of records you will have to keep, though none of these is very difficult if you plan for them from the start. The first set covers your income. Each time you take a portrait, cover a wedding, or handle an advertising photograph, you must make a record of the client's name, the work done, and the charge. You should also have a list of expenses, including film, processing lab fees, postage, and similar items. With advertising and public relations firms, your expenses will generally be listed separately and charged directly to the company. With portrait and wedding customers, your expenses are figured into your final charge but not listed separately. The difference is that weddings are considered a complete service, whereas with advertising accounts, you're usually charging for time plus expenses.

I like the idea of keeping cross references. In a standard ledger book you can write in day-to-day transactions, expenses, charges, payments, and so on. Then a second set of records is kept on a card file. Keep a card for each customer, listing the customer's name, address, the date, type and cost of each service performed (portrait, advertising, photo, etc.), and money re-

ceived. There may be a single date entry for some customers, while others, giving you repeat business, could have many insertions running over onto additional cards.

There are other approaches as well. Your library will have one or more guides to record keeping for small businesses, which you might want to read if you have no accounting background. Some beginning professionals go to the expense of hiring an accountant to help them set up a bookkeeping system. This is well worth the modest cost. However, if you do hire an accountant, keep in mind that his fee can be reasonable or staggering depending upon the individual you use. Don't be afraid to get a cost estimate for such work from several accountants before deciding on a particular one. The quality of an accountant's service is not always reflected by the size of his bills.

Keep receipts for all business-related purchases. This includes cameras, film, flood bulbs, paper, stationery supplies, and countless other items, both large and small. These can be filed in standard file folders by month and/or year. You'll use them at tax time when figuring your deductions. Be sure to save them at least ten years in case of audit; this will get you well past the statute of limitations.

Negative Files

Your negatives and contact sheets must be filed, and this is an area to which you should give as much thought as to financial records. As you'll learn in the chapter on file sales, negatives represent long-term income as well as satisfying a client's immediate need. You must be able to find any picture you have ever taken, with a minimum of searching.

When I first started as a professional I threw each roll's negatives into an envelope and tossed the negatives into a drawer. I took all the contact sheets and made a neat stack for shoving into a second drawer. When I needed an old negative I would open the drawer in which they were located, pull them all out, and start examining envelope after envelope until I found the right one. This meant excessive handling, which resulted in exposure to dust, greasy fingers, and abrasion, all of which made my negatives look as though a cat had sharpened its paws on them.

From time to time I pulled my stack of contacts from the other drawer and looked through them to refresh my memory of what I had. This was a good way to pass an afternoon, but not so good as going out and looking for work, which is how I should have spent my time.

One day my printer got tired of retouching my prints and said, "Look, dummy, why don't you put each negative into an individual, glassine holder? They scratch each other when they brush together in those envelopes. And when you keep taking them out, they get even more damaged. You'll need six glassine holders for each roll of 36-exposure film, but the cost is next to nothing."

So I listened. I also added the splendid idea of numbering each contact sheet and putting the identical number on the glassine holders containing the negatives from which the contacts had been made. I still had to rummage through my drawers to find everything, but at least I wasn't destroying my precious negatives.

The next evolutionary step in my file system came when I bought some manila envelopes designed to hold an 8 × 10 negative or print. I placed one contact sheet and the glassine-encased negatives for it inside the envelope. Then I marked the outside of the envelope with the contact sheet number. Finally I arranged them numerically in a file drawer. I thought I had it made!

About 15,000 exposures later I was faced with a few facts I had blithely overlooked. The first was that the envelopes were jammed so close together they were being bent and damaged. Secondly, if Boom-Boom Brannigan, the cheerleader for Benedict Arnold Senior High whom I had photographed some time in the distant past, suddenly wanted another print, I had to open every envelope until I found the negative. My methods were vastly superior to my original approach, but they were still grossly inferior to what a successful studio needed.

And so we come to the present, when I'm a marvel of efficiency and simplicity, thoroughly organized and orderly—at least when it comes to my negative files. Here's what I did.

First, I took my contact sheets from the envelopes and began

using one of the notebook systems available. I can thumb through them easily whenever I want an overview of what I have. The negatives are placed in special holders, each holder numbered as before, which fit inside the notebook. This latter approach is not essential, just the one I chose. I could just as easily have filed them in the same sequence as the contacts, using one of numerous file drawers specifically designed for this purpose. The best known, but not the only ones, are the stacking drawers marketed by Neg-A-File and available through most camera stores.

Next I bought a horrendous supply of three-by-five file cards and sat down with my contact sheets to produce a proper file. I made a separate card for each subject, listing the subject's name and the number of the contact sheet sheet(s) on which he, she, or it could be found. For example, one heading might read "Algernon Goodbody." Then, below the name, I might write the codes B-210, B-217, and B-323. With my system, this would tell me that Algernon appears on sheets 210, 217, and 323, and that all the pictures were taken with 35mm black-and-white film.

I currently have four different sizes of negatives on file. I have 35mm with the "B" designation, $2\frac{1}{4} \times 2\frac{1}{4}$, which carries an "A" designation, 4×5 with a "C," and 8×10 with a "D." Color is designated with an E added at the end of the number. If there is no "E" the film used was black-and-white. Because of the way my work is sold, I haven't found it necessary to mark my transparencies; the bulk of them are bought by the clients and the few that remain are filed in clear sheets kept in notebooks. I do maintain internegatives of all slides with file sale potential, and these are filed with my other 4×5 negatives.

Many of the photographs are cross-filed. For example, Twinkletoes Rafferty, prima ballerina with the Butterfingers Ballet Company, is filed under Rafferty, of course. But the same file number appears on the card marked "Ballet," as well as on one marked "Butterfingers Ballet Company."

Suppose Twinkletoes got married? Perhaps her heart was won by Billy Butterfingers, scion of the family that owns the ballet company of that name. I would then add another listing reading "Twinkletoes Rafferty Butterfingers" and file it under her new

last name with the notation "See Rafferty." That saves me from writing the code numbers again.

Of course, I've taken photographs of all types of things, not just people. Many of these make excellent file photographs for long-term sales for calendars, greeting cards, posters, and so on. How do I handle these?

Suppose I take a photograph of a sailboat at sunset on Lake Itchie-Finger in Beautiful Kiss-And-Tell, Oklahoma. In addition to such headings as "sailboat," "sunset," and "Lake Itchie-Finger," I also include Kiss-And-Tell, Oklahoma, with notations indicating what's in the photograph ("Kiss-And-Tell, Oklahoma—Sailboat at sunset," and "Kiss-And-Tell, Oklahoma—Lake Itchie-Finger sunset"). Finally, I file it under "Sunset—Lake Itchie-Finger," Sunset—Kiss-And-Tell, Oklahoma," and "Sunset—Sailboat."

A lot of work? Of course. But there will come a day when your files are a major source of income. People will come to you saying, "What pictures of Kiss-and-Tell, Oklahoma, do you have?" or "Do you have any nice sunset pictures of Lake Itchie-Finger?" or "Let me see some of your sailboat shots." Without the numerous file cards under every possible heading, you might overlook a considerable number of salable photographs that perfectly fit the client's needs.

How long does this filing take? The original work, covering several years' photographs, took me more than six months working an hour or more every night. It was tedious, dull, and necessary. Today it takes only a few minutes every couple of days to keep everything up to date. Since you're just starting out, you can figure on spending no more than an hour a week, and probably considerably less, getting organized. After that, it takes very little time and will eventually repay you handsomely.

Once you're established you can make money long after your assignments are forgotten. Your files are the key to extra income, so it's important that you start off properly. Don't wait to put them in order until you have 15,000 to file, as I did.

5

Wedding Photography

No matter what type of photography you eventually hope to do, weddings will probably prove to be your earliest source of income. Weddings generally take place during weekends, which makes them easy to cover even if you have a full-time job. They're all handled on location, so there's no need for a studio. And your selling is done in the home, so there's no need for an office. You aren't bothered with the zoning laws, building inspection, and other factors that will be a part of your life when you open your own business.

Equipment

Wedding photographs can be taken with almost any equipment you might own, though most photographers standardize with either $2\frac{1}{4} \times 2\frac{1}{4}$ or 35mm rather than using the 4×5, which was once traditional. The smaller equipment is easy to hold, generally offers interchangeable lenses, and is easily maneuvered.

The Necessary Spare

The important point to remember about weddings is that no matter what equipment you use, you must always have spares.

You must have at least two camera bodies, two strobe units, and three or more synch cords for the flash. You'll need more synch cords than anything else because the cords are notorious for failing to work at crucial moments. I have yet to find a truly long-lasting synch cord, regardless of price and manufacturer. In fact, I am convinced that for every three synch cords I buy, one will have a crucial wire break, a second will commit suicide midway through an assignment, and the third will mysteriously disappear from my gadget bag.

While many assignments can be delayed or repeated if you have equipment failure, no one is going to postpone a marriage just because your camera jammed or your strobe suddenly stopped working. The wedding will go on, with or without you. Thus it is essential that you prepare for any catastrophe that might befall your equipment.

It isn't necessary for the equipment you carry to be all the same type. You might have a pair of 35mm single-lens reflexes, or you might use one 35mm camera and a 2¼ × 2¼ backup. If you do mix film sizes, though, be certain that you have enough film for each camera to more than adequately cover the wedding. This may mean four or five rolls of 35mm film and perhaps a dozen of 120 film. All of this increases the amount of equipment you'll have to carry around with you, which is why most photographers try to use cameras utilizing the same film size.

When I covered my first wedding I used a 2¼ × 2¼ single-lens reflex and a borrowed 35mm camera. The 2¼ × 2¼ SLR wasn't the expensive, sophisticated piece of equipment such cameras are today; it had all the mechanical perfection of a rejected Cracker Jack prize. In fact, I learned after arriving at the bride's home that the flash synch did not work properly. However, the lens was good, and that seemed to compensate to some degree for the fact that I had to keep a repairman on permanent retainer to be sure my shutter would function.

The 35mm camera was better mechanically but suffered in its optics. Together the pair conveyed all the professionalism of a golfer who has yet to break 100 for the first nine holes. But when you're first starting out and that's all you can afford, you buy a lot of masking tape for repairs and spend considerable time praying.

Flash Equipment

When it comes to flash equipment, it isn't necessary to have identical units. The best flash is electronic and comes with a high-powered battery pack. Such units can be purchased for as low as $60 to $70 and as high as $200 or more. The price reflects the unit's features rather than its quality, so you can safely go with whatever you can afford. The reason for the high-powered battery pack is that such units recycle quickly, enabling you to take photograph after photograph without waiting ten seconds or more between images.

Your back-up unit can be almost anything—provided it can handle complete wedding coverage. A small electronic flash, perhaps in the $30 to $40 range, might suffice, but be sure you take several sets of fresh batteries, as you'll probably need to change them at least once during the course of the day.

You can also use regular flash equipment. When I did my first wedding I used a huge flash meant for an old 4 × 5 press camera. It used flashbulbs the size of 100-watt household bulbs. I was quite a sight trying to maneuver my gadget bag filled with enough bulbs to cover the entire wedding. Fortunately, that's an extreme you can avoid. Even the tiny AG-1 bulbs like those in flash cubes produce an immense amount of light. As long as you know the limitations of your lighting equipment and don't move in too close or back away too far, any type of flash will work. The ideal backup if bulbs are your choice is one of the inexpensive polished reflector holders for AG-1 bulbs (not cubes). The holder, a dozen packs of flashbulbs, and three or four sets of alkaline batteries will fit into a corner of your gadget bag.

Wedding Procedure

Wedding coverage can be handled several ways. Generally a photographer is hired to photograph the wedding, the wedding and reception, or the wedding, reception, and the period at the bride's home when she's getting ready for the ceremony. Prices rise according to time and the degree of coverage. Naturally, you should always try to convince the bride and groom to hire you for maximum coverage.

All weddings are photographed in color negative film, as it's inexpensive, has wide exposure latitude, and is extremely ver-

satile. Color negatives can be printed in color or, should your clients be on a low budget, in black-and-white. When the latter situation occurs, you can count on future sales from file: with follow-up promotions, your clients will buy individual color prints to supplement the coverage. If you take the original photos on black-and-white film, it's not likely that much future business will be generated from that wedding. Color negative film can also be made into transparencies, should they be desired.

The Package You Offer

You'll have to do some shopping around to learn lab prices and service time before you decide what you're going to offer. Most professionals use labs that process the film and return 4 × 4 or 4 × 5 proofs, loosely stuffed into an envelope. A few labs mount the proofs in a miniature album, and others make 8 × 10 prints from your negatives if they are desired. I feel that all proofs should be mounted in an album before being shown to the bride and groom. You can do this yourself if your lab doesn't offer this service.

An album of proofs looks more professional than just loose prints. More important is the fact that the proofs are permanent color prints, not the old-fashioned proofs that faded in sunlight. With some aggressive salesmanship you can convince both sets of parents to purchase one or more proof-sized albums. Sometimes a proof album is bought so the parents can have a duplicate of their son's or daughter's album. Other times the bridal couple buys your minimum 8 × 10 album, containing perhaps twenty prints, as well as a proof album with copies of every photograph you took.

It's important to stress that any photographs that go unsold reduce your total profit. When you have proofs made and use them strictly as a vehicle for selling the larger wedding albums, the cost of those proofs must be subtracted from your profit.

At this point it's important to mention a tenet of professional life which, depending on your present circumstances, you may not know: never show any client every photograph you take during an assignment unless every photograph is perfect. The

pictures you cropped poorly in the viewfinder, the ones that were a little too light or a little too dark, the ones that caught the bride with her eyes half-closed or the groom with his mouth open like a fish are all discarded. Since you're a professional, there shouldn't be very many discards, but there may be one or more in every roll you take. Let your clients think that every photograph was perfection itself. Let the clients think that they're seeing all that you took. Your reputation will be all the greater for it. But *never* show mistakes and near-misses. At best, you'll tarnish your image; at worst, if you catch your clients in an embarrassing moment, it could cost you business.

What to Charge
Wedding coverage charges include several factors. The first is your time; your basic charge for covering the wedding and providing an album of perhaps twenty or twenty-four prints must include an hourly rate as well as expenses. What should this hourly rate be? That's up to you, though some extensive guidelines will be found in the chapter on pricing. I feel that in most communities you should consider your worth to be a minimum of $25 an hour. Figure an hour for the wedding, a second hour for the time in the bride's home before the ceremony, and perhaps two hours for the reception. This means that you should charge $25, $50, or $100, exclusive of expenses, just for your presence during one or more aspects of the wedding day.

You can save money on your expenses in several ways. The first is by buying rolls of film in quantity, preferably from a wholesaler. Generally a minimum order of twenty rolls is necessary to get a substantial discount, but this varies with suppliers. If you're using 35mm film you might be tempted to buy bulk film and load your own cassettes. This represents a tremendous theoretical savings—and unfortunately, a potential for disaster.

When I was first starting out I bulk-loaded film for use at a polo game. Not only did I get the action photographs I've always dreamed about, I also got negatives that were scratched so badly that no retoucher could save them. Manufacturers say that they have bulk loaders designed to make scratching impossible, and this is true today. But can they also guarantee the super cleanli-

ness of the cassettes you get when you buy packaged film? Of course not. Furthermore, if you're using a custom lab for your color, as almost everyone does, it's not going to bother returning the cassettes you hand-load. Suddenly your cost is almost as high as for fresh film, and you have enough potential for disaster to cause an ulcer. It's not worth it. Buy in quantity, but don't bulk-load.

You save money when you standardize your exposures. Test your flash in advance to determine what guide number gives you the most accurate negatives. Then take all your pictures with a thought to proper exposure. When you have wildly varying settings causing over- and underexposure, you increase lab problems. Instead of being able to give you quality prints from a machine, the cheapest way to buy them, the lab will have to hand-print some of the negatives, at a cost of up to five times the price for machine prints. Color prints of quality are now being produced at low cost by labs using sophisticated machinery. It's only when your negatives are poorly exposed that the human element has to be added, at a cost that sends your price per print skyrocketing.

The Traditional Approach

Many photographers delight in unusual approaches to wedding photography; they make multiple exposures in the camera or use special attachments to help them take pictures that put images within images. Some have their labs use overlay sheets to put the couple in the middle of a heart or surround them with the sheet music of their favorite song. However, no matter how wild your wedding photography happens to be, there are still some basic straight photographs you must have to fully satisfy the wedding couple and their families. You must photograph the bride coming down the aisle on her father's arm, the bridesmaids and best man, the wedding ceremony, the throwing of the rice, the bridal bouquet, and, sometimes, the garter. You must show the couple dancing with each other and with their parents. In other words, you must *always* provide traditional coverage no matter how creative you choose to be with supplemental photographs. It's the only way you can be sure of pleasing every client.

The best way to be certain you remember to take all the traditional wedding photographs is to make yourself a small checklist; type it on a three-by-five card and carry it in your gadget bag or attached to the back of your camera. It serves as a reminder you can check until you become more experienced in this field.

Advance Work: Asking Questions

Photographing a wedding is more than just being hired and showing up with your camera on the day of the marriage. There's advance work that must also be done.

Where is the couple being married—in a church? a temple? City Hall? the parents' house? on a high mountaintop at dawn? If the ceremony is a religious one, how must you dress? Women photographers must cover their heads in some churches or they won't be admitted; Orthodox Jewish men cover their heads at all times, and many temples require a male photographer to do the same before entering. Ask the bride to check on the requirements well in advance of the day of the ceremony.

Where is the reception going to be held? Will it immediately follow the ceremony, or is there a delay of a few hours? In the latter case you'll be kept on the hook for several nonproductive hours. How will you get to the church and/or the bride's house? What about the reception? If you can't ride with one of the families you'll have to arrange for your own transportation.

Where can you take posed portraits of the bridal couple and their families immediately following the wedding—in the church or temple? If posing is permitted, where can you do it, how much light will there be, and what equipment will you need? If not, where will you go with them? You can't wait for the reception unless it immediately follows the wedding: Grandfather could get worn out and decide to stay home; rich Aunt Harriet's car might break down and she could miss the pictures. You must take posed family portraits as soon after the marriage ceremony as possible.

Who will gather the family for the photographs? You have no idea who should be included and who shouldn't; you don't know which cousins are feuding and can't be posed together. You don't

know who's a grandparent and who crashed the wedding to take advantage of the food at the reception. It's not your job to know—someone must be assigned to accompany you and gather everyone who belongs in the photographs. Know who this person is *before* the day of the wedding. This isn't something that can be left for the last minute.

Bear in mind that this is the bride and groom's day and that they're never at fault for anything that goes wrong. If they don't make arrangements for someone to help you gather family members, by the twisted logic of the wedding day, it will be *your* fault, not theirs. You'll be blamed for the lack of photographs of people they care about. That's why you must be covered in advance.

Billing

Wedding photographs are paid for in three stages. On the day of the ceremony, you should receive a check for an amount that will at least cover film and processing costs. This should be given to you before you leave the reception. It's given in good faith, as you haven't yet shown the family any results.

A second check, generally a larger one, is given to you the day you show the proofs. This should cover your time and the cost for printing the basic album agreed upon in your initial charge. The final payment comes when you deliver the prints, and covers all other purchases the family makes. Some photographers vary the amount charged at each stage, but almost all take their money in the three steps mentioned. This is especially important when you're first starting out, because you can't afford to absorb very many expenses.

Extra Photos

There are two photographs you might be expected to take that normally require the use of a studio. These are the engagement portrait and the full-length formal portrait of the bride in her wedding gown. Both these photographs are meant for use in the newspaper, and may or may not be desired. If you're requested to take them, some fast talking may be in order.

My approach to such requests at first was to insist that they be

taken on location or in the bride's home, since familiar surround-
ings are so much more elegant and natural than a stark studio.
For the engagement photograph I could work anywhere, pro-
vided I had an inconspicuous background. This is only a head-
and-shoulders portrait, and I often used a 90mm lens on a 35mm
camera, stopping it down only slightly to minimize depth of field.

The photograph in the wedding gown is something else again.
Generally I would take it at the church. However, if it was needed
before the day of the wedding, I would photograph the bride at
any nearby location that would be effective. Sometimes this
meant her back yard. Other times it meant a park or a church, or
even a school with massive columns that looked like a church
front. I've even taken this photo in a shopping center before the
stores opened. The pictures were more dramatic than studio
photographs, so the bride and her family were happy—and I
breathed a sigh of relief at not having to open a studio area.

Albums

The wedding album you prepare for the bride and groom is
going to take some thought. Wedding albums are available for
anywhere from under $10 to over $100, exclusive of the prints.
Some are plastic, others are tooled leather over hard wood. Most
photographers offer a limited range, including the least expen-
sive they can buy, one that costs perhaps $15 to $20, and one in
the neighborhood of $25 or higher. They use a different set of
wedding photographs for each of the sample albums, something
you won't be able to do for a while.

Your best bet when starting out is to select an inexpensive
album that's attractive, dignified, and well enough made to last
for several years at least. This will probably cost $10 for 8 × 10
prints and around $15 for 11 × 14 prints. What you pay will vary
with where you live and the number of stores handling such
items. Shop around for the best price, and if you can afford it,
have two sample albums made, one 8 × 10 and the other 11 × 14.
An 8 × 10 may be easier to store, but an 11 × 14 can be a dramatic
coffee table addition that's looked at again and again by the
couple's friends, who may themselves be in the market for a
photographer. Eventually, it's essential that you have both sizes

of albums to show, as they will increase your business. However, if your budget only allows one sample, let it be the 8 × 10.

The number of photographs in your sample is up to you. Some photographers put in the exact number that will be offered with their basic charge. Others put in as complete a selection from the wedding as possible. This may mean forty or more prints, assuming the album is easily expandable, rather than the twenty to thirty that will be part of your basic album.

Advertising

Handling wedding photography is a little like going into retail sales. When you first start out, you'll have to spend money to make money. You'll have to advertise and promote yourself, expenses you may wish to avoid but which will prove essential.

Advertising can take many forms, but it must be planned to reach your potential customers. This means selecting media that will be seen by many people of marrying age. Remember that it's the bride and groom, and/or their families, who will select the photographer. They are the ones who must be reached.

The Student Market

Most high schools have newpapers and/or yearbooks that are avidly read by the students. These can be an excellent medium in which to purchase space. However, there are a few precautions.

First visit the high school and talk with someone on the administrative staff. If this isn't possible, see if you can reach someone in the office of the superintendent of schools in your area. What you want to know is what the students tend to do after graduation. Do the bulk of them go on to college or take other advanced training? If they do, there will be few marriages soon after graduation, and your advertising will be wasted.

When I first started in the business, the two high schools in my immediate vicinity prided themselves on the fact that 90 to 95 percent of their students went on to college or vocational school. However, a few miles away the rate dropped to just 35 percent in a different high school, with quite a number of the students planning weddings in June and July. Theirs was the newspaper in which to advertise a wedding photography service.

Most colleges and junior colleges also have newspapers, and these are perfect places for your advertisements. Plan on regular appearances in the publications, preferably with every issue but at least once a month. Keep in mind that plans for a photographer are made well in advance of the ceremony. Furthermore, the idea of the June wedding doesn't hold with colleges; couples tend to marry any time they have a fairly long break from studies. There are as many, if not more, marriages taking place in December, during the long Christmas break, as in the "traditional" month of June.

To be effective, your advertisement must be fairly large, and it must be accompanied by a photograph. No matter how cleverly they're written, advertisements don't get read unless they have some way to attract the eye. You could use a drawing, but be honest with yourself. Would you trust a photographer who used a drawing rather than one of his or her own pictures? My attitude would be that the photographer was a poor one, ashamed of his work. It's an unfair generalization, but it's one the average reader might also make.

What type of photograph should you use? Anything that has eye appeal and spells romance is good. The simplest picture would be a bride, perhaps in profile, but this shot isn't very arresting. Perhaps you could try a couple in silhouette. Keep in mind when examining your past work that the photograph will be printed quite small. Something that looks perfect in an 8 × 10 might not be very dramatic in a small advertisement. If you have nothing that fits your idea of what the advertisement should be, go out and take something. Ask your friends to help you, or any young couple you can find.

When you have the final photograph, you must be careful about the way it's printed. Newspaper reproduction is notoriously poor. If you provide a print with the wrong contrast, subtle tones will be lost and the entire effect will be muddied. Unless you're skilled in making prints for newspaper reproduction (or your printer has this skill if you use a custom lab), you should provide each paper with three photographs—one that you consider a perfect reproduction, the second of somewhat higher contrast, and the third of somewhat lower contrast.

As an example of how important having the right print can be,

I once opened a newspaper to an advertisement run by a national restaurant chain. The advertisement filled the entire center fold of the newspaper, taking two complete sides of a major metropolitan daily. Obviously a small fortune had been spent for the ad, but the photograph, a picture of a pastoral lake scene as viewed from a restaurant window, was hideously black. The print had looked perfect to the photographer's eye but was the wrong contrast for newspaper reproduction.

I had been trying to land that particular account for some time and the advertisement delighted me. I knew heads might not be rolling over the error, but a few people in the advertising department would have their necks on the line. I gathered my portfolio and went down to the advertising director's office without an appointment.

Somehow I talked my way inside and was allowed to present my work. As the director looked through it, I casually mentioned the fact that my final prints were supplied according to the medium being used for reproduction. I stressed the fact that my printer could handle the special needs of newspapers, for example, though I never mentioned that morning's fiasco. I left the office with an assignment.

The same situation holds true with your advertising. If you don't have a photograph that reproduces properly, some other photographer is going to take away your business. Your clients don't understand the idiosyncracies of printing; all they know is that the photograph in your ad looks either beautiful or terrible. If it's the former, you'll get their business; if it's the latter, they'll call your competitors.

Your advertisement need not have your address, but it must have a telephone number. Needless to say, you must have that answering machine if you can't guarantee that someone will be home every day during normal working hours.

Weekly Newspapers

Weekly newspapers can also be a good place for your advertising, though not as good as the school papers. Again the cost is reasonable, and you have the added advantage of reaching a definite buying audience. Except in small, isolated communities

where the weekly newspaper is the main source for community information, most weekly papers are considered "shoppers." They go to the reasonably affluent suburbs, and are vehicles for small stores and neighborhood specialty shops whose owners can't afford the rates of dailies. The news they contain is only an excuse for these papers' real purpose—to sell advertising. Most of the news revolves around strictly local events, such as Suzybeth Spinletter, age seven, who played the role of the string-bean in her class play about vegetables. No one really cares about such matters except the Spinletter family, but the weekly shopper runs the item to fill space. However, the advertising *is* read, and will give you a good market.

Daily newspaper advertising is too expensive for you at this stage in your work. The only area where you could really afford to appear would be in the Classified Section, where you couldn't run a photograph. Often photographic services are advertised in the Personal column, a section that does have a loyal following of curiosity seekers. Personal columns tell of busted marriages and people seeking other people for one reason or another. Occasionally a romance is carried out through the columns. However, whether these columns ever generate much business for the commercial firms who use them is questionable. I don't feel it's worth the gamble.

Later on you can get into other forms of advertising, such as radio and non-network commercial television. Both of these areas are relatively low-cost, and you can get statistics from the stations as to who is listening or watching at any given hour. However, for now your best advertising is done through school newspapers, yearbooks, and weekly "shoppers."

Other Methods of Promotion

Hotel Sales

There are other ways to promote yourself. As you may or may not know, hotels are frequently the scene for both planned and unplanned weddings. There are the catered affairs, of course, but there are also spur-of-the-moment nuptials. Most of them involve couples who got a license, were planning a large, formal

affair, and got turned off by the hassle of all that confusion. They elope one night, going to a hotel and trying to arrange for someone to marry them. It doesn't happen with great frequency, but it does happen.

The best way to take advantage of these weddings is to contact the catering office. If your area hotels don't have a catering office, they probably have one or more staff members involved with this service. Take your sample portfolio and explain that you're new in the business and you wonder if you could leave your business cards for anyone planning a wedding who may not have hired a photographer as yet. Many hotels will be quite happy to accept your cards and help you generate business. Some will even call you to photograph the spur-of-the-moment variety, though get cash in advance for these from the bridal party. Otherwise, you may get stuck for the lab costs.

Mutual Promotion

Try to establish a rapport with the various private firms that are involved with weddings. Talk with caterers, florists, renters of formal clothing, jewelers, and the like; discuss the fact that you're just starting out and see if an arrangement for mutual promotion can be made—you'll be expected to promote their services if they're willing to promote yours. Naturally, when one particular shop or service agrees to help you, you must not also try to work with a competing merchant. You can have a reciprocal relationship with just one jewelry store, for example.

Such mutual promotion can work two ways. In many cases businesses are happy to pass out your cards or mention your services just to help you out. Others want to get the promotion you can give them. A few will want a kickback.

Kickbacks work in a variety of ways, but the one many people consider the most legitimate is for you to pay the business a finder's fee. If a bridal couple calls you and mentions that you were recommended by Ptomaine Tilly's Tasty Catering Company, Ptomaine Tilly will be paid a fee when you get the couple's business. This fee can be almost any size, but you can expect it to be around $5 or $10. The exact amount must be established in advance if you're going to work this way. Naturally, your bills to

the bridal couple will have to be marked up to include the figures.

Should you pay a finder's fee? That's up to you. There are many businesses where a kickback as such is illegal. But their circumstances are quite different from those of the wedding photographer. I feel that the decision to pay fees for wedding referrals must be an individual one only you can make. However, I have personally never operated in this manner.

Public Exhibits

You can promote your work through an exhibition of your wedding photographs in strategic locations. Make some dry-mounted prints of your most dramatic work in sizes ranging from 5 × 7 to perhaps 16 × 20. Take these to an area merchant who deals with wedding-related items—bridal gowns, jewelry, or specialty gifts. Talk with the owner about running a display of your wedding photographs as a way of bringing more people into the store. Naturally, your name and telephone number will be prominently displayed along with the photographs, and if the merchant is willing, your business card will also be left behind.

Some stores don't have the room for a photographic display; others won't want to be bothered with you. Still others will feel that it could increase their traffic, and will be happy to display your work. They might even give you long-term space on their walls with the understanding that you regularly bring in new work to replace what has been on display for a while.

Religious Groups

Religious leaders can also be a source for work. Many factors influence members of the clergy in regard to referring you to members of their congregations. Sometimes the individual church or temple has a regulation against such a practice. Other times the entire sect is against it. Occasionally it will be against the clergyman's beliefs as to what his role should be.

It does pay to at least talk with neighborhood clergymen. While many of them wouldn't dream of suggesting one or another of the community's photographers, there may be other ways they can help you. Perhaps the list of church members

getting married is an open record you can check for leads to contact. Or perhaps the religious group has a membership bulletin or newsletter in which you can insert an advertisement. If you've already photographed a wedding in the church or temple, you may even be allowed to display some of the photographs over one or two weekends.

Direct Sales

Direct sales to bridal couples is a highly competitive business, but it's a game most photographers play. Marriage license applications are public information. Many newspapers publish this information, giving you leads to names and addresses of future brides. Other times the leads come from engagement announcements.

Whenever you read about a couple's plan to marry, call the bride or the groom at home. Tell them you're a wedding photographer and ask if there might be a time when you could talk with them at their convenience, perhaps in one of their homes. Say that you'd like to show them what you can do, explain your services and prices, and see if your work would fit with their plans. Some will refuse you; others will say they've already hired a photographer. A few will be interested, and those few make the time spent searching the newspaper and calling prospective customers worthwhile.

Weddings are emotional experiences, and seldom are they planned on a rational basis. A couple may be determined to approach the wedding plans in a businesslike manner. They may call eighteen caterers in three states to find the one with the best price. They may shop from florist to florist looking for the cheapest roses. But when they look through a wedding album, the businesslike approach falls apart, and they're no longer objective.

Bridal couples mentally project themselves into every photograph. She is that bride coming down the aisle; he is the groom meeting her. They're the ones being married and then pelted with rice. And if your bridal photographs have utilized an attractive couple, as stressed earlier, you are the one they will hire. Very few couples talk to more than one photographer, unless

several of your competitors phoned about the same time you did and they made several appointments before seeing anyone. Wedding couples hire on impulse, and on the emotional appeal of your sample album.

Your Working Image

Your appearance and the way you handle yourself are important aspects of wedding photography. In general, you should always dress conservatively when meeting with clients for the first time. Your individual taste should show only after you're certain the couple and their families will not be turned off by whatever clothing happens to be "your thing." It isn't fair for a client to judge you by what you wear rather than the photographs you take, but some do, so play the game and dress conservatively.

For the wedding, wear whatever the other guests will be wearing so you can remain an inconspicuous recorder of the day's events. This might mean formal clothes for elaborate church and country club affairs, or denims for a dawn wedding in the park.

Never drink, smoke, or eat at a reception, regardless of how the families encourage you. If you think you'll get hungry, slip a packet of mints into your gadget bag. If you get thirsty, drink some water. If no water is available, take a soft drink, gulp it down quickly, and return to your work. Don't stand around holding a glass. No matter how much anyone says it's all right, when they get your bill there's going to be some resentment. "That S.O.B. has the nerve to charge me all this money when he spent half the night standing around eating my food and drinking my liquor!" is how the client will react if you aren't careful.

Your first few weddings are liable to be those of family and friends, and it's only natural that you'll be invited to partake in the reception. However, family and friends are likely to be even less tolerant than strangers when it comes to your indulging in refreshments. They're going to be shocked to discover that you really have gone professional—that your bill is competitive with other area pros instead of being a discounted charge. And unless you've been working constantly during the affair, you're liable to create hard feelings that can never be mended.

A photographer's job is to take photographs. Even during idle moments you must look busy, if only for the sake of your image. When the work is completed, go home. You can stop at a restaurant along the way if you want to—but never, under any circumstances, should you act as a guest at any wedding you are paid to photograph.

After the Wedding

There are actually two selling times for the wedding photographer. The first is before the wedding, when you get your client; the second comes when you deliver the proofs. If the couple purchases just the base album with the minimum photographs that you agreed on, you'll make your profit, but you'll also have numerous images left over with no immediate market for them. Ideally, you should sell every good photograph you took, and often two or three prints from the same negative.

Let's say you used 120 film to cover the wedding. You used six rolls of twelve exposures each and have sixty-eight prints you're proud to show (the remaining four are in the trash). Let's also assume that you promised the bride and groom that you'd record the wedding and provide them with an album containing twenty-four prints of their choice, all 8 × 10 color, for $150. This price is meant only for an example; your actual charge might be lower or higher. For now the figure used is randomly selected and based on nothing.

The Finished Package

Proofs. The best approach is to have all sixty-eight proof prints mounted in an album. This gives the bride and groom and their families an idea of the scope of the coverage, as well as showing them that they can buy small albums in addition to the one they've contracted for. Be sure to edit the proofs so your clients see the day in sequence. As they turn the pages of the proof album they should be able to relive those memorable moments.

Prints. Besides proofs, there are several other samples you'll need. These can either be made from the negatives of that

particular wedding or they can be general samples you carry from bride to bride. These additional samples will show both larger sizes and special effects.

For example, assuming your clients ordered the 8 × 10 album, have an 11 × 14 print available for dramatic comparison. You may then be able to upgrade their purchase to the larger and more expensive album, or even to sell them two large albums. Many times photographers using this approach sell the parents the 8 × 10 album originally desired by the bride and groom, and the bridal couple gets the more dramatic 11 × 14 album.

Also include one or more 16 × 20 prints, preferably framed and ready to be hung. The print should be either of the couple together or of the bride alone. The sample should be an attractive, dramatic photograph the parents will be able to picture hanging in their home.

Special Effects. Finally, include some samples of special effects photographs. These should include montages, soft-focus or "misties," overlays, and unusual shapes, like the couple within the heart. Most of these effects are lab tricks that can be provided for a nominal fee. If the lab you're using doesn't offer them, consider switching labs. Special effects aren't popular with every couple, but they increase your sales enough with those who do like them that you should give all your customers the opportunity to buy them.

Completing the Contract

Ideally, all you should need is a verbal agreement for an order, and you could deliver the finished work confident that your clients would pay for it. Unfortunately, what's ideal and what can happen in the business world are two entirely different matters. As a businessman, *you must have everything in writing* before you commit your valuable time or endanger your budget by placing an order with your lab.

Before you arrive at the wedding, you should have a signed work order from the bride and groom and/or their parents. This form can be prepared by a printer to your specifications. It need

not be on very high quality paper; it's just a means of committing the family to the use of your services in a more legally binding manner than if you only had a verbal go-ahead.

The form might read something like this:

I am hiring (Photographer's Name) to photograph my wedding on (date) at (church name and location). The wedding will be held at (time). (Photographer's Name) is also expected to take photgraphs in my home before the wedding (Yes) (No) and at the reception after the wedding (Yes) (No). The reception will be held at (place and location) at (time).

(Photographer's Name) agrees to provide full photographic coverage as well as an (8 × 10) (11 × 14) album containing (number) color prints. I may also buy any additional photographs I select from the proofs taken for an additional fee.

Signed: _____ Date: _____

Such a form commits everyone. The photographer's duties are spelled out and the clients have committed themselves in writing. Leave blank spaces where there are words to be filled in; where there are alternative choices, the one that doesn't apply is crossed out.

Besides this form, have the bride or groom fill in a brief questionnaire giving you specific information concerning time, place, etc. This should have spaces for such items as the following:

Name, address, and telephone number of bride.
Name, address, and telephone number of groom.
Date of wedding.
Location of wedding, including church or synagogue
name and address.
Person officiating.
Restrictions concerning photography during the ceremony. Is available-light work permitted? May flash be used during the ceremony? May any photographs be taken during the ceremony? Must the photographer stay in one spot during the ceremony? Must the photographer's head be covered?
Place and address of reception.
Time of reception.
Length of reception.

Will transportation be provided the photographer from the place of the wedding to the reception?
Will the photographer's services be needed at the reception after the bridal couple has left?

Follow-up Sales

Your wedding photography sales don't end with the final selection of prints. A studio owner thrives on repeat business, and on establishing a long-term clientele. He or she also needs to be recommended to those who have yet to try the studio.

One simple approach to follow-up sales is to have your studio name and address and/or telephone number stamped inconspicuously on the lower part of the inside cover of the album(s) sold each couple. Every time their friends thumb through the pictures, your name will be readily visible. Few, if any, couples will bother to keep your business card after they've finished with your wedding services, but that album will be treasured all their lives.

A second method of self-promotion comes from aggressive sales months after the wedding pictures were taken. Keep a card file of newlyweds, their addresses, and their parents' names and addresses. File the cards both alphabetically and by the month of their marriage. Then, two months in advance, check the cards coming up to see whose anniversary is approaching.

For example, suppose you photograph the nuptials of Lydia Lovely and Stanley Trueheart on March 14, 1976. A card with the previously mentioned information is filed under March. Then, the following January, you thumb through your March files for 1976, removing the Truehearts' card as well as the cards for anyone else you photographed that month. Next check your sales records to see exactly what albums and loose prints were sold.

In the cases of the Truehearts, you find that they bought your basic wedding album, containing twenty-four 8 × 10 prints, three proof albums, and one framed 11 × 14 portrait of the couple, all in color. Further checking your files, you find that you took seventy-five photographs altogether. This means that they are potential customers for fifty-one more 8 × 10 color prints for

their album, not to mention seventy-five different framed en-
largements for their walls. If you or your lab can add montages,
overlays, and similar special effects, you increase the potential
sales even more.

When it's roughly six weeks from the couple's anniversary,
send letters to them and to their families. Mention that the
anniversary is approaching and that they might wish to celebrate
it with additional photographs. Mention to the couple that they
might like to have a first anniversary portrait taken for their
home or office(s). Mention to the parents that enlarging the
couple's album or providing them with framed enlargements
would make a perfect remembrance. Then, a week after mailing
the letters, follow up with a telephone call. If the bridal couple
has moved out of town, naturally, omit both the call and the
mention of an anniversary portrait, and do your follow-up with a
second letter. Be sure to include a self-addressed, stamped en-
velope for the convenience of out-of-town clients.

This assumes that you're taking portraits at this stage in your
career. Naturally, you may be handling weddings only part-time
for two, three, or more years, in which case the anniversary
reminder will only discuss buying additional prints. However,
when you finally do open a studio that can handle portraits,
announcements should be sent to all the couples you married
and to their families. You want to get their portrait business, and,
especially, the job of photographing their children as they grow.

The bridal couples you photograph can become the basis for a
mailing list. When you have Valentine's Day, Sweetest Day,
Mother's Day, Father's Day, and similar special-event promo-
tions, contact them with information about your offering. You
must constantly work to get people into the picture habit. With
regular sales efforts, you may be able to get your customers to
think photographs whenever they want to give a gift.

6

Public Relations Photography

Weddings or portraits comprise the bulk of the assignments for many, if not the majority of, commercial photographic studios. However, as someone just entering the professional field, taking portraits may not be realistic for you. Although they can be done in the home or on location, as will be discussed later on, most portraits are done in a controlled studio setting. The studio or home studio area represents an expense that may not be realistic for you as yet. So we should first explore those areas you can handle strictly on a location basis.

Aside from wedding photography, public relations is the easiest field to enter without a studio. You don't need specialized equipment for this as you do with architecture, though admittedly the more versatile your cameras and lenses, the more you can do for your clients. Interchangeable lenses are essential, but you can use 35mm, 120 roll film, and even 4 × 5, though the latter is not recommended. Many of your assignments will be available-light, so quick-operating equipment with fairly high-speed lenses are a must.

Who Uses Public Relations Photography
Public relations photography should never be confused with

advertising, though both fields are often handled by the same photographer. The advertising photograph is meant to sell. It is visually stimulating, emotionally exciting, and often a fantasy creation that results from technical manipulations in a carefully controlled studio setting. Public relations photography, on the other hand, tells a story. It communicates information in a less flamboyant manner and is almost always straightforward. Admittedly this work is one-sided; it conveys the viewpoint the client wishes to get across to the viewer. But the work is almost always done on location, and is rarely the result of technical manipulation.

The annual report is a good example of public relations photography. This report is prepared for the stockholders to show them why business is great, lousy, or unchanging. If a company's profits are down and its expenses are up, the photographer will be asked to show the reason for the problem. The photographs might picture large numbers of employees at work on the assembly line while the text told of increased union wage demands. There might be photographs of the products being made, stressing the numerous materials that are needed to make them; the text would explain about the rising cost of material goods, the oil crisis, and other factors. Then there might be photographs of the packaging, the shipping, and perhaps even stores with "Sale" signs or "Going Out of Business" signs. The latter would be used to point up the fact that consumer buying of all goods has declined with the changing economy, a fact that relates to retail product sales.

Of course, public relations work is self-serving, and the annual report reflects this. Although all the facts stated are accurate, rising costs having hurt gross profits greatly, the real reason for the dividends dropping so sharply might remain unsaid—and no one would ever know that the company president had been systematically embezzling funds all year.

The same company might wish to expand or sell out to a large conglomerate. In either event it must convince others that it's sound enough to warrant a large investment. Again the public relations photographer is used, this time to stress the opposite of what went into the stockholders' annual report. If the assembly-

line workers are shown, the caption stresses that production has increased without the hiring of additional personnel. If stores are shown, the people in them are buying the company's products. Shipping is shown to stress how expenses have been reduced through use of company drivers and leased trucks rather than expensive private delivery services.

Hospitals use public relations photographers to show the community new facilities for serving the public. If the hospital is in need of expansion, the photographer shows overcrowding and, perhaps, the deteriorating exterior.

Political candidates rely on public relations photography to show themselves as human beings, family people who are like anyone else. Even agencies like United Appeal rely on public relations photography to show the public the many services their contributions help support. It's an extremely broad field, filled with opportunity for both beginning and established professionals.

Getting Started—PR Agencies

Public relations photography usually requires you to have free time during the normal working day. To contact the people who might be interested in hiring your services, you'll have to be available when they're in their offices. This means being able to make the rounds during the typical nine-to-five work day, at least once a week and preferably more often. You'll have to have a fairly flexible schedule on your other job, working nights, part-time, or weekends. Naturally, if you're working full-time at starting your photography business, there's no problem.

Your potential customers are seemingly unlimited. For a starter, check the Yellow Pages of your telephone book under the heading "Public Relations." There you'll see a list of firms that specialize in this field. In smaller cities these firms generally do advertising work as well.

To enter the public relations field you'll have to be able to show a portfolio that in some way relates to the work you're seeking. This means story-telling pictures that can stand alone or in a series.

The PR Agency Portfolio

For example, when I wanted to handle public relations photography for a Model Cities program, several of the samples I showed were photographs taken in low-income areas. One picture showed a street of abandoned, condemned houses. At the end of the street was a sad little girl, pulling a broken wagon and staring back in my direction. Another photograph was a close-up of an aged, bearded man—his face reflected the crushing sadness of a lonely retirement with inadequate income. A third showed a group of happy children at play, but their play yard was a lot littered with trash. The photographs, taken separately over a period of months, were selected from file because they seemed to show the need for change that Model Cities was supposed to meet. My approach was successful—I got the job.

To be hired for an annual report you may have to show a sequence of photographs that tell a story, generally of a business or service. When I first went after manufacturing accounts I used pictures taken in a factory. These same photographs sold my services to a hospital and to a welfare agency.

As I mentioned earlier, it may be necessary to take photographs specifically for your portfolio, as I did when I recorded a company that manufactures electric lift trucks. You can approach an area hospital, the company for which you work, a department store, or anywhere else you feel you might get cooperation. However, first check through your files just in case you can piece something together from work you've done in the past. Remember, if you're reading this book it means you've been taking photographs for quite some time. Many of these are probably of high professional standards, and if you can use some of them for your portfolio, so much the better.

The Right Contact

I started my professional career in a large city; it had numerous public relations firms, so it was natural for me to go to them. In a smaller community, you'll have to work with the staff member of a business or industry who handles company public relations. Try local department stores, area hospitals, manufacturers, and so on. Each of these firms has someone whose duties cover public

relations, and the hiring of a photographer when necessary. It might be someone with the title of Public Relations Director, or it might be part of the advertising director's job. In small companies the president may be the person to see; with welfare agencies it's likely to be the Executive Director.

Once I went to a large department store to look for photographic assignments. After querying at the main offices, I was sent to the "Public Relations Department." When I reached there I encountered a woman standing in a booth behind a sign that read COMPLAINTS. I went over to her and said, "I think I've been directed to the wrong room. Can you direct me to the public relations department?"

"I'm public relations," she said loudly. "What's your complaint?"

"There's been some mistake," I said, making a hasty retreat. It turned out that the real public relations director worked from the store's advertising office. The woman handling complaints had been indoctrinated to believe that she held the position, since she did, in effect, deal with the public's problems relating to the store. Even the person I originally asked for directions looked upon her in that light. But she was definitely *not* the person responsible for hiring a photographer.

Chapter 2 covers your approach to making the rounds. No matter how warm your initial reception, winning new business requires constant follow-up with the people you contact. This is essential with almost every type of professional work.

Your Potential Clients

Aside from public relations agencies, where do you look for clients? Department stores, of course, as well as hospitals, manufacturing plants and large businesses—they're all good prospects. But there are other places you may not have thought about.

Radio Stations

Radio stations can be an excellent source of income. Beyond any needs they might have on a regular basis, several times a year every city's stations are rated by one or more survey associations.

These ratings tell who listens to which stations, and are used to gain advertising revenue. If a station is number one with a particular age group, it can charge a higher rate for air time to advertisers whose products relate to that same age group. Thus, ratings mean economic success or failure for many stations.

Technically, a station may not deviate from its normal broadcasting approach just to win listeners during the rating period. In practice, that station will do anything it thinks will attract someone. Some stations give away money; others give away furs, jewelry, and similar valuable prizes. A few utilize such way-out programming as a sleep-learning experiment that requires the listener to leave the station on softly in the bedroom while sleeping. One station near me has used this approach to "cure" people of smoking and obesity. I don't know if anyone was ever helped by leaving his radio on all night to take advantage of sleep learning—but the health of the station's ratings certainly improved.

But promotions aren't much good without someone to photograph the results, so radio stations do need photographers. The photographs may be as dull as the recording of contest winners, or they might involve documenting station personnel doing "good works." I've photographed the opening night of a musical that was sponsored by one station as a benefit for a charity; I've also recorded a group of disc jockeys and their followers sweeping the downtown streets to make the city a "better place to live."

To obtain assignments from a radio station you should contact the station's general manager. If for some reason he or she can't see you, the only other person who's likely to do such hiring will be the Program Director. Larger city stations may also have a promotion director, but such people may or may not exercise hiring authority.

Television Stations
Television stations can also use photographic services, though they're likely to handle their needs internally; newsmen and cameramen often do double duty as still photographers. Still, it's worth checking with the management. I've run into stations where the news photographers were so overworked that they

had no time for public relations assignments. An outsider was essential from time to time, so I was able to pick up extra income.

The good, and bad, part of working for the broadcast media is the fact that employees are not known for their longevity. Turnover, even in top management, can occur every few months or sooner. This is bad if you're working with someone who thinks you're a genius and uses you every possible chance. When that person goes, the replacement may think you're a bum and never call you again.

On the other hand, the current management might not comprehend the need for an outside photographer. If you watch your paper's Radio/TV Section to learn when there's a change in station "top brass," a renewed effort to sell your services could result in success.

Specialty Shops

If you live near a college or university, chances are there are one or more streets near the campus that feature small specialty shops. Most of these stores probably offer handmade goods, such as jewelry and leathercraft. There may be a bookstore, a vegetarian restaurant, a natural foods store, antique shops, and similar places of business. Many of these enterprises are run by young adults of college age; others are operated by older people who have been in the area many years. All of them share a common difficulty—the desire to attract new customers and a lack of excess income for promotion.

The answer to this dilemma for an increasing number of businesses in these areas is group promotions. For example, in communities where I've lived, merchants selling in college areas have staged wine-tasting parties, arts and crafts shows, cheese-tasting festivals, and even a street carnival. The cost for the promotions was shared, so no single store was strained financially.

Groups of specialized, fairly low-income merchants are ideal targets for selling your services. They need promotion, most are visually oriented, and the average commercial studio never thinks to approach them.

What type of work will they want? Generally, they need a

variety of photographs—some showing the entire street as a single unit for an advertisement, often a photo taken from a distance, using a telephoto lens to compress space and bring the shops close together. Sometimes the shops are photographed individually, with each store handled in a unique way according to the products it sells. These photographs are then grouped together in a montage for an eye-catching newspaper promotion of the area.

Still other photographs could be of the street festivals the merchants stage. Such work may be sent to newspapers in the hope of some free publicity. Or, if the merchants have an association, the head of the group may justify the members' dues by using the photographs to stress how much he or she is doing to increase area business. The photos are also shown to reluctant business owners thinking of moving to the area, to assure them that efforts are made to attract customers for everyone.

What can you expect in terms of pay? This varies with the group. Find out what the merchants' budget is and see if you can work with it. Generally, these groups will pay whatever you charge, limiting the use of your services to the amount of time they can afford. These people are often selling their own talents, so they're sympathetic to someone else in a similar situation. Other times they'll tell you how much money they can spend and what they expect in return. This may or may not be reasonable to you. If it is, by all means accept the assignment.

Colleges and Universities

Brochures and Catalogs. Colleges and universities offer an unlimited market for your services, and they want only location photographs. More important is the fact that they have large budgets for promotion despite the money crunch you hear so much about. Schools may be hurting for salaries and building maintenance funds, but they know the only way to get money is to promote, and illustrated brochures sent to prospective students and wealthy alumni are essential parts of money-raising campaigns. Even when dormitories are partially closed or some courses are eliminated to reduce expenses, photographs are still bought.

Your first source for information about whom to contact is the school's administrative offices; you'll be referred from there to your primary source of photographic assignments. This may be someone with the title of Public Relations Director or it may be the Admissions Director. In the case of a truly small school it may be the college president. Whoever the person is, his or her main job will be to attract students to the campus. The curriculum catalogs, the promotional literature, the school guides, and related material are all handled through this particular office. All of this printed matter must be illustrated—and that's where you come in.

College brochures are prepared on a regular basis; most are updated annually. Timing is critical when you're doing this type of college work. Catalogs are prepared both for students entering the school and for high school seniors who have not yet committed themselves to higher education. If you miss the period when photographs are needed, return to the school on a regular basis. Generally some major project is handled every three months, though the exact timing varies with each school.

Your approach to college photography will determine whether you're rehired. I have found that many times the person who hires photographers can't express specific needs. The photographer is given vague directions, yet is unfairly criticized if he or she returns with improper work. For that reason I'll go into the needs that are common to all colleges and universities, regardless of size or areas of specialization.

First and foremost, when photographing students, select only those who are happy, alert, and attractive. Keep in mind that the student looking at the brochures is going to picture himself in the photographs. The viewer could be five feet tall and weigh 250 pounds, but when he sees a handsome, athletic youth strolling across campus, he knows that's how he'll look if he goes to the school. The fantasy is much the same as that behind sample wedding albums and the psychology behind your work must be similar.

There are several points you are selling, albeit subtly, with your photographs. The first is enjoyment. Many college students are away from home for the first time in their lives. They're

making their first major step into an adult world where independence is a necessity, and whether or not they admit it, they're a little scared about what they're going to encounter. They want your photographs to reassure them. They want the pictures to say that other young men and women in the same position are having a good time experiencing this new learning situation.

A second selling point is sex. Regardless of an individual's goals in life, regardless of future plans concerning advanced education and a career, students are aware that they may meet their eventual spouses at the college they attend. The person looking through the catalog will, consciously or unconsciously, analyze the students in terms of dating.

If the school you're working for isn't coeducational, it's essential that you show couples together on the school grounds, even if you must work during a weekend party. There are many reasons for a student to choose a college limited to just one sex; however, the one reason that almost never exists is a desire to avoid a social life. The person considering the school wants to be certain that at least the weekends are filled with opportunities for dating. And the only effective way to convey this information is through your photographs.

Don't just show couples at parties or embracing outside the dormitories. Show them walking hand-in-hand across campus, studying together in the library, deep in animated discussions. Emphasize happy interpersonal relationships, lots of opportunities for casual meetings, rather than just physical relationships.

A third selling point is the educational experience. Students considering a school want to be certain they'll get a quality education that's both stimulating and enjoyable. Show students in laboratories; the impressive-looking equipment makes a great framing device for your photographs. Show classes actively in discussion rather than students passively listening to what may be a quite boring lecture. Show students in the library, and emphasize the vast number of books available as resources. And show students talking with professors: too many schools use graduate students for day-to-day lectures, making the students

wonder why they bothered to come. Prospective students want to be certain that professors conduct undergraduate courses.

Finally, show students enjoying the dormitory life and the food. College is a whole life experience, and many of those seeking admission are planning to live on campus. They'll be concerned that their creature comforts will be enjoyably met. Regardless of the type of food served, be sure your photographs make it look attractive, and show only those students who seem to be enjoying it.

Dormitories should be photographed two ways. One approach involves groups of students talking, laughing, and studying together. The other shows students alone, perhaps studying quietly or wearing earphones while listening to a stereo. Some students crave constant companionship; others feel the need for private moments every day. Both types will read the catalogs, and both types are desired by the school. Your work must convince both of them that this is the place they should be.

Many large universities have their own photography staff, which supposedly handles all necessary work. However, university officials are notorious for hiring only when the manpower shortage has become critical. Even then they hire the minimum number of people to get by, overloading staff schedules so that staff members can never handle all the work given to them. Staff photographers either are constantly behind in fulfilling requests for pictures or refuse to work for everyone who needs pictures, handling only the most important requests. This means that the outside commercial photographer is usually able to sell to one or more departments regardless of what is being handled internally.

Athletic Departments. Who else might desire photographic services? The athletic department is a good bet. The coaches may be glory seekers who want their victories recorded forever. The teams might be major alumni attractions, and photographs encourage past graduates to increase their donations. Whatever the reason, a visit to the athletic director can bring lucrative assignments.

Never be sexist in your approach to athletics. Although the "masculine" college sports of football and basketball have long been of prime interest, women's athletics are coming into their own. The increased opportunities for professional women athletes have caused some schools to improve their women's athletic departments, and the next few years could see a great many changes in this field. The day may be coming when women's sports will be everywhere considered as important as those for men—and will receive equal funding. If you get involved now, your studio will receive increased assignments in this area in the years ahead.

Research Facilities. Research facilities on campus are another source for picture assignments. Many schools receive donations from business and industry supporting the sciences. Photographs show how the money has been spent, and illustrate the reasons new grants are being requested.

Is there a medical school connected with the university? Again, photographs will be needed.

Graduate Programs. Graduate programs often have individually budgeted departments, each of which needs photographs for mini-catalogs they prepare themselves. The Department of Library Sciences, the Department of Chemistry, the Department of Sociology, and many others all try to attract graduate students, and send specialized bulletins outlining their curricula. The photographs you take for these bulletins should be similar to those needed for undergraduates, though stressing a limited area of study. Check with every department head to see about the need for photographs. Remember that this work is also seasonal, so if there's nothing at the moment, keep checking back until you get an assignment.

Publications Departments. Larger universities have their own publications department, including a book publishing arm— Harvard University Press, the Press of Case-Western Reserve University, University of Chicago Press, and the University of Arizona Press, to name a few. Some of these presses publish

limited-interest work by the school's professors; others publish books of general interest by a wide range of people, in competition with the major publishing houses. They all share an occasional need for photographic services, either for book jacket photos or for internal illustrations. Again, a check with the director is in order.

As you can see, the most obvious source for college photographic assignments is only a starting place. You might end up photographing for the Dance Department, the Drama Department, or any of numerous other areas. It's all a matter of your persistence, as you gradually increase the number of your clients.

Hospitals

Hospitals are another source for varied opportunities. As with schools, start with the department that's likely to have the greatest and most frequent need for photographs—public or community relations. Generally this department is handled by one individual hired specifically for the task; occasionally it's assigned to several people who do it as a part of some other work. In very small hospitals and private health care facilities community relations may be handled by the director. When in doubt, the director's office is the place to start.

Public relations departments in hospitals have several areas of responsibility that can include a need for photographs. One is patient orientation; pamphlets and brochures are prepared to instruct patients about what they'll encounter during their stay. They include rules concerning visiting hours, explanations of equipment and testing procedures, and general information about this strange and rather frightening experience. The photographs used usually include scenes showing patient care, from surgery to someone making a patient's bed.

If a hospital needs money for rising costs or expansion, the public relations department turns to a professional photographer. Before the project is funded, photographs are needed to show whatever problem is to be alleviated. If it's the problem of rising costs, then the vast number of people involved with patient

care must be stressed. For example, one of my area's hospitals turned to me to show the public the costly behind-the-scenes activity essential to quality health care. I photographed the people who operate the laundry, maintain equipment, and prepare instruments for surgery. I showed the people who prepare patients' meals, who run the countless diagnostic tests, who provide security and scrub the floors. I showed everyone *except* the doctors and nurses. In other words, my photographs stressed all the people the patient seldom sees but whose salaries comprise the greatest percentage of most hospitals' operating costs.

The result of my assignment was increased community support for the hospital. Voluntary contributions increased, banks became freer with credit, and a bond issue was approved. Could the appeal for funds have been so successful without my photographs? Probably not, for no amount of text is so dramatic as actually seeing the people involved with health care.

Annual Reports. Many hospitals, both public and private, issue an annual report justifying their charges and expenditures during the previous year. This is identical to the type of annual report you might handle for business or industry; it shows the operations of the hospital, emphasizing whatever areas the director feels the community needs to understand better. It's an expanded version of the coverage I provided when recording the behind-the-scene employees.

Departmental Needs. Individual departments can also have special needs. My favorite time of year for hospital photography is the period just before National Hospital Week. Many hospitals try to have special displays for the public during this period, and when they do, each department has special photographic requests. During the last National Hospital Week I had separate assignments from the Radiology, Physical Therapy, Research, and Surgery departments of a local hospital, in addition to overall work for the community relations director—and that was just one hospital.

Hospitals, like universities, often have a staff photographer. However, he or she is usually overloaded with work. Further-

more, the staff photographer is liable to be a scientific photographer, with neither training nor interest in public relations work. Even if he can handle the additional burden of the community relations department, it's doubtful that his skills can match your own in this field.

Newborn Photography. There is an additional source of income possible from some hospitals: in many smaller communities, hospitals have a need for a photographer of newborn babies, in part for records and in part for sale to parents. Hospitals that have staff photographers handle this work internally, but smaller facilities often use outsiders. If any of your area hospitals have maternity wards but lack staff photographers, talk with the hospital director concerning the possibility of your handling this work for them.

Keep in mind that the photography of newborn infants can be a long-term money-maker for your studio even after you've graduated to far more lucrative assignments. The work is so fast and simple that your receptionist can easily be trained to handle the task during slow periods. And hospitals are open twenty-four hours a day, so you can complete many such assignments at your own convenience.

Staff Portraits and Portrait Equipment. You can generate your own assignments with hospitals. For example, ask the public relations director when photographs were last taken of the staff doctors. Probably the entire staff has never been photographed, and even if some of the doctors have had portraits made, it's a good bet that they're out of date.

Although portrait work of any type is handled, ideally, in the studio, portraits can be taken on location. Avoid mentioning your lack of a studio by stressing that doctors' time is too valuable to make them come to you. Tell the director that it's better for you to work inside the hospital, to keep time spent posing to a minimum. Your thoughtfulness will be appreciated, and you'll save yourself problems.

There are many ways to handle portrait work. When I'm asked to do black-and-white photographs I know will only be

enlarged to 8 ×10 inches, I generally use a high-speed film like Tri-X, with a 90mm lens on my 35mm camera. The hospitals I photograph all have areas that are well enough lighted to give me excellent portrait conditions with this equipment. However, you'll be entering the field with no knowledge of what you're going to encounter. It's important that you arrive prepared for any situation.

The ideal, super-portable location portrait studio for the public relations photographer consists of a camera, a two-power telephoto (unless you're using a noninterchangeable-lens, twin-lens reflex), and three flash units. The flash units need not be expensive; they can even be AG-1 units with polished reflectors, all connected by long synch cords joined at your camera. One flash is your main light, the second a fill light, and the third a hair light to separate your subject from the background. These should be mounted on the cheapest stands you can find. If the flash units don't attach directly to the stands, tape them to the stands with gaffer tape, available through most photographic supply stores.

My own preference is for cordless portrait flash. I use a main light attached to the camera with a long synch cord, so the unit can be placed on a stand and maneuvered for best effect. My other two lights are triggered by the cheapest slaves I can find. These are available in the $10-to-$20 range, and should work perfectly for many years with careful handling. Since recycling time isn't critical, you can use inexpensive electronic flash units if you like, spending no more than $125 for everything. Conventional flash units can reduce that figure by about a third, so the choice is a matter for your budget.

The reason for slave lighting is that it eliminates worry about trails of cords on the floor that someone could trip over. For the same reason I never use AC electronic flash units, even though these are sometimes the cheapest available. Another reason for using only the battery units is that some hospital rooms must have only special electrical cords to avoid the risk of sparking. Explosive gases are used in many parts of hospitals, and all plug-in electrical equipment must be specially wired.

Your flash stands should be collapsible and lightweight. These

need not be heavy-duty items, because they won't get a lot of use. But while the number of portraits you take in this manner will be minimal, the potential dollar volume generated can be considerable.

The biggest advantage to supplementary lighting is the fact that it lets you use slower films, which can be greatly enlarged. For example, when working with color I use only Kodachrome, since I know I can enlarge to 20 × 30 or 30 × 40 with no loss of detail or of color saturation. This means I can occasionally sell extremely large portraits, custom-mounted, of the most important members of the staff. Such portraits are sometimes commissioned when someone is to be honored; they're often presented at testimonial dinners—which, by the way, I also photograph.

Another advantage of taking portraits with the slower film is that often the subject's family will see your work and like it, and will want to order prints of various sizes for their own use. One word of caution, though: if you use transparency film and your client will be getting the slide, first have a 4 × 5 internegative made for your files. Otherwise there's no way for you to make additional prints. Stay with the 4 × 5 internegative, rather than anything smaller, because it's easiest for most labs to handle and won't increase grain problems.

Theatrical Photography

Theatrical photography is a special type of public relations photography that you might not have ever considered. Most photographers think of theatrical photography as being lucrative only in such major production centers as New York, Chicago, and Los Angeles. However, wherever your studio is located, theatrical photography can be a regular source of income.

There are two types of theatrical photography. One might be called interpretive; this is generally done for high-budget companies. Actors go to the photographer's studio, where carefully controlled lighting, props, and backgrounds are used to interpret the play being promoted. This is more in the advertising line, and is far too costly for the budgets of the vast majority of companies.

The second type of theatrical photography, the one of impor-

tance to you at this stage in your career, is strictly location. You work in the theater, using existing light or, occasionally, electronic flash. You might be positioned in the wings, in the audience, or onstage. You take things as you find them, photographing during rehearsal, at a special camera call, or during a performance.

Who Uses Your Services

Special Productions. The highest-budget theatrical groups are generally found in such major production centers as New York and Chicago; these are companies put together only for a specific show. Broadway theaters, for example, fall into this category. Special-production companies often include major names in the acting profession, and the plays might be the latest creations of such famous writers as Neil Simon or Arthur Miller. Millions of dollars may ultimately be involved with these works, so only the best-known photographers are usually hired for production photographs. Someone with no experience and no portfolio has a difficult or an impossible time getting an assignment to produce publicity photographs.

Resident Companies. The next highest budget is generally found with resident companies. These are found in most of the larger cities, such as Cleveland, San Francisco, and Atlanta. These companies perform a wide range of plays, but always with the same cast; the professional actors receive annual salaries rather than a fee based on the runs of their shows. Some of these actors work all their lives in the same theater; others—like Joel Grey, who got his start with the resident company of the Cleveland Play House—move on to Broadway and Hollywood stardom.

Resident companies are supported through ticket sales and/or foundation grants. They operate with a fairly fixed annual budget, and have a set amount of working capital for photography. They generally have either a publicity director or an executive director in charge of hiring photographers.

Theater groups require photographs for several purposes. The most important is publicity: they submit photographs of

their current shows to the news media shortly before they open to the public. These photographs, run on newspaper entertainment pages, for example, are supposed to entice thousands of people into wanting to attend a performance. Although several pictures are taken and more than one may be submitted to each newspaper and television station, it's rare that more than a single photograph is actually used. Thus, every photograph you take must catch the essence of a production if it's to be of value as a publicity photograph.

Summer Stock. If there's no resident theatrical company near you, the next best group to approach is the summer stock company. These groups can be amateur, amateur with one or more professional guest stars, or fully professional. They perform in barns, in rustic theaters, "under the stars," and in school auditoriums. Your local newspaper's entertainment page editor can tell you if any such groups perform in your area.

Summer stock groups have the same needs as professional companies; however, they often have a much larger budget. Summer stock is so popular that many tiny communities are able to pay big-name guests $10,000 a week and up for their appearances. More important is the fact that they usually operate at a profit.

Amateur Theatrical Groups. The greatest picture buyers are the cast and crew members of amateur theatrical groups that perform regularly in schools or small theaters rented for each performance. Again the entertainment page editor can guide you to the ones that have been active for several years. However, bear in mind that the amateurs primarily need photographs to stroke their vanity. They're as happy with snapshots as they are with exquisite professional photographs, and as a result, they're very often unwilling to pay a realistic price for your work.

Talk with the company directors to see about handling publicity photography. Show your work to the cast and crew, and demand what you feel is its fair market value. But if these people object to your prices, go elsewhere. It isn't worth wasting your time when you're trying to build a profitable business.

Touring Companies. Many small communities have a theater where touring companies and individual entertainers make one-day appearances. Naturally, it's usually impossible to reach the director with so little notice, but the management of the theater may be interested in publicity photographs.

When you work for a theater that's used by touring companies, you will inevitably have to work during the performances. This means quiet equipment, used wherever you're allowed to photograph. Sometimes you'll be backstage, other times you'll be in the balcony or in the booth from which the spotlights are operated. You will probably have limited freedom of movement, and telephoto lenses may be essential.

There are two other potential customers for touring company photographs. The first is the booking agent, if he or she is different from the theater management. Some communities have independent booking agents who bring talent to a theater for a percentage of the gross after all expenses are met. Check both the Yellow Pages and the entertainment page editor to learn if such people work in your community.

The third client comes when there's an outsider participating in the booking of a particular act. For example, often a booking agent teams with a local radio station to bring in a singing star for a day or two. The radio station gains tremendous publicity in this way, and the management delights in having photographic coverage of the event.

Entertainers. There is a multiple market for entertainers making one-night stands around the country. There are the promoters, the theater managers, and so on, but there are also some other areas for sales: entertainers have agents who handle contracts, appearances, and related matters. You can learn the agent's name from whoever handles local booking. Then, after you're sure you have unusual photographs of a performance, contact the agent to see if there's any interest in them. Whether you decide to send samples is a personal matter. If you do, make certain they are few in number and not very large. Follow the precautions mentioned in the chapter on file sales, but don't expect to get your prints back.

Keep in mind when working for a booking agent, theater owner, or similar person that he or she must prove to the entertainers that his or her promotions draw a crowd to the theater. Entertainers work differently from each other—some have a set fee; others take a percentage of the gross received at the box office rather than a minimum guarantee. These performers won't work when they feel the house may not be packed. If you can show crowds of people filling the theater for an act, the photographs will be snapped up by the promoters to convince entertainers that they can, indeed, fill the house.

If the agent isn't responsive, find out if the entertainer is also a recording artist. A check with your local record store will alert you to any albums or singles out, as well as giving you the name of the record company the entertainer has contracted with. The record company's address may be on the album. If it isn't, you can get it by checking the reference section of your local library. Directories of major businesses can guide you to the company's home office.

Write to the record company, explaining that you have some unusual photographs of the entertainer taken during a concert. Say that you feel they might be of value for a future album cover, and request permission to submit examples on speculation. You will probably find the company quite receptive if you approach it in a businesslike manner and use your studio letterhead.

Other entertainers in your community are either on the rise or on the decline in their careers. These are the ones who appear in local clubs, restaurants, and hotel lounges. They may work on their own or with a local booking agent, but they can all be approached directly.

When I want to contact an entertainer appearing locally, I talk with the manager of the club or restaurant where he or she is performing. I explain who I am and that I'm interested in talking with the entertainer about publicity photographs taken during the performances. I ask if it would be possible to talk with him either before a performance or between performances. Seldom is there a problem—and when there is an objection, I just wait for the entertainer to move on to another club.

The nicest part about working with lesser-name acts is the fact

that when you open a studio you'll have so many more potential customers for your posed portrait business. If the entertainer becomes nationally known, your photo files will prove to be a gold mine in the years ahead. It's also impressive to display an enlargement of the entertainer; your studio will have a vicarious aura of glamour.

Equipment

Almost any equipment you own can be used for theatrical photography, but I prefer 35mm and 120 roll film cameras with fairly high-speed lenses. Lighting generally runs from excellent to terrible. Even worse is the fact that when the lighting is terrible from a photographer's viewpoint, it's generally at its most dramatic from a theatrical viewpoint. As a result, I usually have to standardize on ASA 400 and ASA 500 color films, with black-and-white pushed to ASA 800, ASA 1,200 or ASA 1,600. This increases contrast and reduces shadow detail, but that can't be helped. I also carry a tripod, a unipod, and a gunstock mount to ensure steadiness. Shoulder pods are also effective, but they're harder to find.

If all your work will be during rehearsals or special camera calls, noise won't be a concern. You can use a 2¼ × 2¼ SLR with a mirror slap that sounds like a rocket going off, and no one will care. However, if you might be photographing during a performance, the sound of your equipment can kill the mood of the play. Your shutter can detract from dramatic high points or shatter the delicate tones of a musical passage.

My personal preference is for the ultra-quiet 35mm range-finder equipment and the interchangeable-lens 2¼ ×2¼ twin-lens reflex. Even these sound noisy in a hushed theater, as I once learned when photographing a ballet from the back of the audience. My ancient screw-mount Leica had a 135mm lens on it, the entire unit mounted on a tripod. The lens was slow and shadow detail was important, so I was limited in my ability to push the film speed. I had to take pictures at ⅛ second, much too slow to catch motion.

The answer was to wait for a high point in the movement. The beauty of dance photography is that there are moments in even

the most exuberant pieces when the dancers are virtually mo-
tionless for a fraction of a second or longer. If you can anticipate
these moments, releasing the shutter just as the high point is
reached, you can obtain a magnificent photograph. This is the
approach I was using. Unfortunately, these pauses for the danc-
ers proved to come during silent or extremely soft passages in
the music. The seemingly endless whir of my shutter made that
⅛ second seem like forever as people sitting in my vicinity
glowered at me and my camera.

No one said anything at the time, but I learned the intensity of
feeling against me the next day when my photographs were
published in the newspaper that had sent me to the perfor-
mance. A woman I had noticed at the performance walked over
to me and said, "It's a good thing your pictures came out so
beautifully. You made so much noise it almost ruined the show
for me!" And that was with a camera whose shutter sounds like a
fine watch—imagine what would have happened had I had the
extra noise of a mirror bouncing up and down.

Never underestimate your equipment needs for theatrical
photography. I generally take seven lenses, ranging from 21mm
to 400mm, and frequently use them all. The more versatile your
equipment, the more versatile your photographs. However, I've
seen magnificent work done with an old noninterchangeable
twin-lens Rolleiflex. Equipment increases your versatility but it is
no substitute for personal creative ability. A camera is only as
good as the person who is using it.

Staging the Photographs

Ideally, you'll be permitted to photograph during a special
period set aside strictly for preparing publicity. This will enable
you to alter lighting and rearrange actors for the greatest visual
impact.

Remember that the action of a play is designed to appear
dramatic to an audience aware of the continuity of action. Emo-
tional high points may occur with the actors widely separated, so
that a photograph taken during the performance will show them
quite far apart. The visual impact of that recorded incident of
time may be minimal despite the electrifying tension felt by the

audience. If you can rearrange the actors, perhaps moving them closer so you can frame tightly on their faces, your photograph will be far more effective than one taken from the same vantage point the audience will have. This is possible only during a special photo session, however.

It's important that you try to read or see the play being performed before you actually take your photographs. You must be constantly aware of what will happen next if you're going to photograph during a performance. Naturally, how much time you spend on such preparation will depend upon how much you're being paid. If your fee is marginal, you'll have to settle for a verbal synopsis provided by one of the cast. Never try to photograph without some knowledge, though, as you'll miss many of the most important points.

When there's a special cast call for photographs, you can work from any place that provides the best visual effects. When you must photograph during a rehearsal or performance, you'll find that you're most effective when working from the audience. This is because plays are written to be visually most exciting from that viewpoint. Backgrounds, props, and the players' movements are all planned with the audience in mind, and when you work from the wings your perspective is badly altered. The illusion of reality the set is meant to communicate is totally lost; you'll end up recording actors who look like actors performing on a set that is obviously make-believe. This is never truly satisfactory, and your pictures will suffer as a result.

Making the Sale

Most resident companies have a low budget for photography, and will try to work out an arrangement for a package sale. For example, you might be asked to supply ten different 8 × 10s for $50, with the understanding that you work only one hour. The company may have you supply only the prints, or they may ask for contacts from which they can choose. However, every time you have to go back to the theater you're using time that could have been spent earning money behind the camera. You must weigh all factors before agreeing to any package deals.

Assuming the pay is low, you can compensate by getting per-

mission to offer your prints to the actors and actresses at a moderate but profitable charge. This might be $10 for an 8 × 10, or slightly more or less, depending on the maximum you feel you can get. These prints will be used as part of theatrical portfolios, to be discussed later in the book, or just as reminders of the performance. Even well-established professionals enjoy having photographs of themselves for no other purpose than to put in a scrapbook.

Remember that the sales to cast members are not certain. You shouldn't go to great expense making sample prints at first. You should also avoid exposing several rolls of film when the images might be unwanted.

My approach when working with a theatrical company for the first time is to photograph according to what's desired for publicity. For example, suppose the company wants ten 8 × 10 prints. I take just one roll of 36-exposure film, from which I will have enlarged contact sheets made. The ten photographs are selected and printed, then taken back to the theater. I make it a point to return when the entire cast is present, showing the ordered prints as well as the enlarged contacts. The cast sees everything I have taken and has ten examples of how enlargements will look. They can then place their orders.

I follow this procedure the second time I work for the same company. By the third time out, I have a fairly good idea who the regular print buyers are likely to be, and I have additional prints prepared which I think they'll want. I'm seldom disappointed.

Prints for the Papers. The eventual use for your photographs should guide you when dealing with theatrical groups. Publicity photographs must never be identical. Inexperienced public relations people hired by theatrical groups sometimes try to save their budgets by ordering ten copies of the same print rather than ten different images. What they fail to realize is that competing media want exclusive photographs. If the *Morning Bugle* prints a photograph from a play that's being promoted, the *Afternoon Herald* isn't going to print the identical photograph. Remember, these prints are being run without charge as theatrical news. Identical prints are fine for advertisements, but not for

publicity uses. They must be different, a fact you may have to explain to the client.

And of course, as discussed before, newspaper printing is notoriously poor. Since your pictures are liable to be somewhat high-contrast initially, watch carefully to be certain you do not let those with subtle tonal variations be submitted to the press. You don't want to repeat the restaurant fiasco I mentioned earlier—your competition is waiting for just such a mistake.

Collecting the Fee. *Caution: Get your money when you deliver your prints to the cast!* Theatrical people are notorious for not paying their bills. Some have the best of intentions but little money; others have no intention of paying. Still others are so successful that they can't understand the fuss over so few dollars. Whatever the reason, you're the one who gets stuck. If someone can't pay until "next week," go back next week with the print rather than leaving it with him. You can't afford credit or charity.

Theatrical Promotion

All types of theatrical photography can be used to generate increased business for your studio. Once you've been taking theatrical photographs for a few months, put together a display of several dry-mounted prints in various sizes, from 5 × 7 to 11 × 14. These should be your most dramatic or unusual prints, preferably in both color and black-and-white. Then ask your clients if you can use some of the lobby area for a display. Mount the prints on the walls for the public to see when they arrive and during intermission. The display is a promotional vehicle for the theater—and, of course, your name, telephone number, and address should be readily apparent.

There are two advantages to such displays. The first is that they make your name familiar to people in your community. Since most theaters charge fairly high ticket prices today, audiences have a generous number of affluent business people who may be in the market for commercial photographs. In addition, many hero-worshiping adults delight in having their pictures taken by the same person who photographs their favorite actors.

If you're prepared to handle portraits, let your theater display

be a subtle statement of that fact. In addition to the stage photographs, you might include a few dramatic close-ups of single actors, actresses, and/or entertainers. These face shots are actually candid portraits, and can be quite impressive.

Shopping Malls

The last area to be discussed in this chapter is the shopping mall. For many people shopping malls represent some of the problems with our society. The malls have been responsible for urban sprawl (or perhaps the result of it), and have led to the deterioration of the downtown business district in many cities. But for the commercial photographer they offer seemingly unlimited sales potential. Ideally you can even locate your studio in a shopping mall, though that's a matter to be discussed in the chapter on studio location.

The owners of large shopping malls are faced with numerous problems, the most serious of which is determining how to fill the complex with customers. A variety of stores, a location in the midst of a population center, and ample parking all help. So do the advertisements run by individual businesses. But the owner of the mall knows that additional efforts must be made on behalf of all merchants as insurance that the customers will keep coming back. Otherwise businesses will seek other locations.

Promoting Entertainment

In recent years bringing special attractions to the mall has encouraged business. These attractions aren't businesses, and they aren't competitive with existing merchants. They're free or low-cost events or displays that are meant to draw people who might otherwise not be attracted to the mall: once people visit the complex they're likely to make impulse purchases.

This entertainment varies with the mall. However, certain attractions travel the country, visiting malls in different states once or twice a year. Jett's Petting Zoo, for example, is constantly traveling. The animals are kept in a large penned area where children pay to feed them. But the pens are so arranged that everybody can watch the animals without charge.

Another well-traveled display is a miniature, hand-carved,

animated circus whose creator is constantly enlarging it. Then there are the jazz bands, the carnivals that set up on the grounds for a week or two, and numerous other attractions.

The Mall's Photographs. What do these attractions mean to the photographer? Double sales. Your primary client must be the shopping mall. The owners are established, and will be operating in the same spot year after year. These are the people who will be long-term repeat customers.

Mall operators have several uses for photographs of attractions. Close-ups of the people or events can be filed for use as newspaper promotions when the attractions are brought back every few months. There's so little change in the attractions that travel the country that the mall can use old photographs for publicity.

A second type of picture needed by the operators is one showing people enjoying the event. This photograph is either easy to take or must be faked. For example, I once had to photograph a puppet show being presented on a Saturday afternoon. Hundreds of children were in the mall, and the majority were sitting enraptured by the puppets. All I had to do was go up to the balcony and aim my camera down on the scene to capture the entire event. The mob was real and the attraction was obviously drawing a response.

Another time the attraction was a local jazz band performing on a Monday evening. Monday evenings were dead times for that particular mall, which is why the management brought in the band. Unfortunately, while the musicians were excellent, no one was present to hear them. Perhaps twenty-five people surrounded the portable stage on which the group was performing—hardly a crowd by anyone's imagination, and, to make matters worse, they represented the majority of the people in the mall at that hour.

What to do? I used two approaches. The first was to move in close behind a group of four or five people. I used a wide-angle lens to photograph the band, framing them with the heads and shoulders of the five observers. My second approach was to move back from the group, attach a telephoto lens, and photograph

through the people. The lens compressed distance, turning widely scattered viewers into a compact mass. Both photographs seemed to show that the place was mobbed.

Did I cheat? Of course. But the client didn't ask me to make a record of what I found. The client asked me to take a photograph showing masses of people observing the band.

The reason such photographs are needed by mall operators is that the businesses in the mall expect the management to spend a portion of their rent money on promotions. When it comes time to sign or renew a lease, the management likes to have pictures of past promotions on hand to remind the merchants that efforts are being made to attract customers.

The Entertainers' Photographs. A secondary market for the photographs of fairs and other attractions is the people who own and operate them. Groups who tour nationally have a central address through which they can be reached; this can be provided by the mall management. Local groups are much easier to find, of course.

When it comes to selling to nationally touring attractions, two approaches can be used. You can contact them by mail, then send contact sheets or small prints if there's an interest in the pictures. Unfortunately, there is the question of honesty, and this procedure may result in your not getting samples returned or your not getting paid for photographs ordered.

The second approach is to file the photographs until the group returns in a few months. Then show them what you have and make your sales while they're still in town. As with theatrical photography, get your money immediately upon delivery.

Promoting the Shops
Many of the shops in a typical mall are small businesses, which may have only this one outlet. They have limited advertising budgets and generally can't afford to hire an agency to plan their campaigns. As a result, the typical commercial photographer often bypasses their account. He or she is used to dealing with agencies and chain stores while overlooking the smaller businesses.

Because single-outlet stores are small, their business is limited. If such stores were spread far apart throughout a city, they wouldn't be worth your time. But when they're clustered together in the shopping mall they become sources for excellent remuneration.

The prime need small stores have for photography is for recording their window displays. These displays take extensive time and planning. It's important to have a record of them so that successful ones—the ones that draw an unusual number of people into the store—can be repeated in the future. A secondary reason for having photographs taken is because the display was probably the creation of the owner. The photographs provide a tremendous ego boost.

Window displays are best recorded when the mall first opens. All you need is your camera, tripod, and a Polarizing filter for your lens to eliminate glare. Taking the picture early in the day prevents your having to fight crowds. Monday mornings are even better, as they're likely to be the least crowded time of the week.

Never work for just one store in a mall. Line up several that desire your services, and photograph them all at the same time. You can record an entire mall in an hour or less. Since you'll have to work on a per-print basis for most stores, you can't afford to keep coming back to the mall. You should take care of as many businesses at one time as possible to ensure the highest profits. Occasionally you'll be forced to record a single store, but that should be only after it's a well-established customer whose business you want to keep. If you work on a strictly individual basis when starting out, such a project will cost you too much money.

Interior displays might also have to be photographed. When this occurs, be sure you arrange to visit the store before it opens. If you wait until business hours there may not be room to maneuver.

One note of caution: use only electronic flash for supplemental lighting. I once brought in flood bulbs, one of which came a little too close to a handkerchief on display. Before I could react a huge brown hole had been burned in the fabric. The same problem can occur with flash bulbs. Remember that stores fill

their space with merchandise, so you're always limited when trying to maneuver your equipment. Hot lights are too dangerous to use under such conditions.

As can be seen, there are many ways of obtaining lucrative commercial assignments without a studio, in the area I loosely call public relations photography. Study local business, read the Yellow Pages, and see which places are worth approaching. With persistence and a competitive portfolio, you should begin gaining clients whose repeat business will form the nucleus for your full-time studio.

7

Architectural Photography

The photography of architecture is yet another area where a professional photographer can earn a living without the expense of a studio. The photography of buildings and interiors must be handled on location. There is no way to move the subject matter to a more "convenient" spot.

Equipment

The great myth of architectural photography is that it can only be handled by a view camera offering swings and tilts to correct perspective. In many instances this idea is based in fact. It is impossible to photograph a soaring skyscraper from ground level with a fixed-lens camera; when you tilt the camera to take in the full height of the building, its sides are distorted. This may be no problem for some clients, but if the photographs are for the people who designed and/or built the building, those tilting lines are taboo. These clients want to see an exact rendition of the structure, as perfect as the architect's original sketch.

However, there are a great many architectural photographs that can be taken with a fixed-lens camera if you know what you're doing. Interiors, especially, can often be handled in this

manner. And no matter what type of equipment you own, you'll be able to seek at least a few assignments in this field.

Camera Limitations

The ideal camera is, of course, the 4 × 5, 5 × 7, or 8 × 10 view camera with full adjustments. Since the two larger formats are more expensive in terms of film and lenses, most professionals using view cameras stay with the 4 × 5.

Most "experts" feel that a photography studio is incomplete without a view camera. They feel that its sophisticated adjustments are essential for many assignments. More important to some, perhaps, is the fact that the camera is so complex that its mere presence shows the world that the owner is truly "professional".

In reality, a view camera is only of value if you need its many adjustments. The advertising photographer will find such adjustments invaluable; so will the full-time architecture specialist who must be prepared to take any and all assignments. But most other studios can get by with less sophisticated equipment, thus reducing their overhead.

A few camera manufacturers offer perspective-control lenses for 35mm equipment. The two best types are the fairly extreme wide-angle with limited perspective control and the highly adjustable type that truly approaches the flexibility of a view camera. The former is typified by Nikon's 28mm Perspective Control lens; the latter is offered by Canon, among others. These are not automatics, a minor point since these lenses are not meant to be used rapidly. In architectural photography, they're tripod-mounted and carefully adjusted according to the scene to be photographed.

It is possible to do a limited amount of architecture and interior photography with normal small equipment. I have photographed restaurants, two-story hotels, and single-story houses with both 35mm and 2¼ × 2¼ SLRs using standard and wide-angle lenses. One of the photographs hangs in the office of the head of a major motel chain.

The secret of all architectural and interior photography is to keep the perpendicular lines parallel to the camera's film plane.

With a camera that doesn't permit perspective correction through swings and/or tilts, this means never tilting the lens to take in more of a building. You might move back, change your vantage point, switch to a wider lens, or do any of several other things to ensure that you don't tilt the camera. In some cases, as with the skyscraper, you'll have to bypass the assignment.

Film

Another problem with using small cameras is film enlargement. Invariably clients want prints that are a minimum of 8 × 10, and I'm often asked to supply 16 × 20 or 20 × 24 sizes. These are used for displays, sales, conventions, and similar purposes. They must be eye-catching and dramatic, and they should have no readily noticeable grain. As a result, conventional films you might normally consider for an assignment may not provide the needed results.

When it comes to 35mm color work, at this writing there's only one choice—Kodachrome. If you compare Kodachrome enlargements with smaller than 4 × 5 prints made with any other film, you'll be hard pressed to notice a difference. I've gone as large as 30 × 40 and not seen the image come anywhere near breaking down; you'd probably have to be commissioned to produce a mural before this film would fail to meet the demands placed on it.

For black-and-white I tend to concentrate on an as yet little known product—H & W Control Film, processed in the H & W Developer recommended by the manufacturer. This is a micro-copying film which gives a full grey scale when developed in the company's products. The slowest film, officially rated at ASA 25, can be enlarged to several feet. The only drawback is that H & W has too generous an ASA rating; a rating roughly two-thirds the "official" guide will probably give you better negatives and prints. I rate the ASA 25 film, for example, at ASA 16. However, you should experiment on your own before using any film for an assignment. There can be a difference in actual exposure times when two identical cameras are set at what is theoretically the same shutter speed, and there is also a variance among meters

and developing techniques. You should determine what speed is best for the equipment you own and the way you work.

If you're going to be limited by your equipment, as I was when I first began, it's important that you recognize the assignments you can't handle. Never automatically accept an assignment: if possible, visit the location in advance to determine if you can handle it; if you can't visit, check the architect's renderings or get a full description. It's better to turn down an assignment than to not be able to fulfill it properly.

Getting Assignments

The best approach to seeking architectural assignments is to stay alert to construction projects in your community. For example, I learned that a motel chain was erecting a new building just a short drive from where I live. I went out to the spot, carefully noting the building's height and the surrounding terrain. Since I didn't have a view camera or a perspective-control lens, I studied the partially completed building in my finder, moving all around the complex. I could see that I could easily maneuver far enough back to include the entire building in one frame without cropping or tilting the lens. Then, when I had convinced myself that I could effectively record the building, I noted not only the motel chain for which it was being built but also the construction company, the various contractors, and the architect, and approached them for the assignment. This information was on a sign at the front of the site.

Important: Every person who is involved with a construction project is a potential client. In the case of the motel, more than half a dozen companies had a hand in the construction. Each firm had a special interest, but they could all utilize my photographs. The architect wanted a photograph of the finished project for his wall, where it boosted his ego, and for showing to prospective new clients. The construction company wanted photographs for the same reason, as did such subcontractors as the electrical and plumbing firms involved. The motel chain needed prints for promotional literature, to attract people to the new facility so they would make their money. More important was the fact that

the same set of prints could often be sold to several different firms, since they were in no way competing with each other.

Working for the Client

Architectural photographs must be taken according to the needs of the clients. In general, the various subcontractors working on a construction project want close-ups of their workers installing equipment. An overall view of the building is often of consideration too; the builder stresses the finished product and wants it to appear well-made and attractive. Both the architect and the building owner want photographs that stress the building in use. The overall building photograph should show happy people staying at the hotel, coming to work at the office, or whatever. This is especially true with the architect, for if no one wants to stay in the structures he designs, builders will stop turning to his firm for its ideas.

Once again you'll have to have sample photographs before you'll get assignments. If you don't already have quality photographs of buildings and/or interiors, you'll have to take some. Usually you can select any interesting structure in your community and photograph it without concern.

Financial Background and Multiple Sales

Always try to learn the full financial background of a project you're photographing, as it can give you leads to additional sales. For example, Hospitality Motor Inns is a rapidly growing chain of motels, primarily in the Midwest. The chain hires photographers to cover each new addition, but a little digging into its corporate background reveals that Hospitality is a division of Standard Oil of Ohio (Sohio), which immediately opens greater possibilities for profit. The same photographs that sold to the motel chain might also be desired for the parent company's internal publication, *The Sohioan,* whose rates are competitive with many national magazines. Then there are the public relations and advertising divisions of the company; these will probably be interested in photographs for the annual report to the stockholders, among other uses. Suddenly that one assignment has the potential for bringing at least triple returns.

Office buildings offer a unique opportunity for multiple sales. Once you've taken some dramatic photographs of the building, you can use these as a means of gaining entry to the office of the president of each firm that rents space in the structure. At the very least, you're likely to sell the firms framed photographs of the building. These firms are proud of their new home or they wouldn't have gone to the expense of renting space. Most firms are delighted to buy a photograph of the building at the time they move in, if only to show people how far they've come since they started into business.

Often the exterior photographs will convince each new tenant that you have the skill to record his office's interior. Sometimes this will be for the company's annual report, sometimes it will be for display, and occasionally the photographs are desired only because the company president's wife was the one who designed the interior and she wants her ego boosted.

The Hazards—and Your Rates

At times architectural photography involves potentially hazardous duty. I once was hired to photograph a Cleveland restaurant on the edge of Lake Erie whose exterior looked like a cruise ship. Unfortunately, the shiplike appearance was not all that evident from the ground. I had to go to the roof of an adjoining thirty-seven-story apartment house to take my photographs.

As it happens, I'm terrified of heights. When I got to the roof I had no intention of looking over the side. I lay down on my stomach, kept my camera in hand and the strap around my neck, and inched toward the edge. When I had almost reached it, I leaned forward so that the camera was over the side and aimed downwards. It was a 2¼ × 2¼ SLR with a waist-level finder, so I could look straight ahead and see the ground below. I took half a dozen photographs of the restaurant, then began to relax. I decided to look around to see if there were other angles which might be effective. That was my mistake!

As soon as I took the camera from my eye I was reminded of just how high up I actually was. Panic set in. I closed my eyes and began crawling backwards until I was several feet from the edge.

Then I stood up, raced down the stairs to the top floor of suites, and took the elevator to the ground floor. Fortunately, the work came out perfectly—there was no way I was going back up.

Such a circumstance requires a higher than normal charge, in my opinion. I would add at least 50 percent to the bill, and, preferably, I would double my hourly rate.

The same holds true for aerial photography, another nemesis of mine. My first experience with aerial photography came the third day after I had quit my job on a newspaper to work full-time as a professional photographer. The client was an advertising agency that needed aerial photographs of a hospital that had recently expanded its facilities. Although I had never been up in any type of aircraft, I managed to convince the agency that I was an old hand at aerial work. The account executive hired me at 11:00 A.M. and told me that a helicopter would be waiting at a local airport at 1:00 P.M. that same day.

During the next two hours I raced to a camera dealer I knew, bought and read a book on aerial photography, and borrowed extra equipment for the assignment. Then I went to the airport, where I was confronted by a two-man helicopter that had a plastic bubble and a door on the pilot's side. The passenger door had been removed, for my "convenience." I said several prayers and stepped inside, my face white and my hands trembling.

I thought I had my emotions under control when I fastened my seat belt. However, I pulled the belt so tight that I had a red mark around my waist for the next couple of days. The photographs printed perfectly and the client was delighted—but the bill was increased greatly as a result of that open-sided helicopter.

Architectural photography is not truly dangerous as such. However, to properly photograph some buildings it's necessary to take risks. Naturally you'll be doing nothing that is foolhardy. But you will find yourself in circumstances you wouldn't willingly endure under any conditions. For this reason I feel that your rate schedule in this field should remain flexible. When it's necessary to go to unusual extremes to meet your client's needs, charge accordingly.

The Uses of Architectural Photography

Retrospectives

I have found that when an architect reaches his forties he begins looking back at the work he's done as well as forging ahead with new creations. Such architects are often interested in hiring you to prepare a retrospective portfolio of prints of the houses, apartments, hotels, businesses, and other structures they've designed. This can be quite a lucrative assignment, and can ensure that you'll be hired regularly in the future to update the album.

If you're asked to handle an album of this type, be wary of negotiating a package price. Since you'll be doing several buildings for the same architect, it might seem logical to offer a slightly reduced rate, much as you charge a client slightly less than your normal hourly rate when you're hired by the day—but unless the buildings are close together, an unlikely situation, the time necessary for traveling from one building to the next is as great as if you had separate assignments. Your expenses will be as high as for separate assignments. And your pay should be the same. Give the client a discount on your work only if it can be completed by concentrating on the buildings over a period of one or more full days. Then you can charge a daily rate plus expenses, so the per-hour cost is reduced.

Advertising and Promotion

You do not have to limit your contacts to new construction projects. At this writing, my part of the country is experiencing a housing slump. Few new buildings are going up and many existing apartment complexes are vacant. But rather than working against me, this situation has actually resulted in sales I might normally not be able to make.

Larger apartment complexes have had to increase their advertising to find new tenants. Buildings five or ten years old and older are mounting campaigns as elaborate as those for new structures, and they're in the market for updated photographs of interiors and exteriors. Some are used for advertising; others are used for displays in the main office.

Occasionally you'll find resistance to your attempts to sell architectural photography services. You'll have to convince the client of potential uses to make the sale. For this reason I feel it's important to list some of the ways architectural photography can benefit a client, so you can make your contacts armed with logical arguments.

Its first use is as a sales tool. Photographs of past work are always effective sales aids for architects, builders, electrical contractors, and others in the construction industry.

Its second use is for files. Firms should have records of their accomplishments, and one excellent approach is through a regularly updated album of photographic prints.

Exhibition is yet another use. Businesses related to construction might want displays of building photographs in their offices. Apartment complexes may want photographs of the different interior designs available with different suites, on display in the rental office. This display can save time for the people who show the units, and is an effective sales tool.

Photographs can serve as a record of the different parts of a far-flung enterprise. If a business has widespread outlets, the home office may want an album of photographs showing each plant, show room, and so on. A school board might want a photograph of each school building within its particular district. A college might want a photograph of each classroom building and dormitory.

Education and Publications

Photographs can even be used as educational tools. Architects who teach courses can often utilize photographs to illustrate design points. These are far more effective in showing the building as it relates to its terrain than are the original sketches made for the client.

There can be special side uses as well. For example, the photographs I took of an apartment construction project using a new type of prefabricated concrete panels ended up as the cover story for *Engineering News-Record* magazine. Both trade journals and popular magazines are in the market for architectural photographs, a situation covered in detail in the chapter on file sales.

Real Estate

There is one type of architectural photography *not* worth pursuing. This is the photography of houses listed for sale by area real estate people. Realtors need record photographs of the homes they have for sale, and there are often quite a few to be taken at any given time. Unfortunately, real estate budgets are very low. Most real estate companies either send their sales people out with a Polaroid or hire an amateur who's willing to work for a dollar or two a print. Trying to sell them professional work for a proper fee just isn't worth the effort.

Architectural photography can be a highly lucrative aspect of your new business. However, you must be careful to go after only those assignments you can handle with your existing equipment. If you find you especially enjoy this type of work and if you can greatly increase your business through the purchase of view cameras and lenses, go ahead and take on new debts. But at the start, stick with projects you can handle without increasing overhead, and you'll be well on your way to establishing a successful business.

8

Fashion Photography

Fashion photography might be considered a bridge between public relations and advertising photography. Some fashion work can be handled on location, without the need for a studio; other projects definitely require the controlled conditions only a studio can offer. Although you can be somewhat selective in the type of assignments you seek in this field, when you're ready for fashion you should be seriously planning the start of at least an in-home studio.

Most photographers think of fashion photography as something that's practiced only in New York, Paris, and other garment-making centers. They envision the staff photographers of publications like *Vogue* magazine traveling to Tahiti to photograph the latest styles in unusual settings. There's something hopelessly exotic about the work, as though a studio owner in Dead-At-Night, Iowa, could never hope to earn a portion of his living photographing fashion. The truth is quite the opposite.

The bulk of fashion photography is handled by commercial photographers, both in large cities and in small towns. It doesn't involve the recording of a top designer's latest collection, nor does

it involve extensive travel to paradisal settings to capture the mood of the clothing. It's done for clothing retailers, both large and small, not for the manufacturers. The volume of this work will vary with the size of your community and the aggressiveness of your competition, but fashion work can be a stable part of your annual income right from the start.

The Limitations: Time and Equipment

Before you can start to look for clients you must know your limitations. What is the *maximum* time it will take before you can deliver a client contact sheets? black-and-white prints? transparencies? color prints? What size transparencies can you provide?

Depending on where you seek assignments, the answers to these questions can be crucial. For example, I once approached the advertising department of a major department store. This department produced magazine-sized promotions, mailing pieces for charge account customers, and advertisements for newspaper pages. The time between the decision on which items were to be photographed and the day the transparencies or prints had to be delivered was extremely short: photographs taken as late as Monday afternoon had to be in the art director's hands by Wednesday morning. In addition, color transparencies had to be 4 × 5—nothing smaller, nothing larger. The art director felt that anything smaller gave him eyestrain and anything larger was too bulky to be handled.

The art director liked my approach to photography, and wanted to use my services. Unfortunately, I didn't own any 4 × 5 equipment, nor could I be certain a 4 × 5 camera would be available for rental at the time I might need it. In addition, my local color lab charged 100 percent additional for processing quick enough to meet the client's needs. I couldn't afford to absorb the additional charge, and my competitor for the job had his own color developing and printing facility in his studio. At best I could promise a *maximum* of five days between assignment and delivery and still keep my rates competitive.

What was the solution to the dilemma? Did I go out and buy a 4 × 5 camera to get the assignments? Did I set up a darkroom

for processing Ektachrome transparencies? No, I turned down the chance to work for that department.

Your success in business comes from having a reputation for producing quality work at a competitive price in the time necessary to meet your clients' needs. Refusing assignments you can't complete to these criteria will enhance your reputation, not detract from it. There are seldom hard feelings when you refuse work, but there is always ill will when you make promises you can't fulfill. In the case of the department store's art director, he kept my work in mind and hired me for occasional assignments that had longer lead times.

As to increasing your equipment, such expenses may be necessary at one or more times during your career. However, the more you can do with what you own when you first start out, the greater your chance for financial success. The Department of Commerce reports that 95 percent of all new businesses fail within the first two years, and the major reason for such failures is undercapitalization. When you plow your early profits back into equipment you could delay buying until you're more solvent, you're risking your survival in business.

Entering the Field

Fashion Shows

Perhaps the simplest type of fashion photography to enter is the photography of fashion shows. These shows are held in department stores, restaurants, and shopping centers. If they're aimed towards housewives they usually take place during weekday lunch hours; if they're aimed at a broader spectrum of women, they're generally arranged for Saturday afternoons. In either case, you obviously must have weekdays free for contacting potential customers and for handling assignments. As a result, this may be an area you have to avoid until you're working full-time in photography.

Fashion show photography can be handled with any type of equipment, but roll film and 35mm cameras are easiest to use. You must be able to work quickly and maneuver easily, because the room in which the show is held is liable to be crowded. You'll

also need supplemental lighting from at least one, and preferably two, electronic flash units. The second unit allows for more controlled illumination than the direct, rather harsh light of a single unit.

If you work with two electronic flash units, use a slave trigger for the one that is set away from the camera. Long wires are a hazard that must be avoided. Because fashion show models follow a set path when displaying their clothing, you can set your slave-triggered flash on a stand aimed at a predetermined spot. Then stand where you can be most effective, holding the second flash so it's aimed at the same area. You won't have to worry about the stand-mounted unit until it's time to pack it away at the end of the show.

Fashion show photographs are strictly record photographs. They won't be used to gain new business. Often they're sent to the manufacturer of the particular clothing line displayed by the models, to prove that the clothes are being promoted. This generally happens when the manufacturer and the store split the cost of advertising rather than the store paying the entire bill.

In the case of department stores, fashion show photographs are often a means for the fashion coordinator to justify her job. The store is concerned about the volume of sales, and such shows help boost sales. The fashion coordinator wants to be able to show that she's constantly finding new ways to promote the merchandise.

On rare occasions there may be a second sale of fashion photographs. This occurs when a restaurant has a regular arrangement with local stores; the stores supply clothing and models and the restaurant manager gives them space to hold a show once or twice a week during the lunch hour. When this happens the restaurant manager may buy one or more prints for use on displays promoting the shows.

Since fashion photographs are not used for advertising purposes, there is seldom a rush on delivering them. There is also little need for color, as black-and-white prints are usually desired. This makes the work ideal for even the least well equipped photographer.

Department store fashion shows are almost always handled by

the various fashion departments. Check with the fashion coordinator, the head of the women's apparel department, and the head of the junior women's apparel department. Many department stores have teen boards made up of representatives from the area high schools; if this is the case in your community, be sure to contact the teen board director as well. Each of these people, or someone in an equivalent position, has the budget for hiring a photographer occasionally.

Small clothing stores and specialty shops are also worth approaching. This is especially true with those in shopping malls; often a fashion show is part of the mall's attractions. These stores are likely to have their fashion shows on weekends, which may better fit your schedule. Contact the manager or owner of each clothing store.

In general, fashion shows are handled for an hourly rate plus expenses. This is probably the least lucrative assignment you can have in the field of fashion, but it's also one you can handle with a minimum of difficulty.

Advertising

The advertising aspects of fashion work are far more profitable than the handling of fashion shows. More important is the fact that there's seldom a problem with charging realistic rates. Advertising is essential for a business' survival, and a percentage of its gross profit is allocated towards this end. Quality photographs are worth whatever they cost, unlike fashion pictures, which are mostly for file.

Can you do advertising photography strictly on location? Perhaps—everything depends upon where you live and what facilities are available to you for settings.

If you live in a sunny climate the entire outdoors is at your disposal. You can work in parks, near a stream, in a churchyard, or almost anywhere else. However, if your weather is unpredictable this will be impossible. You'll have to settle for indoor photographs in shopping malls or museums, if they allow such activity, or in similar areas. This may or may not prove practical.

In the case of specialty clothing stores in shopping malls, there's no problem. The mall management will be delighted with

the publicity it will get, and the clothing store owner will like being able to watch the advertising photos being made. As long as you work very early in the day, preferably before the mall opens to the public, you can use floodlights or electronic flash with ease.

Working with Models

Finding and Hiring Models

Advertising photographs frequently have to make use of models for their assignments. Generally they turn to modeling agencies, which are found in every large city and in many smaller communities. Agency models usually have a certain amount of training and experience. In addition, if the model scheduled to be photographed fails to appear or becomes ill, the agency can find a substitute in a hurry.

Agencies charge by the hour and by the job. The fee a model receives often depends upon what type of modeling must be done. Posing in the nude, for example, commands a higher fee than posing fully clothed.

Some models are specialists. There are those who pose only for leg photographs, as in stocking ads. Others make their reputations through unusually beautiful hands or eyes. Specialists are usually found only in major advertising centers, because it's only in such places that a specialist can earn a steady income. However, regardless of where you are, if you need a specialist there's a chance a local agency can find one.

A model should be hired through the offices of your client, and *the client should be billed directly by the agency.* If you foot the cost, billing the client for reimbursement, you'll have a serious cash flow problem. You'll end up paying money to the agency which you may not recover for two or three months at least. This can become devastatingly expensive, and must be avoided.

Some photographers prefer to avoid the use of a modeling agency. They hire through a variety of methods, including newspaper advertising in both dailies and college papers. If there's an art school near your community, some of its students may be interested in posing. They often need money, and, being

in one of the fine arts fields, they're aware of what modeling is really all about. Too often when people see advertisements in the paper they assume that the photographer is planning pornographic romps. This can damage a photographer's reputation for no cause.

Your best approach to the modeling problem is to start by working through an agency. Go to the office and look through composites. Talk with some of the models; be sure to interview several before hiring anyone. You want to have a good rapport with the model you choose, something that will not occur with every one regardless of how experienced both of you may be. There is no "best" model. There are only models with whom you can develop a good enough relationship to work effectively.

Clothing

At this point it's very important to discuss the special responsibilities of a photographer handling fashion work. The clothing used by models is *not* expendable merchandise acquired solely for the advertising pictures—it's off the rack. It is part of the store's inventory, and must eventually be sold. That means it must be protected from soiling, tearing, or other damage, and unfortunately you, the photographer, are the person responsible for that protection.

When working with models, no matter how well established they may be, it's always best to assume that they haven't the slightest idea how to put on or take off clothing without damaging it. Remember that they'll be using makeup that can permanently mark a garment. They may also be hot and sweating, and that can stain the underarms of their clothes. They might take care to keep their clothing wrinkle-free before the photo session, then toss it in a heap on the floor after the work is completed.

Makeup should be applied, if at all possible, before the models dress in any clothing provided by a store or manufacturer. Once a model is made up, she should place a large towel over her head and hold one end between her lips. Then a dress, blouse, or similar garment can be drawn over her head without smearing her make-up. If the clothing doesn't have to be pulled over her head, of course, such elaborate precautions are not necessary.

However, care must still be taken to be certain that no make-up touches the garment.

If makeup must be applied after the model is dressed, as can happen on location, she should be wrapped in a robe, a large towel, a blanket, or anything else that will completely cover her outfit. No matter how careful she may be, makeup can spill accidentally, and the clothing must be protected. Remember, you're responsible for any damage.

Absorbent pads should be worn under the arms to protect models' clothing from perspiration, and care should be taken when they're sitting, standing, and moving about to prevent soiling. Models should change back to their own clothing before you take a break to eat or drink.

If it's at all possible, try to get a representative of the store or manufacturer to come along and supervise the handling of the clothing. I go so far as to request that the person accompanying us on the assignment handle the transportation of the garments as well. This prevents me from having to worry about how they've been placed in my car and whether they'll get wrinkled along the way. Too many things can happen, and I prefer not to handle everything when I can get someone else to do the worrying.

Spring clothespins should be part of your equipment for every fashion assignment. Use them to clip folds of material, at an angle unseen by the camera, to take in the garment being modeled so it appears to be custom-designed. Even the best of clothing won't fit your models perfectly when it's taken from the rack, and the clothespins give it the illusion of perfect fit.

Keep props simple, and avoid those that are potentially hazardous unless the client insists upon their use. For example, you don't want your models eating triple-scoop chocolate ice cream cones while they're wearing clean white clothes. The chances of a drip or a spill are enormous.

On-Location Strategy
Time is a critical factor when you're working with professional fashion models. Depending upon where you're working and what's being modeled, the typical model will cost your client

anything from $10 to $15 an hour to $120 an hour or even higher—and that adds up fast. Spend as little time between photographs as possible. This means using locations where there's a way for your model to change clothing quickly; if you're in a park, make certain there is a *clean* public rest room. If you're in isolated terrain, perhaps you can rig your car so your model can change there. When working on the desert, for example, the back seat of my car becomes a "dressing room." The model is hunched down beneath a giant blanket kept for that purpose. I stand with my back to the car, watching for approaching traffic. Whenever I see someone coming I knock on the trunk—but that additional precaution is made out of deference to the model rather than of necessity; the blanket is an effective screen.

If all else fails, rent a small van-type truck for your location photography. These trucks rent for $20 to $30 for the day, depending on where you live and what truck rental firm you use. They make ideal dressing rooms, and they're far cheaper than paying the model for an extra couple of hours spent driving back and forth from the location site to the nearest changing place.

In the Studio

Fashion photography sometimes requires a studio setting. The creation of the home studio is the subject of the next chapter; however, I'd like to cover some of the special needs of fashion photographers working in the studio.

Your lighting equipment will dictate the length of each modeling session. Floodlighting is the least expensive, but it causes the greatest strain for the model. The high heat and constant harshness of floods can be tolerated for little more than five minutes at a time. This means you'll have to take frequent breaks, and, if the model sweats from the heat, do frequent makeup repairs.

Electronic flash will enable you to work until the model tires—at least a full hour. Unfortunately, it's costly when compared with floods, and may be beyond your means. If you can't use electronic flash, be prepared for longer sessions than would otherwise be necessary.

Be sure to tell your model what the photograph is supposed to convey before he or she starts posing; if the model understands

what you're trying to do, she'll be able to work with you towards that end. Let him or her know when expression and pose are what you're after, and use background music to relax the model and help set the mood.

Remember that models are human beings, despite the fact that their work is often such that they appear to be just objects who must be fit into an art director's sketch of a product layout. Treat your models with respect and kindness and your attitude will be reflected in the quality of their work.

A mirror is a tremendous help with fashion work. Models may be more sensitive to minor appearance problems that you wouldn't see, but which would upset the client if they were visible in the final photographs. If there's a mirror positioned near your camera, they can make the changes as they spot a difficulty. One caution, however—some models become so engrossed with looking into the mirror that they don't give the photographer proper attention. If you use a mirror, make certain it's portable and can be moved out of the model's line of sight if it interferes.

A portable high-powered fan is another excellent addition for the home studio. You can aim it to one side to make clothing billow or hair blow. It lets you bring the outdoors inside, and can be a most effective tool.

Other Fashion Jobs

Catalog Work

If you do establish a studio you'll probably be interested in handling catalog work. In larger cities like New York and Chicago major companies hire photographers to produce such items as the Sears, Roebuck and Montgomery Ward catalogs. In smaller communities you may not find such major projects possible, but you can bid on department store magazine-style newspaper inserts.

These have eight or more pages filled with photographs of fashions, tools, and other merchandise being offered. Sometimes the photographs are obtained from the products' manufacturers, other times area photographs are hired for the job. However, unless you're dealing with a store that sells nothing but

clothing or a department store that has only its clothing on sale, you must be willing to photograph anything from toasters to mustache wax. Such product work requires different skills from fashion work and may require a view camera; talk with local companies about these jobs, but don't hesitate to turn down an assignment if it requires equipment or skills you don't have at the moment.

Catalog jobs usually come from the advertising department, or, in the case of a specialty shop, the head of the store. Your bid should be made on the basis of time and expenses. Sometimes you'll have to hire the models, and sometimes the store will provide them. Figuring your charges is included in the chapter on rates and pricing.

Male Fashions

Male fashions have been a neglected area for many years, and the jobs requiring you to photograph men remain few and far between. Department stores seldom have male fashion shows, and their promotion of men's clothing is usually minimal. Your best sources for assignments are manufacturers and stores specializing in men's wear.

The problems encountered when photographing men are less than when you work with women. This has nothing to do with chauvinism but rather with the fact that men seldom wear makeup, and so can put on and take off clothing with fewer chances of damaging the material. However, you must take all the precautions outlined above whenever necessary.

When working with men on location, some photographers have a tendency to feel that they can change anywhere. If you're in a park, you might be tempted to ask a male model to change in the midst of foliage that's dense enough to conceal all vital areas. Don't do it! Although you may not run the risk of having him arrested for indecent exposure, you certainly run the risk of clothing damage. If there's no place to lay his slacks except on the ground, over a bush, or on the limb of a tree, the chance of staining or ripping the fabric is great. The same precautions used for women must be used for men.

Fashion photography can be an integral part of your new business, but it requires care, planning, and constant attention to all details. Only when you consistently return with both high-quality photographs and undamaged clothing can you be certain a client will continue to use your services.

9

The Studio

Before continuing with an overview of the types of assignments you can seek as a professional photographer, it's important to discuss the establishment of a studio. Many assignments, in advertising and in most portrait work, require you to have the facilities to carefully control your photographs. This means a studio area, either in your home or in a separate building.

The Home Studio
I am a firm believer in the home studio. It costs very little money, is easy to establish, and lets you fit many photography sessions to your own hours. You can work at 3:00 A.M. if you so choose, without having to leave the comfort of your own home.

Whether or not you can establish a home studio depends on your available space and on the indulgence of your spouse and/or family. The amount of space you need will vary with the type of work you're going to do. Whatever area you must appropriate can't be subject to frequent use by children, pets, or others. It should be isolated from the rest of your living area or you'll need the full cooperation of family members to agree to stay away from the area when you're working.

To a lesser extent, you must also worry about zoning. If customers will be coming to your home studio, or if you plan to put signs outside your home or prints on display, or have any other aspects of a business visible from the street, check your zoning laws. Many residential areas do not allow businesses that disrupt the normal living pattern. No one cares if you photograph objects in your home, have your office at home, and list your home phone as your business number if it doesn't show. However, someone may care when such actions become obvious to the public.

Working with an Apartment

The majority of my professional work has always been done from my home. My wife and I have always rented extremely large apartments, with far more space than we would otherwise need. One bedroom, generally the largest, has served as my office. It contains hundreds of reference books and numerous files filled with photographs, negatives, records, and related matters. My cameras are stored there, and, occasionally, my lighting equipment.

Remodeling. A second room serves as a studio. In one townhouse, for example, the studio was the basement. It was divided into two sides. Half the basement was unfinished, and meant to be used as a utility room. It contained a full bathroom, as well as large washtubs, plenty of outlets, and room to move. This became a combination model's dressing room and darkroom. The windows were sealed over, enlarging and developing equipment set up, and chemicals stored on a bookcase along one wall. A safelight was put into one socket and special filter material was placed over the blower from the air conditioning unit to prevent a buildup of dust.

The conversion of the utility room was a task that anyone could handle. I say this because I am the most inept of do-it-yourselfers. When I nailed boards over the windows as a partial means of eliminating the light, the hammer blows landed alternately on the nail and on my thumb; I spent much of the time either cursing or running cold water over my blackened finger-

nail. My wife had the good sense to leave the apartment during the remodeling—she had experienced past projects of mine, and didn't want to have this one inflicted on her.

The other room was meant to be a family room. It was tiled and painted a beautiful white—ideal for bouncing light when I desired. I set up a roll of seamless paper on a stand, arranged my lighting, and had a somewhat small but more than adequate studio from which to work. I could handle portraits and any products that could be brought down the steps.

Some studios are so massive that special doors are built into the sides so a car, truck, or piece of earth-moving equipment can be brought inside. But these are used by highly successful photographers in Detroit, Cleveland, and other areas where manufacturers of such equipment are located. When you're first starting a studio, any product you can't carry into your home you probably won't want to photograph away from location anyway.

Living In. I have also established studios in oversized living rooms. One wall of the room was used for hanging seamless paper. Instead of using stands, I screwed cup hooks into opposite sides of the ceiling. A rope, stretched taut, ran through the seamless paper, the ends looped over the hooks. The hooks remained permanently in the ceiling, but they weren't noticeable when the rope was removed. The roll of paper and the rope were stored in a closet between working sessions. Photographs hung flush against the wall for our enjoyment when the studio was "disguised" as a living room.

The living room furniture was kept fairly far from the wall, and it was all arranged so it could be moved easily to the side for work. I could create a space at least eighteen feet wide by twenty-five feet long, adequate for small products and single portraits. With a lot of work and prayer I could also photograph small groups, though I seldom did.

How Much Space?

How much space do you need? That depends on what type of assignment you plan to tackle at home.

Obviously, any home studio represents a compromise, which

might be more of a problem than meeting the overhead of a separate studio. In large cities it's possible to pick and choose the type of assignments you seek, so that you either don't need a studio or can get along with very limited space. In small towns you may have to be a jack-of-all-trades to make a living. This usually requires adequate space for any assignment, and that means renting a studio. Analyze your available space and the types of assignments you feel you can realistically seek. You'll be dollars ahead if you can get away with a home studio. If you can't, skip ahead to the section discussing renting studio space.

Portrait Work. If you're going to do portraits, a fairly small area for your subject will work out perfectly. However, you must have some depth to the studio so you can get back far enough to use a two-power lens on your camera. If you're forced to move in too close with a normal or wide-angle lens, the apparent distortion will prove unsettling.

You must also have the room for full-figure photographs, as well as simple props. Generally nine feet from your subject is absolutely minimal and fifteen to twenty-five is better. Experiment with your spouse or a friend, positioning him or her as you would a subject, setting up your lighting and seeing if you'll have adequate space.

If you intend to use your home studio for portrait work, you'll also need a waiting area and a dressing room. Both of these must be separate from the section where you take your photographs.

The waiting area need not be elaborate. It should have reasonably comfortable chairs and some general-interest magazines scattered about. Naturally, leave albums of your photographs out, or at least some framed prints on the wall in the sizes you are offering.

When selecting magazines for your customers, never choose anything that could be considered offensive. This means no copies of *Playboy, Playgirl,* or similar publications, and no copies of photography magazines containing nudes. My own moral code has nothing to do with this warning. People become offended by a great many things, and if someone feels embarrassed in your waiting room, you won't get him back as a cus-

tomer. Stick with such publications as weekly news magazines, *Reader's Digest,* the *Saturday Evening Post, Highlights for Children,* perhaps some comic books, and similar innocuous reading matter.

My personal feeling is that unless your street is so zoned that you can run a business on it, you should avoid the legal hassle of trying to establish a portrait studio at home. The great amount of space involved, coupled with the parking question, makes this a difficult arrangement.

Advertising. An advertising studio is something else, however. As long as you do not have to worry about clients stopping by, any space large enough for easy maneuvering will suffice.

Product Work. For product photography the space you need depends upon the size of the objects you'll be photographing. However, in general you'll need slightly less room for products than you will for people, unless you get into food photography or other types of advertising work that require elaborate displays. Since you must fit your assignments to your equipment and facilities, you'll have to limit the jobs you seek according to your space. This is true even after you rent separate space, but when you rent you'll have far more space than you can use at home.

Ceiling height is another factor for consideration. With food and other products you may wish to get well above the objects being photographed, and this means a higher than normal ceiling. Since most new apartments have fairly low ceilings, you may again be greatly restricting what you can do.

Lighting

What type of lighting do you plan to use? The least expensive is floodlighting. Heavy-duty units are available for less than $50, each and many companies sell portable flood bulb holders for under $15. These lights can be made even more versatile by purchasing barn door attachments, umbrellas for bounce lighting, and similar accessories. Floodlights are the cheapest way to fill your studio with brilliant, controlled illumination at moderate cost.

They are also potentially dangerous. Assuming you use just three flood bulbs of 500 watts each, your total accumulation is 1,500 watts of electricity, a formidable power drain. If all three bulbs are connected to one circuit, there's a good chance that you'll overload the line. There's also a chance that the power drain will cause heat to build up in your home's wiring system, a problem of which you won't be aware until you start to smell smoke—and by then your home may be on fire.

Find out the maximum load your house's wiring can *safely* handle. Generally this is a maximum of 15 amps, which means roughly two of those 500-watt bulbs. Do *not* try to increase the load by putting a fuse with greater than normal capacity in your fuse box. You'll only increase the fire risk.

If you live in an apartment, check with the building superintendent concerning the load the line can handle. If you can't get the information from him, hire an electrician to check for you. His services are well worth the money.

You'll probably find, as I did, that you must plug your lights into different parts of the house to use the different circuits. This means buying long, heavy-duty extension cords. I once had six lights separately plugged into the living room wall, the kitchen outlet, the bedroom, and the bathroom. It was the only way I could keep from overloading any one circuit.

Floods. There are numerous problems with floodlights, the most serious being that many stands are notoriously unstable. Unless you get very expensive, heavy-duty units, you'll find that floods mounted on fully extended stands, generally six to seven feet in height, are either top-heavy or in a very delicate balance. A slight bump or a tug on the cord will send them tumbling to the ground. If you're working with models, they could be injured by falling lights; you could be faced with a lawsuit. If they fell away from the model, the exploding flood bulbs could set fire to the seamless paper—and your home. Liability insurance may protect you financially, but that's little consolation when such an accident occurs.

If you must use floodlighting, several precautions are essential. The first is never to use floodlighting in any area where people will be constantly milling about. This means both the

floods and their extension cords; someone could be several feet from the light and still send it sprawling if he accidentally tripped over the cord.

Be certain your stands are fairly secure whenever they're close to a model. As an extra precaution with inexpensive, lightweight stands, tape the legs to the floor, using heavy-duty masking tape, or, preferably, gaffer tape. If you're using clamp lights, reinforce the clamp with tape.

Be certain the flood bulb is no more powerful than the socket is designed to handle. Somewhere on or inside the socket is a maximum wattage rating; the flood bulb *must not* exceed limit. With inexpensive units this maximum is generally 650 watts, which means that a 500-watt flood is perfectly safe but a 1,000-watt bulb is an overload.

Use only heavy-duty extension cords, and tape them along the floor if at all possible. This lessens the chance of someone tripping over them.

Be prepared for emergencies. Have on hand spare flood bulbs, spare fuses, and readily accessible fire extinguishers. Always unplug the floodlights when they aren't in use, even when you're only taking a five-minute break. If they should fall, there's far less danger of fire or injury when they're unplugged.

Never let the flood bulbs come near flammable material. These bulbs become intensely hot within seconds after being turned on, and if they're too near seamless paper or even a model's clothing, a fire could result.

Never turn on a flood bulb that's aimed directly at the model; turn the stand so the reflector is facing the other way before switching on the bulb, and then maneuver it where you want it placed. If a bulb is defective or was extremely cold the moment you turned it on, it could shatter in those first couple of seconds. I once carried flood bulbs to an assignment in the trunk of my car on the coldest day of the year. I brought them inside, set them up, and had them turned on five minutes after I arrived. The shock of going from a trunk that was roughly ten degrees below zero to the heat of being turned on caused one of the bulbs to explode. Fortunately, no one was injured, but it was luck rather than my precautions that saved the subjects. Had I turned the

stand so the reflector shielded the model during those crucial few seconds, there would have been no risk of injury.

Electronic Flash. If you decide to work with electronic flash, modeling lights are essential. You must be able to previsualize the lighting effects, and this can only be done with modeling lights.

Most studio electronic flash units are relatively expensive. A flash system consisting of a power source, three flash heads, and three stands usually costs from $350 to $1,000, with more sophisticated units running double that figure.

It is possible to save on electronic flash equipment for studio use. An increasing number of private manufacturers and importers, such as New York's Spiratone, Inc., offer low-cost flash units with special modeling light attachments. The flash units are relatively low-powered, but they're adequate for most uses. They are generally AC/DC units, so you can plug them into a wall when in the studio. Stands, flash, modeling lights, barn doors, umbrella reflectors, and similar accessories can all be purchased individually, allowing you to form a system that fits your special needs. The total cost for an elaborate, low-cost system can be from $200 to $300, depending on what you buy. The only drawback is that these are not heavy-duty units, and some caution must be used when transporting them to and from location.

There are certain types of photography for which electronic flash and its cold illumination are a must. Food photographs are best taken with electronic flash simply because the food lasts longer without the intense heat. Imagine trying to photograph an ice cream sundae, for example, with flood bulbs giving off well over 100 degrees of heat just a few inches from the ice cream.

The photography of models is also easier with electronic flash, as mentioned earlier. If a model swelters under the lights, he or she is going to need frequent rest breaks for a drink of water and makeup repair.

Processing

The Darkroom. Should your studio be equipped with a dark-

room? There are several opinions about this. Some photographers claim that you aren't truly professional unless you have your own darkroom facilities, at least for black-and-white work. Others say darkrooms are a needless expense. I've worked both ways, and while I am against a new studio having a darkroom, I think the pros and cons of each side should be examined.

A darkroom can be a way of giving a client unusually good service. If you have the facilities for developing and printing your film, you can conceivably take photographs in the early morning and have prints in your client's hands that afternoon. That department store that wanted transparencies in thirty-six hours, for example, was satisfied by a studio with darkroom facilities.

A professional's darkroom, however, takes time and money that might be better spent elsewhere. No matter how inexpensively furnished, the darkroom must be designed for speed and quality. This means processing tanks that are fast, easy to use, and efficient. It means careful attention to temperature control, and drying equipment that filters the air so dust isn't left on the negatives. It might mean a self-contained drying apparatus with replaceable filtering system, or the installation of special air cleaners, such as the electrostatic variety, in the darkroom.

The enlarger selected must be heavy-duty and adaptable for color. Enlarging lenses must be the finest money can buy, so your prints can bring out all the quality inherent in your cameras' lenses.

Dryers must be heavy-duty, and, preferably, fairly high-speed. Everything must be planned so that actual developing and printing time is kept to a minimum. Equally critical for the home studio owner, the equipment must be ready for use twenty-four hours a day. It can't be taken down and put up when needed, as this adds time you can't spare.

Another disadvantage to doing your own darkroom work is the cost of the time involved. When do you intend to handle the work? During the day your time is better spent seeking or fulfilling new assignments. You can never charge as much per hour for darkroom work as you can when you're behind your camera. Darkroom work, fair or not, is considered less creative than

camera work. A professional may charge $50 an hour when taking photographs, but the moment that photographer enters the darkroom, the maximum charge he or she can make becomes a fraction of that figure.

Technicians. Hiring a darkroom technician is one possibility. Unfortunately, when you're first starting out you won't have enough business to keep a full-time technician busy. And if your assistant only comes in a few hours a day, two or three days a week, what do you do when someone has a rush order at an odd time?

Custom Labs. My preference is to use custom darkrooms and spend all my free time earning money or seeking clients. When I lived in the East there were custom darkrooms just a few minutes from my studio that could handle both color and black-and-white work very effectively. They could give me the work the same day if I paid an extra rush charge, and they could handle special processing, cropping, retouching, and other services I occasionally needed. They were somewhat expensive, but I adjusted my rates to fit their fee schedules.

Now I live in a city serviced by a half-dozen or more custom labs, none of which has proved very good for my needs. Some can't provide rush service; others custom-process at the expense of negatives returned scratched beyond use. Still others can do anything I want but, for a fee that's far too costly for the work performed. It would seem logical for me to install a darkroom again so I could do my own work—but it isn't.

The nature of my assignments is such that any time spent in the darkroom would cost me money. I am at the fortunate stage where I have as many freelance clients as I have time to meet their needs. Giving up some of the work to "play" in the darkroom would reduce my income. Yet I don't have the volume of business that would warrant hiring a full-time technician.

The answer, for me, has been to locate several different custom labs around the country whose services I can count on. Some have been selected because they give extremely low-cost color prints from negatives and transparencies that can be machine

printed. Others have been selected for their willingness to hand-process in special developers to give me the finest quality work possible from specially exposed film. Still others cost a little more but give me service almost as fast as would be possible with a local lab. I can't handle a client's "super rush" work, but I make this fact clear when I accept an assignment. Since I never promise more than I can deliver, there's no ill will because of my limitations.

Keep in mind that my current work includes many magazine clients, rather than just local commercial accounts. If I did the same volume of work in a studio that served only local interests, it would pay me to hire a darkroom technician on a full-time basis. The technician's free time could be utilized by my offering advanced amateurs in my area a custom darkroom service. Many studios around the country work this way to ensure that every employee is always fully productive.

Quick Handling. Even without a darkroom, there's one way to save on your processing expenses. I maintain a supply of special mailing envelopes and a large quantity of postage stamps in denominations from one cent to a dollar. I also have a postal scale that's accurate for envelopes weighing from one ounce to five pounds. In this way I can package my film for processing or my prints for mailing to out-of-town clients. I can find the exact postage necessary, apply it, and mail it without having to wait in long post office lines. Running to the post office every time you have to mail film can cost you as much as thirty minutes a day in wasted effort. The more you can handle from your studio, the more time you'll have for seeking and fulfilling assignments.

The Rented Studio

When do you really need to rent studio space? As has been seen, many assignments can be done with your home for an office, regardless of whether there's room for a studio area. Weddings are strictly location assignments, as are the fields of architecture and public relations photography. You can handle theater work on location, as well as many fashion assignments. It's only when you get into portraiture and advertising that studio space becomes vital.

If you can possibly survive the first year or two working exclusively from your home, you'll be laying a far stronger economic foundation than if you must meet the overhead of a studio. Photographers in larger cities, like New York, Cleveland, Chicago, Atlanta, Phoenix, and so on often work from home during their entire careers. There are enough assignments available in fields that are handled on location so they never have to go to the expense of renting space. If your circumstances permit the same type of approach, don't become so enamored with the idea of your own studio that you rent space to build your ego. The base from which you operate in no way reflects your talent or success as a photographer. Even more important a consideration is the fact that your prices must be about the same regardless of whether you have the overhead of a studio. Working from home will give you a far greater profit margin.

When You Should Rent
The photographer who wants to specialize in portraits or advertising will eventually have to have a studio. Although this may be in the home, most likely it will be located in a separate building in a commercial district. Let us therefore see what space is necessary, and where the best places to locate might be.

Advertising photography requires working space—the more the better. If your shooting area is as large as a house—2,500 square feet or more—it may still not be big enough. The types of products you photograph, the elaborate nature of the sets you design, the special effects you want to include will all determine the space you must have. In Cleveland and Detroit many advertising photographers rent huge warehouses so they can drive in the cars and heavy construction equipment that are manufactured in and around those areas. A food photography specialist I know has not only a large working area but also *two* huge, ultra-modern kitchens for the preparation of meals he will photograph. Sometimes he has so many assignments that both kitchens must be used for cooking; other times one kitchen is used for preparing meals while the other becomes the background for the photographs.

Before considering the rental of space for an advertising studio, consider the types of assignments that might be possible

in your area. What products are manufactured there? What products do local stores regularly promote? Department stores, for example, seldom require photographs of anything larger than luggage or sound equipment for their advertisements. In many cases the men and women you hire for models will take up far more space than the products.

What to Look For
Studio space is always a compromise between what you must have and what you'd like to have. If you can afford the area, it's a wise idea to rent slightly more room than you immediately need. Perhaps the additional space will always go unused, so you shouldn't strain your budget for the extra room. However, there is a chance that either your assignments will increase or you'll hire a second photographer so you can double your work load.

The Studio. If you're strictly a one-person operation you can get away with using the same working space for all assignments. When you photograph an advertisement, your available space is filled with the product, background props, and other necessities; you photograph a family's portrait, the advertising products are removed, seamless paper rolled down, and the room becomes a portrait studio. However, if you have two or more assignments to be handled at the same time, you must have separate areas for each type of job. Thus, one section of your floor space might be used for an advertisement while a separate area, perhaps divided from the first by a wall or panels, is used for portrait work.

The height to look for in a studio varies with your needs. Photographers who rent warehouses often have ceilings so high that lights mounted at the top don't give adequate illumination. The brightness is reduced drastically because of the distance to be covered. As a result, many have to install low false ceilings for holding lights.

Ideally, you will one day have tracks running along the ceiling with lights attached to the tracks. A long handle or similar control lets you pull these lights along their rail to the point where they're most effective. For the first studio such elaborate equipment is both nonessential and too expensive.

Any lights you suspend from the ceiling are fairly fixed. They might be clamp lights secured with gaffer tape, or lights permanently screwed into the ceiling. A Chicago photographer bought special flourescent lights that are balanced for daylight; banks of them provide overall illumination, supplemented with electronic flash on stands for more controlled lighting.

Most studio owners just starting out use the floodlights and electronic flash equipment mentioned for the home studio. This can change and grow with your business.

What other space is needed? At least one kitchen if you do food photography, of course. However, I certainly do not recommend your tackling this specialty right at the start, because you'll have to spend a small fortune installing a stove, refrigerator, and so on. If you plan to do food photography in the next few years, and if you don't intend to relocate in that time, you must plan for adequate additional floor space to hold the equipment you'll be adding.

The same holds true for your darkroom. If you feel that one day you'll want your own equipment and technician, leave adequate, unused space for its installation.

The Office. Your office can be anything you desire. Some photographers like the idea of a separate room for their offices, it seems more businesslike to them, and they can think better away from the clutter and activity of the studio area. Whatever you decide, you'll need space for a desk, file cabinets, and related matter.

How will you store negatives and prints? A partitioned area filled with file cabinets and containing room for expansion will suffice. Some photographers put floor-to-ceiling shelving along one of the walls, using the shelves to store chemicals, paper, extra film, and other supplies.

A refrigerator is an essential item for every studio. This might be a used Salvation Army special, a tiny three- or four-cubic-foot unit designed for offices and trailers, or a giant, super-efficient model which may one day be a part of the kitchen you want to install. Whatever you buy, use it to hold perishable items purchased in bulk, such as film. Remember that you can save a small

fortune by purchasing film and paper in quantity, and the only way this material will stay fresh is by refrigeration or freezing.

How much can you save buying in quantity? When I buy locally, I can get twenty rolls of Tri-X for $6 less than if I bought the same film on a per-roll basis. Twenty rolls of color film purchased at one time result in even greater savings. If I buy 100 rolls at a time, the price per roll is cut even more. Remember, most dealers are concerned with their profit per order. The actual percentage charged over and above their cost is usually reduced with more extensive purchases. Under these circumstances, the payments for the refrigerator and the cost of the power for operating it are far less than the money I'd spend purchasing just a few rolls at a time.

Reception. A reception area is not a necessity for an advertising studio. Your clients are met in their offices. They seldom come to your studio, and when they do, they're not interested in social amenities; they come for a work session relating to a project for which you've been hired. You should have at least one additional chair located near your desk, but a waiting room is a needless use of space.

The Dressing Room. With both the advertising and portrait studios you'll need a dressing room. An advertising studio needs the room for models; the portrait studio needs it for last-minute makeup alterations by the customers.

The dressing room can be very small. There should be a mirror on one side, preferably surrounded by light to facilitate putting on makeup. All lighting should be bright and shadow-free. Make sure there's a small table or counter in front of the mirror, and a chair to sit on. The table should have a range of makeup items, a jar of cold cream and a box of facial tissues at the very least. Naturally, the room should contain a wastebasket.

Some advertising photographers maintain a supply of hypo-allergenic makeup for a variety of skin types in their dressing rooms. This is a precaution in case the model is improperly made up, or, as can happen with an amateur, has forgotten makeup entirely. The hypoallergenic variety, found in several manufac-

turers' lines, must be used in case your model is allergic to other brands.

The dressing room should also have a place for hanging clothing. This can be as simple as an overhead bar with several hangers suspended from it.

Portrait studio owners sometimes keep a box of inexpensive combs on hand for clients who want to adjust their hair. A fresh comb is given to each client, then discarded after use unless the client keeps it. This prevents the risk of a lawsuit should one customer pass a scalp disease to another after using the same comb. Naturally, buy only inexpensive combs, and keep them in your desk so that they're taken only when needed. The cost is only a few cents apiece, and it will keep overly self-conscious customers from having a poor sitting while they constantly run their hands through their hair.

Locating Your Studio

Advertising and Location Work. If you handle only advertising and location assignments, rent the cheapest space that fits your needs. A studio just has to be roomy and functional. Moving into that new, downtown, fifty-story office building where rents start at $500 a square foot may be great for the ego, but your bank account will be emptied just meeting the security deposit. What you want is something big and cheap, regardless of location. Often such facilities are available just off the main business district of a city. These areas are older, and probably filled with warehouses and old office buildings; the outside may be decaying, but if the building is sturdy and the wiring is good, who cares about appearances?

Another advantage to the older parts of your community is the fact that old buildings were erected when construction costs were extremely low. Older offices and storage areas are roomy and high-ceilinged, and the cost per square foot is probably the lowest available in most places.

If you're handy with tools or have a friend who's a carpenter, you might save some money by renting warehouse space and partitioning it yourself. This will give you custom-designed

rooms. Just be certain before creating rooms that plumbing is available in the approximate area where you'll need water.

With any older building, it's wise to have the wiring checked and to ask the fire department to inspect the premises before you sign a lease. This allows you to be certain of your safety and the safety of your equipment.

Portrait Work. The portrait photographer has a great many problems in determining the location of a studio. Success or failure is often the result of the site selected rather than the skill of the photographer—planning where to locate is far more important than the cost of space.

Portrait studios must be accessible to large numbers of people. They must be in a population center and have extensive parking facilities. Nothing kills a photographer's business faster than inadequate parking; if a family has to drive around, looking for a place to park, they aren't going to bother stopping at all. Other studios with better parking will get their portrait work.

A portrait studio can reduce advertising costs if it's in an area that has many passersby. When people walk past on their way to other stores, they glance in the window, and, in many cases, they'll sell themselves on your work. They'll walk in off the street to arrange for a time when photographs can be taken. This kind of clientele is far more valuable than those who found your name in the Yellow Pages or saw your newspaper advertisement, because it cost you nothing to gain this business.

The ideal portrait studio location is the enclosed shopping mall. The vast array of shops, coupled with ample outside parking, can mean a gold mine in walk-in business for the studio owner. A good window display—discussed in the advertising and promotion section of this book—coupled with occasional specials can result in a high volume of business with minimal expense. The rent for such space can be high, but if your studio is going to specialize in portraiture only or portraiture coupled with location work, a large studio is unnecessary. Renting limited space in a mall may be worth the money.

The fact that your studio is in a shopping mall doesn't mean it will automatically be successful. Other factors help determine whether you've selected the proper location.

Investigating the Area

The purpose of a shopping mall or any other concentrated group of businesses is to serve a particular neighborhood. Americans may have a love affair with the automobile, but we still tend to do minimal driving when it comes to shopping. We like to buy from merchants in our immediate neighborhood. A shopping area in one part of town seldom draws anyone from a different section of the city; business is transacted by local residents.

What does that mean when you're looking for a studio location? It means that if you don't take a close look at the area population of the site you're considering, you could find yourself with a declining income in the next few years.

Before signing a lease for a portrait studio, find out the number of people in your area, their ages, their occupations, their income, and other pertinent data. Is the neighborhood settled or in transition? Are there many "For Sale" signs?

Are the houses new or old? Newer areas are generally fairly stable, since the families living there have only recently bought in and are less likely to be moving in the immediate future. Older neighborhoods can be quite stable too, but they might be filled with retirees who are now on fixed incomes.

How is the neighborhood maintained? The lawns don't have to look as if they're about to be photographed for *Better Homes and Gardens*. However, if they aren't cared for and the buildings need repairs, the implication is that the people living there can't afford basic upkeep. Since people are going to improve their living conditions before they spend money on such luxuries as photographs, such a neighborhood isn't likely to bring you much business.

Young families, preferably with rising incomes, are excellent potential customers. They want records of their children as they grow, and may have single friends to whom they can recommend your services for wedding photographs. When a couple's children are grown and their income has stabilized, the desire for professional portraits will decline.

Your area Chamber of Commerce, or even local realtors, can provide you with information about the income of the section of town you're interested in. They might also be able to provide a

breakdown as to the general range of jobs held by the people in the area. This is especially helpful in communities where one business is a major employer. If that business is hard hit by the recession and massive layoffs are either imminent or in progress, you won't have many customers. A community of professional people is an excellent choice, as is a community where the families hold a vast range of jobs with a number of different companies.

Be wary of taking space in any isolated mall that's planned as the eventual center of a growing community. One Arizona shopping mall I know of is situated amid vast stretches of vacant suburban land. When the mall was first planned it was assumed that the city population would spread rapidly in its direction, and several new houses were being started. The early tenants rented space in the mall, sharing this great vision of the future with the management; it was worth having limited business at first, they thought, so they'd be well-established by the time the mall was surrounded by houses and apartments. Then came the housing slump. Construction stopped and many of the completed homes went begging for buyers.

Today the mall does minimal business; other malls serve the more densely populated areas. Business is slight. Merchants who once had great expectations are now sitting out their leases in the hope that they can move to a better location before they have to declare bankruptcy. Obviously, just being in a shopping mall means nothing if that shopping mall is not located in a major population center.

Another area to avoid is one in the process of being rejuvenated. Many downtown areas, once abandoned, are being rediscovered by merchants. Specialty shops and restaurants, dinner theaters, and nightclubs are often filling once-vacant buildings. People are returning to the downtown area in record numbers. More important economically is the fact that during the transition from deserted business district to "new town," the buildings rent very reasonably. However, these are not for you.

I am not opposed to city rejuvenation; I am in favor of the return of the downtown area as a shopping and entertainment center. I would encourage most types of business to rent space

during the transitional phase, certain that the vast majority of them would do a volume beyond their expectations. But not a portrait studio!

The problem is that during the transitional phase the general public has not yet gotten into the habit of returning downtown for their entertainment. A few nightclubs do a good business after work and on weekends, but for the most part business is transacted during the day. The majority of the customers are from various office buildings, and the big rush comes from 11:00 to 1:30 when just about everyone goes to lunch.

Bookstores, jewelry stores, and similar businesses are quite popular with business people. The public can walk in regardless of how they look, make a purchase immediately, and walk out. But when someone arranges to have a portrait taken, there is far more preparation to be done. An appointment for a sitting must be made, and the customer usually wants to look especially nice—not harried after hours in a smoke-filled office. The only time someone can conveniently stop by is often after work or on weekends. But after work the office worker looks distraught and is anxious to go home, and on weekends it's easier to go to the nearby suburban shopping center. Only after the downtown transition is completed do people get in the habit of returning downtown on their days off, and only then does a studio have the chance to prosper. Until that time, such areas are best avoided by portrait photographers.

What's In It for You?

Air Conditioning. There are other considerations to make when choosing a place to rent. Is it air-conditioned? This is an essential in hot climates and when you use floodlights; your customers must be cool and comfortable or they will go elsewhere. Having one's picture taken is supposed to be a pleasurable experience that the customer will want to repeat again and again, but there's nothing pleasant about sweltering in an un-air-conditioned studio.

Utilities. Who pays the utility bills for your studio? Photographers

use large amounts of electricity, and the utility bill can be almost as great as your rent in some areas. Floodlights, air cleaners, air conditioning, and other items are tremendous power consumers. Utilities must be considered a part of rent. It's often better to pay slightly more rent than you originally planned to, if utilities are included, than to go for a lower rent with utilities extra. In my part of the country, for example, the utility rates are rising disproportionately because oil is burned for electricity rather than the coal often used in the East. It's proved considerably cheaper for us to rent space that includes utilities than to have to rent the same size space and pay utilities separately.

If you're going to pay your own utilities, check to see how well sealed the studio is. Are the windows tightly fitted and well caulked? Is there adequate insulation? Are there vast expanses of glass that bring in so much heat that your air conditioning system will be overworked in the summer? You need window displays, but some buildings have glass all around. This can be an unnecessary fuel drain for you.

The Lease. Check the lease to learn your rights. Can you make alterations in the wiring without losing your deposit? Some building owners let you make all the changes you want, then hold your security deposit when you leave, claiming that your improvements damaged the structure.

Keep in mind that in a court of law your lease is all that matters. A landlord's promise to make additions, repairs, or alterations is meaningless unless it's in writing. A verbal agreement for remodeling to suit your particular needs is no agreement at all; get everything in writing or look elsewhere. And never sign a lease with the understanding that desired clauses will be added "later"—when you sign you're committed to what is on the paper at that moment regardless of any statement the landlord may make.

Try to keep your lease limited to one year's duration rather than agreeing to a three- to five-year lease, as some landlords prefer. There are a great many variables at this stage in your career. Perhaps your customers won't spend as much money as

anticipated and you'll find the space you've rented too expensive. Perhaps you'll find yourself increasingly specializing in one area of photography, and will no longer need as much floor space as you've rented. Or perhaps business is booming and you need far more room. None of these events can be anticipated the first year or two you're in operation, so a shorter-term lease makes the most sense. Once you're fairly well established and are certain the studio is right for you, you can go ahead and get the cost advantage of that long-term lease.

If there's the slightest doubt about what the lease actually covers, take it to an attorney for an explanation. Every point must be clear in your mind *before* you place your signature on it.

Setting Up Your Studio

All studios should have interior displays of photographs, but a portrait studio also needs a window display to attract the attention of passersby. The display area should be large enough to allow you to exhibit several different sizes of framed photographs, ranging from 8 ×10 to perhaps 20 × 24. Each print should show an aspect of your work. Some photographers go so far as to include scenics taken for their personal pleasure; often this means additional sales of the display prints to people who want to hang the photographs on their walls. Your window is both a lure and a sales aid, as discussed in greater detail in the chapter on personal advertising and promotion.

Furniture

The furnishings for your studio represent an expense for which you must carefully plan and budget. The simplest studios require equipment only for you and your staff. You'll need a desk, chairs, shelving, and filing aids.

I am a firm believer in buying used office equipment when possible. It's often quite inexpensive, of course. But I've also found that if you compare a used desk with a new desk that has the same price tag, the used desk is almost always better constructed. Used wooden desks are generally your best buys, but they're often extremely heavy. One used office furniture salesperson pointed out to me that the additional weight means

additional expense every time you move. If you aren't permanently located, it may be cheaper in the long run to buy a slightly more expensive metal desk that's lighter and more maneuverable.

Little can go wrong with a well-made desk. Check the top to be certain it's smooth, with no nicks, gouges, or bothersome stains. Do the drawers work smoothly? How does the underside look? Is it well finished and well made? Are the legs sturdy and not broken?

What about price? Most likely a high-quality used desk will cost between $100 and $200. Comparable new desks are at least double that figure.

You can probably get along with a single desk. Tables can be made from scrap lumber or smooth-sided doors attached to legs available from any lumberyard. These should suffice at first.

The desk chair is also a good value when bought used. Well-made, older wooden office chairs are generally available for from $25 to $50 each. If a chair comes unpadded, you can wrap some material around a piece of foam rubber and use it for a softer seat. When you look at steel chairs, you'll often find yourself paying for styling, the designer's name, or unnecessary handcraftsmanship. Always buy the cheapest well-made used chairs you can find for yourself and your staff. You can go for custom originals after you're successful.

How many chairs should you buy? You'll need one for each member of your staff, as well as three or four additional ones for models and occasional clients who stop by.

If you run a portrait studio you'll need a reception area, with chairs for waiting customers. These should be heavy-duty, well-padded, and attractively covered. Used furniture is still best, but these chairs should be nice-looking rather than just functional. A small sofa can also be added, and your waiting room will require tables as well, to hold sample photograph albums and the reading matter you put out for your customers' enjoyment.

Comparison-Shopping. Where do you find all these items? Check your Yellow Pages or the Yellow Pages of the nearest large city for stores that handle used office equipment, and watch the classified advertisements in your daily newspaper. Businesses

that are either shutting their doors or expanding and remodeling may advertise the sale of their furnishings rather than consigning them to a used-furniture dealer.

Comparison-shop as much as possible, always having a clear-cut idea of the *maximum* you can afford to spend for all the items you need. However, should you find the "perfect" desk, chairs, or whatever at a price you feel is right for your budget, buy it at once. Since it's used, there's a good chance you won't find anything like it elsewhere. Under such circumstances, if you wait to check around, the item may be sold by the time you return.

Never let a salesperson high-pressure you into either buying more than you need or buying everything you need from him when you're only certain you like one or two items. If the person is unwilling to sell you the particular item you want without pressuring you into spending more money, walk out of the store. You want to deal with someone who's concerned with your needs and your budget, not just with the sales commission.

If there are no nearby used office equipment stores, talk with office equipment stores to see if they get trade-ins. Often when a business remodels it trades in its old furniture as partial payment. The equipment firm accepting the trade-in then stores it until someone expresses an interest, sells it to another dealer, holds an auction, or has a separate warehouse from which used equipment is sold.

A strong back and some willing friends can save you additional money. A few stores make deliveries without charge; others have a fee for delivery or have you find your own means for getting the furniture to your studio. All such expenses can be reduced by hauling it yourself, using a rented trailer or small truck. Compare the vehicle rental prices with the cost of the store's delivery charges before deciding which way to go.

Your Reception Area. Your reception area needs either a desk or a table of desk height. Which you choose will depend on your own needs. Some studios have a painted board stretched across a pair of two-drawer file cabinets, one at each end of the board. A cashbox is kept on this table, along with a portable typewriter and various order forms. The file drawers are used for records.

What you decide to do is a matter of taste, budget, and the design effect you're trying to achieve.

One question that may seem minor to you but that could be of great concern to portrait customers is whether smoking is permitted in your waiting area. Increasingly, people are bothered by cigarette smoke, and the latest studies indicate that just 38 percent of the population smokes. An increasing number of cities are passing laws restricting smoking in public places.

I feel you would be wise to discourage smoking in your waiting room even if you're a smoker. A sign posted in a prominent place and the elimination of ashtrays should suffice. It's doubtful that you'll lose a customer as the result of banning smoking; it is quite possible that you could lose a customer because you *do* allow it.

From a purely technical standpoint, smoking in the studio should be avoided. Smoke in the air, even if not visible, can leave a yellow haze visible on some Kodak color films. Eastman Kodak issued a technical warning on this point a while back.

Storage. Shelving for holding supplies, files, and similar equipment can be quite costly. You can buy fairly cheap steel shelving designed for warehouses and work areas, but the shelves are seldom adjustable. You're liable to have either too little space between shelves or a large section of wasted space.

My preference is for the do-it-yourself variety. You can buy either spring-topped poles that fit anywhere or special metal strips that screw into the wall; metal brackets, bought separately, fit into regularly spaced slots often no more than an inch apart. Shelves fitted onto these brackets can be spaced in any way desired. More important from a cost standpoint is the fact that you can buy cheap boards for the shelves or use custom-cut mahogany pieces selling for several dollars each. You might use the latter for shelving in the reception area and the former for the shelves hidden from public view.

One word of caution about shelves that fit on braces screwed into the wall: be certain the wall can support the shelves. I once used them on a divider wall that, unknown to me, was hollow. Each side was made of cheap, thin wood, not much stronger than corrugated cardboard. It supported the shelving with no trouble, but the minute I placed a few notebooks on top,

the screws were forced downward, ripping through the board and causing hideous angular holes. My wife and I had to fill in a total of seventy-five of these holes with wood filler, then paint the whole thing. Even then we lost our rent deposit.

Buy file cabinets used whenever possible, and make sure they're the suspension variety. A full suspension file cabinet will enable you to fill the top drawer only and pull it all the way out, without the chance that the cabinet will go crashing to the floor because it's top-heavy.

If you need only one file cabinet, get the four-drawer variety. This is usually cheaper than buying a pair of two-drawer cabinets, and will give you room for expansion.

An expense worth considering is either a used fire-resistant safe or a filing cabinet with one or more drawers designed to be fire-resistant. This container should be able to withstand high heat for two hours, according to fire department officials, rather than the one hour common with less expensive units. An office building fire, if it occurs at night, is not likely to be discovered until it has been raging for almost an hour, and the fire department feels that it could be another hour before the fire is controlled enough to reduce the temperature around the safe to an acceptable level.

This fire-resistant container is not for cash receipts and similar valuables but for irreplaceable negatives. Over the years, you'll take photographs that you'll value highly. Perhaps they're personally important, or they might be images that have sold time and again from file, as discussed later. Whatever the case, it would be a tragedy to have them lost to fire.

The advertising studio needs a work area for creating props and backgrounds. You'll want a table and perhaps a pegboard-covered wall, with hooks for holding tools and other supplies.

What system will you use for holding negatives? Notebooks fit easily on the shelves. Commercial negative file drawers, such as those offered by Nega-File, can be stacked on the floor and expanded as you grow.

Music. Music is an essential part of your studio. Background music can help relax a portrait client or help stimulate a model as she moves from pose to pose. A radio is the simplest way to

provide music, but it limits what you can play in the background. Records or tapes are preferable, and you can buy a new compact system for under $100 with careful shopping. The sound quality will be nothing to brag about, but that's not important.

Buy records or tapes to cover the entire range of musical tastes—classical, jazz, acid rock, show tunes, folk songs, country-western, and anything else people might want to hear. Numerous discount sources sell inexpensive records, and many drugstores sell albums for $2 or less. Many bookstores have used records for sale; if they're neither scratched nor warped you can get some good buys. There are even retail establishments that have regular sales of slow-moving stock. Tapes generally have to be bought at retail. I have yet to see used tapes for sale, and would hesitate to buy any I couldn't hear first—it's too easy to accidentally erase a portion.

Your musical selection need not be very large, just varied. You also don't need "name" groups or the latest hits; include the *types* of music people enjoy without worrying about their favorite songs. Just ask the person posing what he or she wants to hear, then put on that type of music during the sitting.

Once you're well established, you can install a more elaborate system, with speakers in the waiting area, the office area, and even the darkroom. Right now simplicity is best. Of course, music isn't a necessity, and need not be included in your first studio. But it does help smooth out your work sessions, and it would be wise to plan on including it in the future.

Supplies

Necessary supplies include seamless paper and/or special backdrops as well as stools or chairs for the people posing for your camera. Such equipment is available custom-made for photographers, but when it comes to the chairs for posing, either a used furniture store or a Salvation Army, Goodwill, or similar thrift store is cheaper.

A typewriter is essential for preparing billing forms and writing letters. The least expensive are portable units that can't take heavy use; however, you're not likely to use them beyond their capabilities. A full-sized used office machine that's reconditioned can be an excellent buy, and will conceivably last forever. Elec-

trics vary in their quality, but give letters the appearance of an even touch on the keys even if you're alternately light-fingered and heavy-handed. The price for an electric can range from around $150 to close to a thousand dollars according to quality and features, and I think it's a needless expense. However, if your feel it would be of value, you might check a magazine like *Consumer Reports* to learn which models hold up well with minimum maintenance.

Most printers and office supply stores stock the various billing forms you'll need. As mentioned earlier, you should make your own work orders for weddings and similar assignments, then have a printer run them off in quantity.

When planning a budget for furnishings, be careful to keep other expenses in the back of your mind. Otherwise you might end up putting every spare dollar into furnishing your studio, only to discover that you have no customers because there wasn't enough money left over for advertising.

Another area many photographers forget about is income tax. Remember that self-employed people generally have to estimate their annual incomes and pay on a quarterly basis, and you must have the money to meet your federal obligations readily available. You can't spend all your profits on your studio or you'll have nothing left for other obligations.

Security

Insurance. Your final concern when opening a studio is security. Protection against fire and theft should be uppermost in your mind. You'll have a sizable investment in your studio right from the start, and as the years pass, your cameras alone might be worth several thousand dollars.

The fact that the economy has been in turmoil in recent years doesn't help matters either. A few years ago I made a sizable investment in 35mm camera equipment, buying two bodies and seven lenses for about as much money as I would have had to pay for a stripped-down compact car. Naturally the bill was paid on an installment basis, and my insurance covered exactly what I paid.

Six months after my purchase the dollar was devalued, costs

increased, and suddenly the price for replacing my equipment rose over $2,000! Today my well-used equipment is worth more than I paid for it, and having to replace it, even with my insurance protection, would be difficult, time-consuming, and expensive.

Your situation is liable to be the same. Even with a bare minimum of equipment in your studio, a thief could easily steal readily salable items worth $1,000 or more. Protection is essential.

Locks. Your doors are your first line of defense. The frame should be reinforced, and you should have a double-cylinder dead bolt lock with at least a one-inch throw; shorter dead bolts can often be opened by professional burglars. The double cylinder requires a key to open the door from the inside as well as the outside. It prevents a thief from punching a hole through your door, then turning the handle of the lock. This is especially helpful if you have a door with glass panels.

Your windows should all have key locks, and those locks should be opened whenever someone is in your studio. It isn't likely that anyone will ever attempt to steal your belongings while you are in the studio; however, there is a chance of fire, and you should be able to escape as quickly as possible. Having to find the window lock key will slow you down and possibly prevent your leaving. Only at night, when the studio is closed, should those windows be securely locked.

Alarms. An alarm system is a good idea. You can probably get away with contact switches and an internal warning system that sounds a horn or siren and, perhaps, turns on some lights. The alternative is the silent alarm, which automatically dials your telephone, playing a recorded message for the police, or triggers an alarm in the office of a private security firm. These are expensive and needless unless you have a large number of valuables and are in an area with a fairly high crime rate.

Window alarms should be the type that triggers when sensing foil placed against the glass is touched. This does not detract from the appearance of the windows and is more sensitive than the alarm sensors that are triggered only when the window is

opened. Some burglars remove the glass to come inside, and the foil is triggered by such actions. My personal preference is for battery-operated alarm units, despite the fact that it's easy to forget to replace the batteries as often as recommended. Such systems can't be defeated by killing the power to your building, thus giving you an extra margin of safety. As for the batteries, I've developed a way of reminding myself when they need changing. I use a label maker and attach the date when the batteries were installed. I check the dates once a month, making changes in both the batteries and the label whenever necessary.

Fire Alarms. A fire alarm is another essential for your studio; unfortunately, the most readily available types are also the least reliable. Almost every alarm manufacturer makes what is known as a heat detector. When the temperature near the sensor reaches 135 degrees, the alarm is triggered. These detectors attach to almost any alarm system, and can cost as little as $5 each.

The problem with a heat detector is that by the time the room temperature has reached the point where the sensor reacts, it's probably too late to save anyone's life. The flames of a fire are not what generally kills victims, it's the smoke and poisonous gases that fill a room when the fire first starts. Sometimes the room is drained of all available oxygen; other times flames cause a material to smolder with poisonous results. Many forms of fire-retardant materials used in buildings will not burst into flame but will give off killing gases.

The best protection you can give your studio is what is known as the ionization detector or smoke detector. These sell for roughly $50 each or more, though the least expensive units will suffice. Instead of detecting heat, they detect the first hint of a fire, long before any flames are visible. When the alarm sounds, the fire may be at such a point that you can extinguish it yourself. Of course, the proper way to react is to evacuate the building and call the fire department. Such early-warning devices almost always ensure that everyone can flee safely.

Where can you find smoke detectors? Check with local stores handling alarm equipment. If none of them stocks what you're

after, check with your local fire department for advice. They'll know where such units can be obtained, and will be happy to be of service.

Position the units where they'll do the most good. One should be in the studio near where you have heavy wiring, another in the reception area, and a third, perhaps, in your office. If you have a darkroom, that's the place for yet another detector. The cost is far greater than for heat detection units, but the potential savings in terms of life and property is so great as to be immeasureable.

Finding the Answers

Should you have trouble with financing, or have questions about starting your own studio that aren't answered in this book, there are two places to turn. The first is the Service Corps of Retired Executives (SCORE), a group of volunteer retired businessmen, all of whom have been successful in their careers. They offer expert and practical advice. They are located in almost every larger city, and can be found by checking your telephone directory's white pages.

The other agency is the Small Business Administration. Not only can you receive counseling from them, you can also receive financial backing under certain circumstances. The SBA is a government agency, so consult your telephone directory's United States Government listings.

There may be other counseling groups working on a local basis in your area. Your Chamber of Commerce will be able to tell you if such a group exists in your community.

10

Portrait Photography

Portrait photography is the field in which the largest number of photography studios earn the bulk of their income. A skilled portrait photographer can retain clients for many years, often serving the second and third generations of a particular family.

Portrait photography knows no geographic limitations. Like wedding photography, it can be handled in small towns as well as in large cities. As long as there are people there will be a need for this service.

It's possible to do portrait photography from any location. There are successful portrait photographers working from their homes; others rely strictly on location. Still others work exclusively in the homes of their clients. But the vast majority of portrait photographers have a studio separate from their residence.

Space isn't a problem with portrait photography, as it is when you handle advertising accounts. A fairly limited studio area is all that's necessary when photographing even the largest of families. However, your studio should have greater depth than width, to let you move your lights freely around your subjects to

achieve the best effect. And when you handle portraits you'll need a reception area as well as a dressing room, in addition to your office and the darkroom, if you have one.

Portrait photography can be handled with any size camera from 35mm to 8 × 10, but most photographers seldom go smaller than 2¼ × 2¼ or larger than 4 × 5. The 35mm negative is too hard to retouch, and 5 × 7 and larger negatives are unnecessary. Ideally, you should use a two-power lens like the 150mm on a 2¼× 2¼ camera, but thousands of professional portraits have been taken with such fixed-lens cameras as the twin-lens Rolleiflex. This is one of those fields where anything goes, as long as you make quality prints that show no distortion of your subject's appearance.

Pleasing Your Clients

Unlike other fields, portrait photography is not always "honest" photography. The reason most people have their portraits taken is to enhance their self-image, not to be made to critically examine their facial features. Thus the aging have wrinkles removed, bags smoothed from under the eyes, and other cosmetic retouching handled before the proofs are shown. Soft focus might be used, or a diffusion enlarger screen selected for making the final print. Even minor surgery is performed, the photographer removing a wart or a mole from the picture.

Occasionally you'll encounter clients who are realists, who want an accurate rendition of their physical appearance. I once was assigned to photograph one of the richest women in the United States—the widow of two major automobile manufacturers. She was living in her "small summer cottage" of just forty-three rooms. The walls were adorned with millions of dollars' worth of paintings, and display cabinets were filled with priceless curios from cities throughout the world.

I was impressed with this aged woman the moment I met her. She seemed at peace with herself and with the world; she had an inner calm that radiated from her face. I found her quite beautiful, despite superficial skin defects and eyelids that seemed to operate independently of each other, the result of a muscle problem. I decided to photograph her exactly as I found her, the

only cosmetic aspect of the picture being my waiting until both her eyelids were at the same level. When the photograph was printed, I instructed the darkroom technician to bring out every detail in the negative. There was to be no retouching.

The photograph was made and a copy sent to the woman at the same time prints were delivered to my employer. When he saw them, he became extremely angry with me. I was called callous for my realistic approach, as well as a number of other things I'd rather not quote. He was especially outraged by the fact that I had had the nerve to send her a print before he had had a chance to screen my work. He knew she'd be furious.

Her reaction was what I had suspected it would be: not only did she love what I had done, she also ordered 100 copies for her personal use and refused to let anyone else photograph her. I was the first person in recent years to photograph her accurately, and she was delighted.

While it may be hard to anticipate exactly what a client wants when you take his or her portrait, you can be certain that the majority of your customers won't be like the wealthy widow. They're insecure about themselves, and they want to be made better-looking than they really are. When someone says, "Are you sure you want to photograph me? I might break the camera," what he is really seeking is reassurance that he is, indeed, good-looking. You'll generally have to flatter your subjects to a degree, both in the way you answer that trite remark and in the way you present the final portrait print to them.

Retouching

What does all this mean to you in terms of your business? It means that you won't be able to handle portrait work until you're in some way connected with a good retoucher. This may mean a darkroom technician who handles retouching as part of his duties. It may mean a commercial artist who does retouching as one of his services. Or it may mean that you or your spouse must learn to handle this chore. However you handle the problem, you must plan to use the services of a retoucher before you enter the portrait business.

How do you find a retoucher? If you use a custom lab, start

with their services. Most color labs doing hand-printing can also offer portrait retouching for an hourly fee; there is usually a minimum rate regardless of the actual time involved. Black-and-white labs may or may not be able to offer this service, but someone at the lab can usually place you in contact with a re-toucher.

Commercial artists in your area can be found in the Yellow Pages of your telephone directory. Make sure when checking with them that they understand the type of retouching involved. Some are only skilled at preparing photographs for newspaper reproduction; they use air-brushing and similar techniques that are unsuited for display photographs.

Do not take the hiring of a retoucher lightly: this is a critical aspect of your portrait business. Not only is it essential that a retoucher be skilled and efficient, he or she must also be reliable. The retoucher must be concerned with helping you meet your clients' needs by delivering work when promised.

Before accepting any retoucher's work, give him several jobs to try, using negatives pulled from file rather than current work. If the negative is to be retouched, which is often the case, be certain it isn't returned scratched or damaged in any manner.

Location Work

There are several ways portraiture can be handled. One profes-sional, a woman without a studio, specializes in taking children's photographs on location, in parks, playgrounds, or even their back yards. She advertises in the newspapers in her community and in the surrounding area as well as in regional magazines. Her overhead is low, her prices competitive with studios, and her income extremely high without her handling any other type of photography. Because she works only with children, the cold, snowy winter season doesn't represent slack time for her; chil-dren are delighted to romp in areas where their parents would refuse to go.

In general, you'll find that location portrait work can only be done year-round in areas with mild climates. Location work can be a part of every studio's offering, but the majority of these jobs

come during the three or four fairly nice months of summer; they are not a steady source of income.

Some photographers work in their clients' homes. This requires a fair amount of equipment, including electronic flash units and portable backdrops for unusually cluttered living rooms. Unfortunately, such work is time-consuming, and it's difficult to sell except when it's an occasional service offered by a full time studio.

Working from a Studio

The photographer who is best able to generate a large amount of business in a fairly short period of time invariably has a studio. It may be a home studio, assuming there's room for parking and window displays without running into zoning restrictions. Or it may be in a separate building in a busy shopping district or mall.

The reason for the separate building is that nothing generates portrait business quite so much as a window display. This inexpensive form of self-promotion draws hundreds of passersby, many of whom come in to have their pictures taken. Even I am drawn to photographers' display windows, and I regularly check nearby studios to see what new prints are being shown. In fact, when I recently needed a publicity photograph taken of myself, I went to a photographer who was totally unknown to me. Why did he get my business? Because I liked his display. No other form of advertising impresses me quite so much as the actual work a person has done.

Walk-in traffic represents ideal customers, because it costs you nothing to gain them. Yellow Pages advertisements, though essential, are expensive. Newspapers, magazines, radio, and television promotions all have their place, but all cost money. What does your window display cost? The price of a few sample prints and the time to regularly change what's on view are a small price for all that publicity.

Sidelines

If portrait and wedding work will be your main sources of revenue when you start a studio, you can add photographically

related sidelines to draw additional business. Custom framing, both of your photographs and of paintings and photographs the customers bring in, can be a profitable addition. If you have a darkroom technician with idle time, custom processing and/or printing can be another source of revenue from the people walking by. Remember that once you get someone into your studio, the number of services you can sell him is limited only by your skill and by the aggressiveness of your staff.

11

Advertising Photography

Of all the aspects of professional photography, perhaps none requires the degree of creativity or offers the potential rewards of advertising photography. It's not unusual for major manufacturers to spend $10,000 or more on one advertising photograph, and many of the larger advertising studios consider a week wasted when they "only" gross $4,000 to $5,000. However, the number of studios that receive such financial rewards is quite limited. They're located in major advertising centers like New York and Chicago, and are not likely to consider you as competition—at least for the moment. Advertisers won't risk their money on an unknown.

For most studios, advertising photography is just one aspect of the business they handle. Some do advertising in addition to portraits, weddings, and related work. This requires extensive studio space, which is often practical only in larger communities. Small towns usually don't offer enough advertising assignments to warrant renting adequate space for a properly equipped advertising studio; most small-town photographers concentrate on weddings and portraits, leaving a limited space available for handling the few products they might be called upon to record.

If you live in an area where advertising agencies abound or where there are enough manufacturers to warrant making advertising a specialty, you may never have enough space in which to work. An advertising photograph is often a fantasy: it's created in the studio with special sets, special lighting techniques, and even special costumes for the models. The advertising photographer works to achieve a photograph that catches the eye and entices the viewer to buy whatever product is recorded. Sometimes this is as simple as a screwdriver or a hammer recorded in a straightforward manner for a hardware equipment catalog; sometimes you must create a romantic fantasy to sell a new perfume. In automotive centers, you may be required to photograph cars or even buses if you have the room to handle such an endeavor.

The new professional should probably avoid advertising except for location assignments, which are covered in the chapter on public relations photography. This includes the photographing of restaurants and hotels for their promotional brochures, for example, and related advertising. The equipment necessary for location work is minimal compared with that required in the studio.

The Requirements

To handle any type of advertising work you'll need plenty of light, the ability to build various backgrounds, and room to move around the product being photographed. Sometimes you'll need tents of seamless paper around a product, sometimes it will be miniature scenes that require controlled illumination. You may have to work with models in addition to the products. All of these things take room.

If your advertising studio is in your home, it will have to dominate the room or rooms used for this purpose. You may have to construct a set over a period of several days, working in your spare time, to satisfy a client's needs. This means leaving everything in its place each time you stop work, rather than disassembling it as you would a portrait background. You can't have pets, children, or even other adults tramping through the area.

My personal feeling is that you shouldn't seek studio advertising assignments until you're situated in a studio separate from your home. Then you must start out slowly, building skills, clientele, and a portfolio that will enable you to seek larger and larger accounts.

Getting Started

The best approach to entering advertising photography is to start with location work. Try to get the business of area restaurants, hotels, motels, and similar facilities. Approach the fashion departments of your local department stores. Gradually build a portfolio of photographs related to the advertising field.

Assembling a Portfolio

Your portfolio is all-important in the advertising world: it reflects both your technical skills and your creativity. Since advertising is different from both the type of work you probably did as an amateur and the bread-and-butter accounts of most studios, it's hard to build a portfolio for this field. A few photographers go to the trouble of buying products and creating advertising photographs of them specifically for their portfolios. This is time-consuming and expensive, and it shouldn't be necessary.

As you gain contacts and experience with location work, go after assignments that require minimal studio space. Fashion can often fit this area, or you can expand your work in a department store and arrange to photograph items that will be offered for sale through newspaper inserts and mailers. This usually requires color, and 4×5 is preferred because of the ease with which the art director can study the transparency. Reproduction from 35mm can be just as effective, but the art director has a harder time examining the smaller slide.

Most department store circulars show products either alone or in a very simple setting. Often the job calls for simply setting an item on seamless paper, lighting it, and photographing it. It's straightforward work, but at least displays your technical ability.

Specialty stores should also be approached. Luggage stores, for example, might want you to photograph some of their items,

and so might gift shops and the small shops of craftsmen. If you live near a college, you're likely to find a street of art shops, as mentioned earlier. These shops offer handcrafts, which the owners will be delighted to have you photograph. Slightly more creativity is required for this, but still nothing that can't be handled in a fairly small area.

Contacting Clients

If you can put together a portfolio of quality prints in the public relations field, including product photographs that at least show technical excellence, you're ready to begin approaching advertising agencies. My approach is to find out what clients an agency has before making appointments to see the account executives. When you know the clients you'll be able to determine what you can handle and what you can't, and will thus be able to avoid products that are too large to be effectively handled in your studio space.

The best approach to learning an agency's clients is to call and ask. Explain who you are and why you want the information. In almost every case you'll find the receptionist happy to supply you with the details you desire.

Keep in mind that as you expand your clients, you may also need to increase your studio space to adequately handle their products. My feeling as I said, is that you should avoid advertising in the beginning, concentrating on location work and getting the feel of the potential business in your area. Gradually expand your portfolio as discussed, constantly evaluating the market in terms of income potential. When you feel ready to take the plunge into renting a studio, look for space based on the jobs you feel you can realistically obtain in the near future.

Setting Realistic Goals

For example, suppose you live in a smaller community. Working from home, you've built up a business of wedding photographs, location portrait work, and public relations photography. You've also photographed clothing for a specialty shop, and some small products for a department store. There are no manufacturers in your immediate area, and the advertising agencies

seem to buy very few product photographs. You're ready to open your own studio, but what space will you need?

Based on past work, it seems obvious that weddings and portraits will always be moneymakers. People satisfied with your location work will use you for more formal portraiture, giving you a solid base for building that aspect of the business. The wedding photography won't change, though with a studio a prospective bride or groom can drop by to see you during business hours, eliminating the need for you to go to their homes. The public relations work has been nothing very great, but it is steady and should continue. Since it's all on location, it will have no effect on your studio space needs.

Finally, there is the advertising. Business has been limited and relatively infrequent. You could branch out into a nearby large city, seeking more clients than can be found where you're currently living. But that would take a great deal of time, and you can't regularly commute to one area when your studio is in another. More important is the fact that the major business you *can* count on is right where you've been freelancing from home. It's not worth worrying about the potential somewhere else when you have a solid base where you are. This means that you'll have to resign yourself to the fairly limited number of advertising accounts available in your community.

So how big should the studio be? Just slightly larger than you would need for portrait work alone. Advertising may be exciting, and it's quite lucrative for some photographers, but when you're just starting out in your first studio, it can actually cost you money. Every square foot of studio space that isn't regularly used costs you money in terms of rent and utilities. It's better to have slightly less space than you would like and to use it regularly than to have a mammoth studio that's fully utilized just four or five times a year. You can eventually move to bigger quarters when your volume warrants it, but for the start, keep overhead to a minimum or you may find yourself in financial trouble.

12

Personal Advertising and Promotion

It has been said that if you build a better mousetrap, the world will beat a path to your door. But that saying is only partially true. That mousetrap won't bring you the fame and fortune you so richly deserve unless people know about it.

The same is true with your photography studio. You might be the most brilliant photographer ever to come along. Your portraits could be almost three-dimensional, your advertising photographs make products totally irresistible, and your wedding albums so moving that every couple you photograph immediately get a divorce just so they can have you provide them with additional albums when they remarry. But having such a talent does *not* mean your studio is going to succeed; some of the most skillful photographers go bankrupt at the same time their less creative competitors are becoming rich.

What makes the difference? Advertising and promotion! Unless people are made aware of your studio, they won't hire your services. And since no one cares about your success or failure as much as you do, you're the one who's going to have to mount a promotional campaign to ensure that your name and work are kept before the public eye.

There are two ways to promote your work. The best is through

"free" advertising—publicity gained for your work and your studio without your being charged a fee. The other approach is with paid advertising. Typically, this involves the advertisement you pay to place in newspapers or magazines, on radio and television. The effectiveness of paid advertising does not relate to the amount of money you spend, but rather to where and how you place your advertisement.

The Media for Promotion

Before we discuss special promotions and the way to design an advertisement, let's look at the media in general to see both what is effective and what costs are likely to be. Unless you understand where to place an advertisement you can't hope that that advertisement will result in new business.

Television

One of the most popular of all communications media is television, yet this is also the medium least utilized by photographers. When you consider the fact that television is a totally visual experience, it seems odd that more professionals haven't taken advantage of it.

There are two types of television stations through which you can advertise your work: the network stations and affiliates—ABC, NBC, and CBS—and the nonnetwork, commercial stations. The latter are often UHF stations; they are independently owned and operated but are profit-oriented. Nonnetwork, commercial stations should not be confused with educational stations, which are nonprofit and do not accept advertising in the traditional sense.

Most people think that prime time for television viewers is 7:00 to 10:00 in the evening. What they fail to realize is that prime time varies with the people you're trying to reach.

The daytime hours, normally considered "dead" time by many people, actually represent prime time for people who are home all day. Evenings are prime time for adult viewers, but if you're trying to reach children, the daytime hours are virtually useless for your advertising plans. Only Saturday morning finds children watching TV; the rest of the week they're in school.

Radio

Radio is quite a different matter. Prime time radio is commuting time, from 6:00 A.M. to 9:30 or 10:00 A.M., and from roughly 4:00 P.M. to 6:30 or 7:00 P.M. These are the hours that get the largest audiences of any period of the day. Generally, every member of the family is up early in the morning, eating breakfast and starting off to work or school. In the afternoon, many people listen to the radio while driving home from work, or relaxing after work or school, or preparing dinner. These two periods are the biggest times of the day; the evening hours do have a definite audience, but their numbers are much smaller.

The most loyal audience in radio, though certainly a minority among listeners, are those who turn on their sets between midnight and 6:00 A.M. Insomniacs, the sick, night workers, and others who are up during such hours use the radio for companionship. In most cases they listen intensely rather than just using the set for background sound. Advertising rates are also lowest during this time, so late-night radio can be a good buy if you can determine that the listeners are likely to be photography customers.

An interesting fact about radio is that the average listening time during the morning and evening rush hour periods is about twenty minutes, whereas television viewers may spend one to three hours or more staring at the tube. The short listening span during radio's prime time means that an advertisement repeated frequently constantly reaches a new audience. Instead of saturating the same people, as you would if your spot appeared every half-hour or hour on television, you reach more and more people every time your ad is played on radio.

Newspapers

Newspapers represent another area for promotion. Consider carefully the different parts of the newspaper in which you can appear and the different types of newspapers to consider. Generally the most expensive advertisements are those placed in daily newspapers. Advertising charges are based on circulation, and the dailies are usually the largest papers serving a given area.

Just placing an advertisement in a newspaper, regardless of

size, is no guarantee of final results. The number of readers for any given page will vary. Most important to you, this variance is often predictable.

The front page of a newspaper is always well-read. Unfortunately, few, if any, dailies allow advertising on their front pages. The television listing page is perhaps the best-read part of the newspaper; almost everyone turns to that particular page regardless of other interests. An advertisement near the radio and television listings will be well-read.

The sports section is well-read, too, and not just by men. However, it has a limited audience compared with those reading the radio and television listings. The comic pages represent another good location. A cross section of people read the comics, so an advertisement placed there will again reach almost everyone.

Depending on the paper, certain features will prove popular. A consumer-oriented "Action"-type column ("Action Line," "Action Please," and other titles of this type) is often quite popular. However, even a feature that's popular can have its audience limited by how it's positioned in the newspaper. A feature must be located in the same spot in the same section, day in and day out, to develop a large following. Many people refuse to thumb through the pages looking for a feature; they either stop reading it or read it only occasionally when they can't automatically turn to the same spot each day to find it. This sounds ridiculous, but according to newspaper reader studies, it's true.

The advertising director of any daily newspaper can give you specific information about the popularity of the features it carries. Reader polls are conducted regularly, and information from them is available for advertisers.

The classified section is the cheapest type of newspaper advertising, but I'm not convinced that it represents money well spent. There are people who read the classified advertisements religiously—some read everything listed; others look for certain product headings (such as "Photographic Equipment," "Office Supplies," or "Jewelry"); still others are addicted to the "Personal" section, where almost any message, divorce item, love note, or plea for help is liable to appear. The question remains as

to whether these readers actually patronize the businesses that advertise there.

If you want to try the classified section, take advertisements in two or three places. One advertisement might go into a "Services" section, another listed under "Personal," and a third under "Photography." The latter is of questionable value, however. If you have a few responses, I'll be surprised, but delighted by your good fortune. And if you have a poor response, you'll probably have lost less than $10.

The day of the week on which your classified advertisement appears can be critical. If you select just one day for your advertisement, choose Sunday's paper. This is the best-read newspaper of the week; people often sit down and read everything, page by page, including most of the advertisements.

The worst day to place a classified ad is Saturday afternoon. People on their way to parties, dinner out, a movie, bowling, or other entertainment give Saturday afternoon's paper a cursory glance, then discard it.

The alternative to advertising on Sunday only is to take a full week of advertisements. This costs considerably less than buying space on a per-day basis, but is costlier than just Sunday. However, daily ads do reach everyone who's likely to look at the classifieds.

Weeklies. Weekly newspapers are often called "shoppers." Many of these are started in the suburbs of large cities. Their purpose is to sell advertising space to the small businesses that don't have the budget for the more expensive dailies. Shoppers' news items are minimal, and their staffs are small. Often the editor is also the reporter, photographer, and layout man all rolled into one. What news does appear is of strictly local interest, like the story about Mary-Beth Farquar, who is playing a radish in the Benedict Arnold Elementary School's Third Grade play. People read the shoppers for news about themselves and their friends; these papers have the space for all the trivial matters dailies ignore—lodge awards, bowling league winners, and the like all have their day.

Are shopper advertisements well read? The publishers think they are, and they often manage to retain advertisers for many

years. Certainly a trial advertisement in such a newspaper is worth a portrait and/or wedding photographer's money.

In smaller communities you'll occasionally find papers appearing from one to three times a week that really are newspapers. These are community-oriented but contain syndicated features and national news wrap-ups. They supplement the coverage of a daily newspaper located so far away that the editors ignore the community served by the weekly. Such papers often go daily as soon as the community's population can support the endeavor. The advertisements placed in them are well-read and inexpensive, at least while they're growing.

School Pages. A third type of newspaper is often overlooked by studio owners: the high school or college paper published by the students throughout the school year. These papers are meant to give the students a taste of journalism, and are avidly read by their classmates. Advertising space can be bought in them for surprisingly little money.

Wedding photographers are naturals for advertising in college papers, because many students marry while in school or immediately after their schooling is completed, and if your advertisements are eye-catching and interesting, your name will be in their minds. Since it's usually the bride and groom who decide the wedding photographer, their familiarity with your name is more important then being in media that will be viewed only by their parents.

Some high school newspapers are appropriate places for wedding photography ads. High schools can be vocationally oriented or college preparatory; in the latter instance the students almost always go on to college, postponing marriage for from two to four years or more. However, the students in a vocationally oriented high school get jobs after graduation, with only a handful seeking college entrance. Many vocational high school students are engaged in their senior year, and your advertisements will prove most effective in reaching them.

How can you tell which way a high school is oriented? Ask the principal or the superintendent. Such information is not confidential, and will be readily released.

Portrait photography can also be sold through student news-

papers, but it's more difficult to sell than wedding services. You'll have to come up with some gimmicks to convince the students to part with what little money they have.

Magazines

Magazines are an increasingly popular way to advertise photographic services. Major magazines with national and international circulation often offer regional advertising space at reduced cost; these advertisements appear only in a limited area. Unfortunately, this limited area often means one or more states, far too wide a territory for a photography studio to care about.

Another type of magazine is the regional publication. This might be put out by a state, as are *Arizona Highways* and *New Mexico*. Or they might be for a city, like *New York, Chicago, Cleveland, Atlanta, Philadelphia, San Francisco,* and others. City magazines rank the highest in terms of return for money spent. They tend to be purchased by the more affluent members of a community, and almost all their readers of your city's magazine live close enough to your studio to be potential customers.

The last type of magazine you may be interested in is the trade journal. This is a publication prepared for a business or industry. For example, in our field of photography there are well-known national publications, like *Popular Photography* and *Modern Photography.* But there are also trade journals sold to professional photographers. These are not found on the newsstands, and their circulation is naturally limited. One is *Rangefinder* magazine, which deals with the business practices and problems of the professional studio. Companies offering products or services aimed for the professional photographer know they have a solid market in such publications.

If you specialize in a type of photography that could be used by the readers of a trade journal, it might pay you to consider advertising in it. Check your local library for the *Gebbie Directory of House Organs,* the annual *Writer's Market,* and other reference books listing the numerous trade journals. Make note of the ones that relate to your work and query them about obtaining a copy of the publication and a list of advertising rates.

Trade journals are, for the most part, national. This means

that if your studio is advertised, you must be willing to travel. Since many companies hire only local photographers, there's a definite question as to how valuable such ads are. It's wise to investigate trade journals, but think carefully before committing much money to advertising in them.

No-Cost Promotion

Before exploring the many approaches to paid advertising, let's look at some possible ways for you to promote yourself without cost. Self-promotion is limited only by your imagination. Anything you can do to come to the public's attention in a manner that enhances your reputation (sticking-up a bank is definitely out!) and that doesn't drain your pocketbook is extremely beneficial.

Exhibits

The Window Display. The simplest method for gaining free publicity is through the exhibition of your work. One display area is your studio window, if you're a portrait and/or wedding photographer. This is where you have your opportunity to entice passersby inside.

What should be in your window? Primarily, there should be a constantly changing display of photographs showing the full range of your skills. This means portraits, wedding photographs, perhaps some scenics, unusual industrial prints, and so on. These prints should be in a range of sizes, starting with 8 × 10 and going up to 20 × 24 or larger if you have something appropriate.

The bulk of the photographs should be of your studio's specialty. If you're promoting your portrait work, display head studies, full figure work, and, if you do location work, some photographs taken outdoors. Use pictures of young and old men and women, children, family groups, and, if you do them, pet photographs.

Always select the most attractive people you've recorded for use in your window displays. Using plain or homely people for display will work against you. Someone stopping to look into

your window won't know if the unattractive person on display was really unattractive or if you're just not a good photographer. Certainly he or she won't spend money to find out what your skills are like.

If you have photographs of different racial and national types, these should also be displayed. Many times minority group customers hesitate to use a photographer whose window display shows only white subjects. The customer feels, often with reason, that the photographer won't be able to handle his skin tones effectively. The broader the range of people you display, the more customers you'll find coming inside to arrange for sittings.

Will you offer custom framing? If so, your display prints should be framed in a variety of styles covering different price ranges. Be certain you can remove the prints from the frames without much difficulty, though. When you place new photographs on display you'll want to use the same frames. If you have to custom-frame each new display, the cost will be prohibitive.

The wedding photographs you display should show each type of style you take. For example, use some straight photographs of bridal couples at the altar. Then add some "misties," some multiple-image prints and some overlays with the couple in the midst of their favorite song, a heart, and so forth. Display both what you can do with the camera and what your lab can do in the darkroom. Couples might be turned off by any single approach you could display; by showing the full range of styles you can offer, they're more likely to consider you for their wedding.

Scenic photographs, action photographs of sports, racing, rodeos, and other events, or anything else you might take for pleasure should be on display as well. These prints can often be sold "as is" to customers who want to decorate the walls of their homes or offices. However, limit the space you give them. They'll be a minor part of your sales, and the prints may only prove to be attention-getters.

Unusual industrial, advertising, and public relations photographs should form another minor section of the window display, if you handle any of these specialties. Business people passing by won't stop in and hire you based on one or two prints

in your window. However, if the work catches their attention, your prints and the name of your studio will stay in the backs of their minds. When you eventually approach them about handling their business photography needs, your name will trigger their memories. They'll think of you as someone who's well-known even if they've never heard of you except when they passed your studio window. You'll be more likely to take their assignments.

I once had a display of photographs that was seen by the account executive for a public relations firm. He was apparently impressed with the work, for when I went after his business, quite by chance, he was delighted to see me. "I've heard all about you," he said. "You're one of the best in the city. How come you haven't been around here before?"

When I got to know the executive better, and when he was thoroughly sold on the way I handled his accounts, I asked him where he'd heard of me. As we got to talking, it became obvious that he had never heard my name mentioned by other businessmen. He'd seen my photographic display and my name had stuck in his mind. He admitted that had he realized it was the display he was remembering and not an endorsement from someone who had used me, he wouldn't have been so anxious to try my services.

Your window display should be changed regularly. I believe in placing new prints on display at least once a month, and every two weeks is better. Of course, the volume of business you handle your first year will be the determining factor of how often you can change the display.

Window displays should also be used for seasonal promotions. Whenever you plan to have a special for Easter, Mother's Day, Christmas, Valentine's Day, and so on, the window should let the public know about it. Such displays should be put up from four to six weeks in advance of the event to give people time to convince themselves that a portrait is a good idea for a gift. But even when you have a theme for your window, keep changing those display prints. You want to draw people to your window again and again rather than have them give a cursory glance, note that it's the same old display, and walk on.

Shopping Mall Exhibits. If your studio is in or near a shopping mall, see if you can convince the management to let you display your prints there. You may find that your personal work is rather limited in scope and that the management doesn't feel it would be a crowd-pleaser. When this happens, see if you can get together with other professionals in your area and mount a joint exhibit. Thus, when one studio specializes in portraits, another in weddings, another in industrial advertising, and so on, the sum of their work covers the complete scope of professional photography. A joint exhibit like this is certain to draw a crowd, and you'll have no trouble getting permission for the display.

To get the greatest mileage from a joint display, each professional participating should be given his own display space, so that people viewing the prints are confronted with several examples of one person's work, then move on to see someone else's photographs. This enables the viewer to study each photographer's style, and will more firmly implant the photographer's name in their minds. The alternative, a random grouping of all the work, is visually exciting, but it doesn't help any of you. Passersby won't be able to keep track of which prints are by which photographers.

Shop Displays. Where else can you display your work? If you're a bridal photographer, jewelry stores, specialty gift shops, and similar places are naturals. Mount a range of pictures, in sizes from 5×7 to 11×14 or, occasionally, 16×20, on the store walls. The display serves a double purpose: first, it draws people into the store when they might otherwise have just glanced into the display window and moved on. Second, it sells them on using you for their photographer without your ever having to contact them. Some stores might even be willing to place a sample wedding album on a counter for customers to thumb through.

Talk with the managers of jewelry stores and similar establishments to see if they'd be interested in providing you with wall display space. If their walls are such that mounting an exhibit would not be possible, see if they could use some small wedding photographs as part of their window jewelry display. Naturally, a

studio credit notation should be placed wherever the work is shown.

Commercial Displays. Photographs of businesses and industries can often be displayed in bank lobbies. More and more banks are devoting space to art exhibitions, and you may be able to be a part of one. Banks might also be interested in your personal photos of scenics and other subjects unrelated to business. However, it does you more good to have at least a majority of the displayed prints relate to your normal studio assignments.

Talk with interior designers about your work. An increasing number are recognizing the impact photographs can have on home and business walls. If your work fits what they view to be their clients' taste, they may buy from you.

Also approach furniture stores. Those with sample rooms could just as easily place photographs on the walls as the art prints and paintings they often use.

There are other businesses where your work can be displayed. Just be certain you pick a location where people are liable to spend money on photographs. A display in a camera shop, for instance, would probably be of little value. Its customers, though generally somewhat affluent, would not go to your studio if they liked your work. Instead, they'd study your prints and try to learn from them. Then they'd photograph friends and family members, attempting to duplicate your techniques.

Restaurants. Restaurants represent another source for promotion. Established restaurants may be quite satisfied with the wall displays they've been using, but when you start photographing new businesses, you'll have an in when it comes to determining the decorations to be used. Show the owners some general-interest photographs in various sizes to see if you can convince them to display your work.

With restaurants there are three ways to work. The first is to use "pretty" pictures, which are made available for sale to the customers. A business card is placed in the corner of each frame, along with a price for the print. The display is mounted at your

expense, and the restaurant is just a vehicle for promoting your sales.

A similar situation occurs if you have a constantly changing wall display. You might have twenty prints on the walls, up for a month or so and then replaced with twenty more. You may or may not offer them for sale, but your name should be attached.

The last approach is to sell the restaurant photographs for wall decorations. These might be fairly small framed prints behind glare-free glass, or they might be huge wall displays. A restaurant near my home uses prints as large as 30 × 40 for an effective color display. One photograph shows a motorcycle racer turning a corner, another a sailboat moving into the wind. Every one catches the eye. The only problem with the photographs, from my point of view, is the fact that the photographer's name is not apparent. However, I'm certain he or she was well compensated for the work.

Professional Offices. Doctors' offices are often overlooked areas for additional promotion. If you specialize in the photography of infants and children, or if you take such photographs as part of your work day, you have a potential display for a pediatrician's office. Take a few prints and make the rounds of pediatricians in your area. Show the photographs to the receptionist and ask if there would be a time when you could show them to the doctor. Explain that you would like to mount a few framed prints on the wall, perhaps changing them every six months so the patients could enjoy them. Make it clear that there is no charge to the doctor and that all you expect is to be allowed to place your name, address, and telephone number with the prints.

To locate pediatricians, check the Yellow Pages under Physicians, both for M.D.s and for D.O.s (osteopaths). Their specialty is listed below their names. Check for both pediatricians and those involved in "family medicine."

If you photograph pets, veterinarians may be interested in putting your work on their walls. Two approaches can be used when selecting prints for this type of display. The first is to use photographs of pedigreed animals shown in stately poses; all the important physical characteristics of the breed should be obvi-

ous. The second approach to pet displays is to present appealing and amusing photographs of pets, alone and with their people. You might show some kittens at play, or children cuddling a dog. Just make certain that the pet is the most prominent part of the photograph.

People tend to take their animals to vets with less frequency than they take their children to pediatricians. You can probably get away with changing the display on an annual basis if you don't regularly handle enough pet photography to constantly mount new displays. However, for the sake of the staff, it would be nice to change the prints every three to six months, or you may find yourself sharing wall space with another photographer.

Local Programs

If you feel that you're fairly articulate, it's possible that you can appear on radio and television. All stations do a certain amount of local programming. There might be an interview segment of a half-hour local TV news program, a daytime local women's program, or a local talk show. Radio stations regularly have special features relating to the community. People of local prominence or with something interesting to say appear on such programs, and you can be one of them.

How do you get on the air? Figure out some topics that might interest the public and then see the Program Director of the radio or television station you feel might be receptive. Just be certain you check their newspaper listings to be certain they originate programs where you can appear. An all-music radio station, for example, will use almost no interview material during the course of the day. What little local programming is done is generally produced only because the government requires community service material. However, it's buried in times when the audience is minimal.

Topics of Interest. What topics would appeal to the general public? Around May and November, think about weddings, because June and December are traditionally high marriage months. Perhaps you could talk about "How to Save Money on

Wedding Photography," or "What's New in Wedding Photography." The former might discuss having a black-and-white album taken with color film so it can be upgraded later. Or it might mention planning the photographer's time so there are no idle periods for which charges must be made. You decide on the specifics of the subject.

As to "What's New in Wedding Photography," you might discuss sight-and-sound wedding albums, or movies and video-tape-recorded weddings. You might even mention three-dimensional wedding pictures taken with stereo equipment. Just be sure that whatever you mention you can provide for anyone who wants something different. When you talk about a service, the public looks on you as the expert on that service—they expect you to be able to do whatever you mention, and they won't deal with you if they find that you can't.

Question-and Answer Programs. With radio you might go so far as to set yourself up as the local professional photography expert. If there's a phone-in program on which the guest is expected to answer questions called in by listeners, you can be the expert on photography. People will ask questions about everything from how to best utilize a portrait studio to "Why did my roll of film come out blank?"

Paid Advertising
Paid advertising is a rather tricky matter. What you say and how you say it will determine who responds.

Television
Television advertising is a field that's long been untapped by professional photographers. The types of stations have already been discussed but there are some facts you should know.

First, television advertising salesmen will do anything to make a sale. Radio advertising men are the same way, but you can make less of a fool of yourself on the radio because no one can see you doing it.

When I say the ad men will do anything to make a sale, I don't mean they'll ply you with liquor and members of the opposite

sex. Nor will you be subject to blackmail, extortion, or having your spouse kidnapped and held for ransom. What I do mean is that they will encourage you to advertise in any way that will help them make the sale. They'll offer to write copy for you so you can avoid an agency's fee, for example. Most advertising salespeople are hack writers at best, so these offers are of questionable value.

Personal Appearances. Perhaps you'll be hesitant to advertise because you can't afford the services of a professional announcer. No problem, the ad men will tell you. Your magnificent voice, charismatic appearance, and handsome or beautiful body will sell your studio for you.

How many times have you turned on the television and seen a stiff, almost terrified figure talking about his carpet showroom, furniture dealership, or appliance store? The person looks foolish, has little life as he reads the teleprompter, and generally does a rotten job of trying to convince you to come to the store. Car dealers can get especially silly, and they're always encouraged by the ad salespeople.

"We play on their egos," one television advertising salesman told me. "Businessmen are flattered to think that they can do their own announcing. They know they're also saving the price of a professional, so that's an added incentive. No matter how big a fool a person appears, the moment someone comes into the store saying, 'Didn't I see you on television?' the guy is hooked and will buy air time again and again."

Looking foolish may help some businesses gain customers, but a professional photographer has an image of dignity and skill to maintain. People must trust your creative and artistic ability. You'll be taking permanent records of precious moments in their families' lives, and they want to be able to respect you.

Also, consider the realities of your career. How long has it taken you to become a professional photographer? I started with a simple box-type camera and began taking rotten pictures. I asked dealers questions, read books and magazines, and gradually improved. I took advanced training in college and with a photography school, all the time reading on my own, experimenting, and selling more and more work. It took me roughly

fifteen years before I was ready to really go on my own, and I consider myself still learning despite the time I've spent as a working professional. And I will venture that everyone reading this book has a similar story.

The same principle holds true with other fields. Professional announcers and commercial actors spend years developing skill, poise, and ability in their fields. You can't just walk in front of a camera or microphone and expect to sound polished or professional. You're going to sound like somebody trying to save a buck on advertising.

This is also true with advertising copy. Neither you nor the ad salesman is likely to be a professional writer. Even if you do write, you aren't likely to have written for advertising agencies. You won't be certain what to say and how to say it so your ad has greatest impact. You'll probably sound either dull or pompous, and neither image is good for your studio.

The answer is to not let yourself be used or abused by salespeople. Don't even go so far as to try a test commercial in front of the studio's cameras. Occasionally a salesman will arrange for you to make a "screen test": you make your speech and the momentous occasion is videotaped, then you get to watch your magnificent performance on a large studio monitor. Unfortunately, in the majority of cases that little touch of show business puts blinders on your brain. When you see yourself on the screen you're likely to be ignorant of what's being said and how it really appears. All you know is that there you are on television, and if you sign on the dotted line the whole world will get to see you. You'll be a star! Next comes Hollywood, fame, fortune . . . ah, Fantasyland!

TV Rates. When you're ready to advertise on television, find out the rates for different times of the day when you feel the people you're trying to reach will be watching. Then check with a few ad agencies to find out what it will cost for them to produce a simple advertisement with a professional delivering your message and a few samples of your prints being shown on the screen. If the price of one seems reasonable and you feel you want to go that route, by all means buy air time and see what happens. But if you

don't feel the price fits your budget, it's better to advertise elsewhere than to do it yourself.

Radio

Radio is a far better medium than television for your advertising. It's cheaper than all but the least expensive nonnetwork commercial TV stations, and the audiences are often more responsive. Production costs are also lower because all you need are trained voices—no props and no acting.

Radio ad rates are set according to the ratings of the station. Although it might seem that the number one station would be the best place to advertise, this is not necessarily the case. In most cities the top spot is held by a rock-and-roll station that caters to the teen market. This might be great for wedding portraits and special teen promotions, but it's the wrong place to advertise if you want to convince Grandma and Grandad to have their portraits taken.

AM radio reaches the largest audience but FM radio reaches the wealthiest. Almost anyone can scrape together three or four dollars for a tinny transistor radio, but FM sets have been more expensive in the past. At this writing plans are being made to force radio manufacturers to make all sets capable of receiving both AM and FM, and when that occurs, both systems will have a wide range of listeners.

When you go with FM radio there are generally four types of stations found in a community: a classical music station or a specialty station that features segments of the classics, segments of jazz, and perhaps segments of folk music from the 1960s; a station that provides "background music," soft sounds people hear without listening to; a third type featuring progressive rock music, generally offering "far-out" music and obscure singers who may or may not appeal to an AM audience; and, increasingly popular, a station featuring country-western music. Each has its own distinct audience, so buy time from a station not so much because of its price or its rating but because it reaches people who might want the service you offer.

Radio advertising copy is crucial. On television a slightly weak announcement can be offset by a display of quality photographs,

but with radio only words can be used to convince people to use your visual services. When your advertisement is prepared, be certain you feel satisfied that it will draw a response before accepting it.

How long should your ad be? Thirty seconds is minimal, though more information than you might imagine can be squeezed into that amount of time. However, thirty seconds isn't as good a radio ad as a full minute. Have copy prepared to fit both time periods and decide which seems more effective to you.

Newspapers and Magazines

Newspaper and magazine advertising space must be reasonably large and carefully planned. In addition, it's best to include a photograph as an integral part of the advertisement unless you're exclusively in the classifieds. A photography studio that doesn't run an attention-getting photograph is not one I would patronize. After all, if the photographer isn't proud enough of his products to show one off, why risk trying his skills?

The type of print you provide the newspaper is critical to the success of your advertisement. Newspaper reproduction again, is notoriously poor, though the method used and the skills of the printers will determine which contrast is best for you to submit.

Before giving a print to the paper you'll be advertising in, visit the paper's photography department. Ask the head of the department to show you the type of print that they have found will reproduce well. Be certain to call ahead for an appointment so he can spend some time with you.

Newspaper and magazine advertising should be simple and should have the least number of words possible to get your message across. Your studio's name, address, and telephone number must always be included, as should whatever special you're advertising. Some photographers just use a family photograph and the words "Family photography by . . ." or a portrait photograph and the words "Portrait photography by" Others have more elaborate ads, and include coupon offerings.

You can probably produce your own advertisement, using the publication's art department to guide you on layout. Or you might turn to its advertising department or to a separate agency for help. The choice isn't as critical as with radio and television.

What to Advertise

Now that you know where to advertise, the question arises as to what to advertise. You need promotions that draw business yet assure high profits.

Special Promotions

One possible approach is to give a free print when a sitting is arranged for a special day. For example, you might offer a free 8 × 10 color portrait of mother when a family has a group portrait taken for Mother's Day. The family must pay the standard sitting fee as well as buying a group portrait in order to get the free print. Generally they'll buy so many additional photographs that you make only slightly less than you would if you received full price for everything.

How about a Honeymoon Special with every deluxe wedding album sold? What the deluxe package might be is for you to decide. However, it should be considerably more expensive and more elaborate than your lower-priced albums; it might involve forty or fifty 11 × 14 prints, for example. However you work it, it must be a reasonably high-priced coverage plan.

When a couple chooses the Honeymoon Special, offer them not only the deluxe coverage but also, at no extra cost, a smaller, blank "honeymoon album" and a small, inexpensive camera to use when photographing their own memories. You can buy these cameras cheaply, perhaps purchasing five or ten at a time from whatever dealer will give you the best price. A flash attachment, a roll of film, and a package of flash cubes should be part of the gift.

What the couple never knows is that you've marked up the price of the deluxe wedding to include the cost of the Honeymoon Special. When running this promotion, don't offer a deluxe wedding package without the "free" camera. You don't want your clients comparing prices.

Special Services

Do you own or can you rent a stereo camera? Try offering stereo wedding coverage in addition to traditional work. You can have an assistant working with you if both the stereo slides and regular prints are desired.

What about movies or videotape? If you're equipped with either type of equipment this is another element of service you can add for a promotion. Few couples want to have their weddings recorded in that manner; they don't want to be bothered obtaining the equipment necessary to view the film. However, the fact that you offer it implies that you're an ultra-progressive photographer who uses all the latest techniques.

Special Approaches

Try coupon specials in the newspaper. A coupon might enable a customer to obtain a free 8 × 10 or a dozen wallet-sized prints, or whatever else you want to offer, when he comes for a portrait sitting at regular cost.

What about eliminating your sitting fee for certain portraits for a four-week special? You might offer the customer a chance to have a framed 16 × 20 color portrait for the price you'd normally charge for the framed print alone, with sitting fee eliminated. Of course, the framed print being sold might still cost the customer $100 or more. The elimination of the sitting fee is just an added incentive.

Why not buy a button maker that will enable you to attach a photograph to a button or badge you can pin on a shirt, blouse, or wallet? Present a window display encouraging people to drop in and have a button made while they wait. You or an assistant can use Polaroid fim to make a quick picture, then attach it to the button, for just $2 or whatever figure is slightly above your cost. While people are in your studio, of course, encourage them to try your regular services.

The button gimmick can be expanded in other ways. You can now buy a liquid emulsion that adheres to anything, as well as photo linen and similar devices. You could offer special gifts of photographs on polished wood, T-shirts, jewelry, and so on. These might involve a considerable markup, as in the case of photographs on wood, since you're selling them as unique gifts.

Advertising Methods

Be careful how you present your studio in your advertising. Don't call yourself the "world's greatest photographer" even if

you think you are; superlatives lose more sales than they win. People simply don't believe them. Wouldn't you be more likely to patronize someone who advertises "quality work, tastefully framed at reasonable rates" than you would someone who claims the finest work at the lowest prices in town?

Keep in mind that *quality* work always sells. Be honest in your advertising. Stress the fact that you aren't the lowest-priced photographer in town but make it clear that your rates are based on the quality of the work you offer: you never compromise quality to make a sale at a lower price.

Display Ads

Your studio is represented by the photography you select to display in your advertising. Assuming you can get quality reproduction in your local newspapers, plan a regularly changing campaign to acquaint potential customers with what you can do.

Do you handle wedding special effects? Then run an example, along with a small but visible statement mentioning that weddings and portraits are handled by your studio. Just the studio name, address, and telephone number should be used; let the fairly large photograph speak for itself.

You might have a composite photograph one week, a wedding portrait with a wedding song overlay another week, and even a misty the third week. Special portrait styles could be run other weeks, perhaps children's photos during yet another period. Remember that words don't sell a photography studio, and that technical terms like "composite" may not be understood by the general public. Let your pictures do your talking.

Follow-Up Mail Promotions

Most photography stores stock or can order sensitized postcards on which you can print photographs. These make perfect promotion vehicles for your current customers, as well as for advertising and public relations agencies.

Start with wedding customers. When you have portrait promotions, you can print a high-quality portrait on one side of the card and type news of the promotion on the other side of the card. On wedding anniversaries, send the wedding couples and

their families cards with pictures from their weddings. The cards should mention that it might be the ideal time to increase their wedding albums or to upgrade from black-and-white to color, depending on the circumstances of the original order.

When you take an unusual photograph for an advertising account or a public relations firm, make a print on the postcard and send the cards to agencies whose business you're trying to land or increase. The card should just mention your studio's name, address, and telephone number. This is a simple yet visually effective reminder that will keep your name constantly in front of the public.

Some photographers like to have examples of their work printed on their stationery. This can be an excellent idea, providing your printer does quality work. However, be certain you don't try to cut costs with such an approach. Insist on not only the highest-quality printing but also the finest paper. Paper is expensive, and it might seem to be an area where you could cut costs, but avoid the temptation. Cheap paper prints poorly, regardless of the technique used. You want your studio image to be quality all the way.

Brochures

What about brochures? With some of your best photographs and a little promotional copy about your studio, have a commercial artist lay out a brochure for your present and prospective clients. This can cover the full range of your studio's services or you can have two brochures made. In the latter case, one brochure might talk about your wedding and portrait photography and a second brochure cover advertising and public relations. Brochures can be either two-sided or four-sided, but they should be 8½ × 11 or slightly smaller, so they can fit in a standard letter-size file folder. "If it doesn't fit in a file folder, I throw it away!" an account executive once told me. "I can't be bothered with something cluttering up my desk."

Should your brochure be in color? Eventually, yes. Color has greater impact when properly laid out. However, it is also very costly to print, and strong black-and-white work will suffice while you're building accounts.

Advertising is essential for business, but you can't let it drain all your profits. There will always be a compromise between the amount of advertising you'd like to do and the quantity you can realistically afford.

Who gets your brochures? With weddings and portrait sittings it can be potential clients you seek or who drop by your studio. Many newspapers print the names and addresses of couples who have applied for marriage licenses. Send them your brochures, following up with a telephone call a few days later.

Agency Mailings

Advertising and public relations agency mailings should be planned carefully. You'll need specific names within an agency so you can send each brochure to a specific individual in a firm. Otherwise it will go to whoever opens the mail—a person who may or may not pass it on to the appropriate party.

With agency promotions it's wise to send a letter to accompany the brochure, with the letter going into a little more depth. Follow the first letter with another, again with the brochure, with a third letter and a fourth. You might go for regular weekly mailings to imprint your studio's name in the minds of potential buyers. The brochure remains the same, but the personal letter should be different each time.

Some photographers send business reply cards with their letter and brochures. The cards have boxes to check next to statements like: "Our photographic needs are currently being met most satisfactorily but we will keep you in mind for the future." "Please call us for an appointment" (Be certain to leave a space for the agency and account executive's name or you won't know who wants to see you.). "You dunderhead, you couldn't fill our needs in a million years."—and other appropriate notations. Include one or more items to be checked, keeping them serious or lighthearted, depending on the image you're trying to convey.

Always keep in mind that ad agencies and public relations firms aren't innovative when it comes to having their photography done. They need to give their clients top quality service to keep them as accounts, and whatever photographer is used must be fast, efficient, and high-quality. If he or she doesn't do

fast, good work, the agency can't complete a project when or as well as promised, and the client will go elsewhere for future work. This means an agency is very reluctant to go with an untried photographer for even the smallest assignment.

Promotional Campaigns

You have to be persistent if you're going to go after new business. You must keep yourself constantly before potential clients. You want to be repeatedly on their minds so that one day they'll give you a break and try you for an assignment. Perhaps it will be when their regular photographers are busy, or perhaps because they were impressed with the way you looked for business. Whatever the reason they decide to try you, it will only be because you managed to keep yourself constantly on their minds.

Referral Bonuses

Your satisfied customers can be your best advertisements. Why not start a promotion campaign to get people talking about your studio? Offer current portrait customers a bonus for each new customer they get to come for a sitting.

For example, if one of your customers brings in someone new to have a portrait taken, the previous customer might receive a dozen wallet-sized prints for the effort. Or if a bridal couple brings in an engaged couple who hires you to do the wedding, the bonus might be an 8 × 10 or an 11 × 14 color wedding print. In effect, this creates an upside-down pyramid that starts with one satisfied customer and begins building from there.

The specific bonus you offer should depend on what you can realistically afford. You need to maintain a high profit margin, so keep it simple but appealing.

How you arrange the referral is also a matter of personal taste and judgement. You might prepare referral cards to give to each customer. These can be specially printed for the job, with space for the customer to write his or her name next to the new client's name. Or you might do something as simple as providing a handful of business cards and telling the customers to sign their names and addresses on the backs when giving them to friends. When a business card is presented to you by a new customer, the

person whose name and address is on the reverse receives the bonus. Naturally, all new customers should receive the same opportunity.

Period Pictures

The nostalgia craze has hit photography. Many studios offer tintypes and other early photographic processes in addition to their normal line. A few have gone so far as to have period costumes people can wear in a special corner of the studio for an unusual portrait in the style of their grandparents. Such promotions are fun and draw customers who might not otherwise be interested in your services.

Consider offering either early types of photographs, if you're a chemistry buff and don't mind formulating the developers, or photographs taken with clients in period costumes. Costume rental shops are one source for such clothing, but check Salvation Army, Goodwill, and other thrift stores for what you can find. If you or someone you know can sew, so much the better. You'll need top hats and other similar props as well.

There are two ways to go about offering such period pictures. One is to charge your normal sitting fee. This may seem practical in terms of your own income, but it might not be so popular with your customers. They look upon such novelties as requiring far less of your skill than standard portraits.

The better approach is to charge a small fee with minimal profit for this work. Use this as advertising, and count on these customers for staying to sign up for a more normal sitting. You might even be able to have an assistant do all the special photographs to free your time for the more profitable work that's your bread and butter.

Restoration Work

Do you do photographic restoration? Not only is restoration a good way to bring new customers to your studio, you might also be able to sell those customers on having a portrait taken in the same style as the one being restored. Custom-frame the restored portrait and the new portrait taken in the old period style so they can hang side by side on a wall.

Promotional Publications

Keep in mind that the appearance of every advertisement, brochure, and letter is of utmost importance. It reflects on the quality of your work and on your imagination, and also can work to grab the reader's attention. Working with a commercial artist is a help while you learn about layout and type; talk with printers and have them show you different styles of lettering and how they appear on a page. Of course, never get so involved with fancy lettering that you produce uninteresting copy.

Price Lists. Are you going to publish a price list? Then think about including information on it that relates to the sitting. This might include details on how to dress, what the sitting entails, when proofs are ready, whether proofs can be purchased, and so on. Put yourself in your customer's position and ask yourself what you might want to know. Then record the answers on the list.

Pamphlets. A second approach is to prepare a small pamphlet, complete with photographs, giving "Questions and Answers about Having Your Portrait Taken." You might go so far as to include such items as "Why is it so expensive?" and "Who cares how I look anyway?"

With the first question, you're countering the reluctance caused when someone has been saturated with the advertising of the "dollar-an-8 × 10" discount house photographers. Discuss the careful attention, the number of proofs, the different printing methods, the years of professionalism, and so on.

The second question can be answered by talking about how a personal or family portrait becomes a treasured heirloom. It adds dignity to the walls of one's home. You explain every reason you can think of—*except* the most important one. That's the fact that it puts money in your pocket!

Newsletters. If you're an advertising and public relations specialist, you might consider putting out a newsletter from time to time after you've established yourself in the business. The newsletter should be short—probably both sides of a single 8½ ×

11 sheet of paper—and should contain photographs. It can tell about unusual work you've handled recently, with appropriate illustrations, or even about new equipment to meet your clients' needs. For example, it might contain fish-eye photographs or super telephoto pictures, or it might even show the path of a bouncing ball as recorded in a darkened room with a rapidly repeating strobe and open-shuttered camera. Just be certain the illustrations relate in some way to your clients' needs.

A full-service studio can use the newsletter for other purposes. In addition to the approaches mentioned, the full-service studio can send a newsletter containing portraits, another newsletter showing some wedding photographs. These can be used to tell your clients that you offer a broader range of photography than they might otherwise know about. Let them know you're ready to help them with personal photographic needs in addition to serving their business or industry.

What Makes a Promotion Work

Advertising and personal promotion are essential parts of your business, and you can never have enough ideas in this field. One way to help stimulate your thinking for new methods to sell your studio is to study advertising for other businesses and products. These don't have to be in the photographic field. They can range from cigarette ads to promotions for upset stomach remedies.

Start with advertisements that reach out and grab your attention. What makes them visually exciting? Is it the size of the advertisement? Sometimes a large advertisement can have impact while a scaled-down version of the same ad loses its appeal.

Or is it the use of color? What about the text? Is there much writing or does the artwork do most of the talking?

Study the layout. Can you learn anything from the use of white space? the style of type utilized? the position on the page? Figure out exactly what you like and then think about how you can use that approach in your own advertising.

Next study those advertisements you know you'd overlook. What is it about them that fails to attract your attention? Are they crowded? Do they need a touch of color? Does the promotional copy sound phony, or, worse, exaggerated to the point of dis-

honesty? Remember the warning about superlatives. Give the facts about your studio, stressing strong points but never claiming to be the best, the greatest, or whatever.

Planning

A photographer must plan advertising campaigns well in advance of when they're going to be put into effect. One way to do this is to obtain a large calendar with plenty of room to write on it. This must show at least three months at a glance and should have important dates listed on it. You must have advance warning of Mother's Day, Father's Day, Easter, Christmas, and other holidays.

Next, make a list of the media you'll use for your advertising. Then find out what their advertising deadlines are. Perhaps the local newspaper wants advertising other than classified in it's offices two days before it's scheduled to run. A magazine might require a three-month lead time, a radio station might want twenty-four hours' notice. Keep the list next to the calendar or transfer it to a corner of the calendar. Always keep it handy.

Now plan when you want to have advertising campaigns and how you want to run them. For example, will you offer a Mother's Day portrait special as mentioned earlier? News of the event will have to be both in your display window and in newspaper advertising. You'll need text and photographs prepared in advance.

May and June are graduation months. Advertising could be included in school papers as well as other media. The same is true for wedding promotions in June and December.

Your campaigns should always consider both the lead time of the medium being utilized and the amount of advance notice someone needs when considering a photographer. A couple hires a photographer as much as two months before a wedding is scheduled to take place. A campaign that starts in the month when many weddings are taking place is ineffective.

Budgeting

Make plans for a wide variety of approaches even though when the time comes to buy space you may be short of funds. During

your first year of operation you can't predict your advertising budget because you can't predict your income. Certainly advertising will of necessity get a disproportionate share of your profit that first year. That's why you must always be able to operate for a full year without any profit before you take the plunge into full-time studio work. You must be able to eat from savings or a working spouse while you struggle to build your business.

After the first year, plan on setting aside a percentage of your profits for advertising and promotion. This might be anywhere from 2 percent to 10 percent, depending on your studio and its income. Once you have a percentage, though, you can begin working out a specific budget that's realistic for the money available. You may find you can go into more media than originally anticipated, or you may be forced to cut back to a limited area like newspaper advertising.

Professional Pride

Be proud of your studio in your advertising. Regardless of how you view yourself, your client must think that the way you do business means he's getting the most for his money.

For example, suppose you work from home, as so many professionals do. You should stress the fact that such work keeps overhead low without reducing your creativity and the quality of your photographs in any way. Give the implication that there might even be a savings in cost because of the way you work. Your client doesn't have to know that your rates are competitive with studios and that your profits are higher because your overhead is lower.

Are you working by yourself? Then consider stressing: "Every assignment gets my personal attention. Your work is my concern, so you know it will be the best possible. I handle every job regardless of size. Small accounts don't get pushed off onto an untrained assistant. They receive the same careful consideration as large orders."

Do you have a staff with at least one other photographer? Your advertising might stress: "We have a large staff waiting to serve your needs. Each photographer is a specialist who brings a unique approach to your assignment. While other studios may

have one man handling everything, we use only the best possible photographer for each job."

As you can see, each type of studio has its selling points. Some are a bit of blarney, I will admit. But all you're asking, in effect, is to be given a chance to prove your abilities. After that, your work will speak for itself.

No matter how your advertising is worded, there are times when the size of your studio can work against you if you aren't prepared. Since the way you fulfill an assignment will determine your future success, I mention it here though it isn't technically a matter of personal promotion.

Coping with Problems

If you're a one-person studio handling weddings, there's a chance that you'll wake up on the day of a wedding with the worst case of plague ever recorded—or at least a touch of the flu. Perhaps you can get out of bed, but it will only be with great difficulty and reluctance. If you could show up at the wedding, you would be neither creative nor effective. You also might cause the bridal couple to spend their honeymoon in separate beds—in the hospital. What to do?

You could call and tell everyone how sorry you are that you can't attend the wedding. The family would "understand." The parents would curse you to the relatives, who would curse you to their friends. The bridal couple would curse you to their friends, who would curse you to their friends, ad nauseum. You would not only lose the current business but also the business of anyone remotely related to anyone at the wedding.

Other fun things might happen. You could be brought to the attention of the Better Business Bureau in a less than favorable light. If there was an advance wedding contract signed for your protection, you could find yourself in legal trouble. Perhaps you could be sued for breach of contract. And what about the mental anguish caused the family by not having a professional to record the wedding? Obviously your studio could be closed down over-night, run out of business by a rightfully upset family.

If you're a one-person studio, you must make plans for what you can do should an important event arise that you can't handle

as planned. Generally this means having connections with two or more studios whose work you like. These should be larger, with more than one person capable of handling weddings and similar assignments that can't be put off. Two or more studios are necessary in case one studio has the staff occupied with its own rush problems.

How you work financial arrangements is a matter for negotiation. You might give the studio covering for you every penny you would have earned. Or you might take a small percentage of the profit for having given the other studio the chance to do the work.

If you're married, it would be wise to train your spouse to handle wedding work in case you become ill. Perhaps the work won't be as good as yours at first, but it will be of sufficient quality to prevent anyone from being upset with it. All you have to do is to take him or her with you on a few weddings, providing cross coverage until your spouse can work alone. Some couples find they want to always work together; others begin taking twice as many wedding bookings, each person covering a different event.

Promotion is one of the most important parts of your business. Plan it carefully and creatively and it will go a long way towards speeding you along the road to success.

13

School and Baby Photography

Two rather specialized areas of professional photography are the fields of baby photography and school photography (other than public relations assignments). Both areas are handled on location, but the specialized aspects of each of them may be such that you won't want to get involved when you're first going into business.

Baby Photography

Baby photography is frequently handled by national firms that contract with area photographers, giving them exclusive territories in different sections of a state. How they work varies from area to area, but this work should not be confused with children's portrait specialists.

The Hospital

The simplest type of baby photography is the photography of newborn infants in the hospital. Almost every hospital handling maternity cases tries to have each new baby photographed before the child goes home. Often this is done by the hospital's staff photographer or an assistant as part of the normal work. Whether the parents can buy prints and the amount of money, if

198

any, the photographer makes in addition to his or her salary is subject to administrative policy.

Some hospitals either lack a full-time photographer or have one who's so understaffed and overworked that there's only time for important medical assignments. Baby photography then takes on too low a priority to be handled on a regular basis.

When a hospital has no one routinely taking baby photographs, the staff often contracts with an area professional to handle this work. Sometimes the photographer or an assistant makes periodic trips to the hospital to photograph the babies, and for this he or she is paid a retainer. How the photographer earns that retainer varies, though. Sometimes it's meant to just cover time, with all expenses additional. Other times it pays for time, film, and perhaps one or two prints of each baby. In either case, additional print sale profits go to the photographer.

A second approach is for the hospital to make the new parents aware of the photographer's availability. If they want to have pictures taken of their child, the photographer is called over to handle the work. All fees are negotiated with the parents, and generally the work is handled in the same manner as location portraiture.

Equipment. Equipment for such work is rather basic. Almost any camera can be used, with one or two electronic flash units. Often a 70mm back is used on a 2¼ × 2¼ camera, as this provides a large number of exposures with a good-sized negative in a format that's easy to handle. However, I have known people who worked with 35mm and others who swore by 4 × 5.

This type of baby photography will certainly not make you rich. In fact, as you begin to obtain increasingly lucrative assignments, such work can become a nuisance. If you have an assistant who can be trained to do this type of photography, it might pay you to go after it. My feeling is that you should seek such assignments only when work is coming slowly and you feel you need the extra money it will supply.

Working with Companies
A second type of baby photography involves companies that

send salespeople into a community to contact parents of new-born infants. Birth announcements are public records and appear in many newspapers. The salespeople use the papers for their leads, something you can do on your own.

Company salespeople talk with the parents they contact about having a series of color 8 × 10 portraits taken of their new baby over a period of roughly four years. For a flat fee that's generally fairly low, often under $100, the parents get an album and perhaps a dozen prints, each to be taken three or four months after the previous one. Thus they'll have a continuous record of their child's growth during some of the most formative years.

When several parents in the same area commit themselves to this arrangement, the salesperson then finds a local photographer to handle the actual work in that community. There might be ten or twenty families who have purchased this service, so the opportunities for the photographer are seemingly quite good.

If the photographer is interested in the plan, he soon learns that there's a little more involved than he anticipated. First, the fee the family pays doesn't go to the photographer; it's split between the salesperson and the parent company. The photographer pays for the contracted prints out of his or her own pocket.

A raw deal, you say? Not according to the salesperson. You see, those photographs, according to the company, are just a come-on, a way of getting a foot into the family's door. Once the photographer has made the required portrait, the profits from any other work he can sell the family are all his. Since no family can resist buying several baby prints each time, as well as a family portrait or two, the photographer can become quite rich taking those "free" prints—or so the gullible photographer is supposed to believe.

First off, it's a bad idea to do any work for free. The time involved in going to the home, setting up the equipment, taking the photograph, and returning to your base of operations is extensive. It will probably mean at least an hour, and maybe two. Secondly, you have expenses for film, flash, transportation, and

the print, none of which are being met by the customer. This puts you rather far in the hole before you even have any idea whether the family wants additional pictures that could produce an overall profit for the session.

There's a great deal of pressure on a photographer handling this type of baby work, a feeling of urgency about making the sale. It's necessary to encourage the family to buy as many additional pictures as possible; the photographer tries to become a super salesperson and often ends up making himself obnoxious. Suddenly he is not only in debt but also held in disdain by people who could have been paying customers under other circumstances. Even worse is the fact that you're committed to do this work for a matter of years. It's not a one-time assignment.

The Independent Approach

Although it's obvious that such arrangements should be avoided at all costs, the original concept is so good that I feel it should be adapted by your studio. Instead of waiting for some company to contact parents of newborns, go out and do it yourself. Offer the same type of package arrangement, though for a realistic figure that allows adequate profit. If you prefer, you might make arrangements to do family portraits instead. The parents will hold the child until he or she is old enough to stand.

Explain to the family that a wide range of print sizes and custom-framed prints is available from the sitting. However, the flat fee covers only one 8 × 10 print for the album. Everything else is extra.

When a family commits themselves to such an arrangement, they're very likely to buy additional prints. They know what you're selling and they're interested in spending money in this manner. Your chances for additional sales are excellent, and even if you don't make any further sales, you get the full fee for your package, so you still come out with a profit.

Remember that it's important to find ways to get families into the picture-buying habit. Too many rely on snapshots and think of professional photography as something you use just for a wedding. When you get families thinking about having a profes-

sional record of their growing children, you'll have customers who will take advantage of your services at least once a year. And that type of business can be a major key to success.

School Photography

School photography is a specialized field that some photographers enjoy and others curse. It involves taking portraits of the children and/or classes, as well as prom photography and yearbook photography.

Almost every school has a photographer under contract to take portraits of children registered. Sometimes each child is photographed individually. When this approach is used, the photographer is given a space in the school where he can set up a stool, his camera, lights, and a simple backdrop. The children are taken from their classes one at a time, posed, and photographed. Usually less than five minutes is spent with each child, so it's important that you like children, quickly establish a rapport with them, and be able to evoke pleasant expressions from them.

Class photographs are a little more involved. Sometimes the photographer works in each classroom, setting up lights and camera and photographing the entire class at their desks. Usually a wide-angle lens and a large-format negative are used. Enlargements greater than 8 × 10 are seldom needed, only twice as large as a 4 × 5 negative. If a few children in the very front or the very back are slightly out of focus, the print won't make the fact obvious.

High schools have two other occasions to call in a professional. One is to handle yearbook photography. An increasing number of schools are either dropping the yearbook as being both expensive and no longer greatly desired by the students or are producing it internally, with student writers and editors planning layout and writing captions. But some high schools farm out their yearbook work to a professional to take photographs of the students and of some school activities during the year. Photographs are taken at different sporting events and dances, of classes, teachers, and the general staff. Special awards assemblies might also be photographed, as well as groupings of the

student clubs. Then the photographs are taken to a printer or someone else under contract to the school to put everything together in the proper form.

Other high schools handle everything internally except the senior class portraits. These are handled by a professional, who provides one print of each student for the yearbook and sells additional prints to the students and their parents.

Getting Hired

Arrangements to handle school photography are made through any one of several departments. Your best approach is to go to the Superintendent's office and get referred from there. He or she might hire you, or you could be hired by some other official or by the school board.

Officially, schools hire the lowest bidder for the job involved. Unofficially, a photographer may get the work for a number of other reasons, not the least of which is the providing of kickbacks to one or more of the people involved in the hiring. This kickback ranges from a flat fee to a percentage of the photographer's gross.

There is both a moral and a legal issue in the matter of kickbacks. Morally there's the question of whether or not you want to take business away from other photographers through underhanded sales methods involving, in effect, the drastic cutting of prices in order to pay bribes. I could never do it, and I hope the very idea will enrage you.

If your moral code is such that you could live with kickbacks, there is also the legal side to consider. I know of no city where kickbacks are legal. If local or state legislators somewhere have neglected to place a law against kickbacks on the books, you can bet that the first time such a practice is called to their attention a law will be passed. Not only will those soliciting the kickbacks be subject to prosecution, the photographer who has been paying them may also be hauled into court. At the very least he will probably be subpoenaed to testify, and his own reputation will be badly marred.

Should someone demand a kickback when you go after school business, either just don't deal with that school system again or

turn in the individual making the request. If it's one of the lower-echelon members of the system, go to the Superintendent of Schools or the head of the school board. If the person making the request is too important for that, then go to either your local district attorney's office or the state attorney general's office. Explain what happened and let them handle the matter. Photographers should never have to compete for business under such circumstances.

Your Costs, Your Profits

The nice part about doing yearbook photography is that you have a fee coming in for work done during the course of the coming school year. Thus, you'll have a regular base income you can count on while you're trying to build your business.

The only disadvantage is that that guaranteed income is usually fairly low. The greatest profit comes from selling the students additional portraits of themselves; this can be quite high, but is unpredictable. Depending upon the economic conditions in the area where you work, the students may not be able to afford the work you've done regardless of price.

For example, in areas where the auto industry is a major employer, the school systems have often had plenty of tax money, and have been able to afford outside photographers. When the economy went bad and auto workers were laid off in record numbers, some schools might already have been committed to having a photographer handle the yearbook. However, the suddenly poor families were not about to waste what money they had in savings and the little income they were receiving. Class photographs were luxuries the children could not afford, and these photographers didn't make anywhere near their originally anticipated profit.

If you're interested in bidding on school photography, talk with whomever makes such arrangements and learn exactly what will be expected of you. If you can learn the prices charged the school system in the past, so much the better. If you can't, at least get the photographers' names so you can hopefully talk with them about the matter.

Next, go home and figure what your costs are likely to be, as

well as the time you feel may be involved. Then try to come up with a fee that covers all expenses plus time, keeping the latter rate fairly low if you'll be selling additional prints to the students. Never let yourself get so caught up in the game of competitive bidding that you submit too low a figure for profit just to get hired. If you can't meet time and expenses from your bid, you have no business seeking such work.

Your custom lab, discussed in the next chapter, can be your biggest help when handling school photography. Many labs offer special packages designed to help the photographer increase his business without straining his budget. There are prom packages containing, perhaps, an 8 × 10 photograph from the negative taken of the couple as well as one or two 5 × 7's and a dozen wallet-sized prints. All comes to the photographer at one time for far less than the prints would run individually. There are also packages for school portraits and other services. Many labs even provide display samples so photographers can get a commitment from students at the time they take the pictures. Since they can see what they're being offered, they're enthusiastic right from the moment the pictures are taken.

School photography is not for everyone. It can be fun and financially rewarding, or it can be a drain on your time, energy, and nerves. Consider it carefully before deciding whether you want to add it to your studio's offerings.

14

The Custom Lab

There are two types of photographers. One type feels that whatever artistic ability and creative skills can be brought to photography come when the picture is initially composed in the viewfinder. It is this original image that represents the photographer's ultimate achievement; darkroom work is the necessary process that permanently fixes the image in a reproducible form.

The second type of photographer looks upon the initial image as half of what determines the photographer's worth. The darkroom is where it all comes together. The original image is enhanced, perhaps combined with other images or altered through dodging, burning in, retouching, and so on. It is only when the print emerges from the darkroom that a photographer can truly be proud of his accomplishment. If the photographer lets an outsider handle the processing and printing, then that photographer is incomplete, a person who has failed to meet his true potential.

I don't know which type of photographer you are, but the question of whether to include laboratory facilities in your studio is a critical one. Whatever you decide will cost you time, money, and, in some cases, clients.

The Disadvantages of the Darkroom

The majority of photographers charge fairly high rates for their time. Their hourly fees are frequently as great or greater than those demanded by attorneys and doctors, though the number of hours actually billed is often far fewer. To convince a client that such charges are worth meeting, the photographer has to offer something special.

The only unique aspect about each photographer is the way he or she visually perceives the world. It is this method of seeing, combined with technical skills learned through study and experience, that causes a client to hire you. The client is paying for a special approach to photography that will result in a magnificent portrait, an almost three-dimensional wedding album, or a product photograph that screams, "Buy me!" And when does the client feel the photographer is earning his money? When he has camera in hand and is taking photographs.

The Time

What does this mean to you? Simply that the only time you can charge a high hourly rate for your efforts is when you're taking pictures. What goes on after that doesn't concern the client, and he certainly won't pay much money for it. If you want to do all your darkroom work yourself, it means time that isn't as financially rewarding as your initial camera work.

When you first start into business you'll have a lot of time on your hands. Customers won't be tearing down the walls trying to hire you. Business will be quite slow, though hopefully on the rise. It will be a great temptation to utilize that idle time by working in the darkroom and saving on expenses.

Looking at your situation realistically, how do you expect to become successful? If you handle portraits and weddings, and if you have your own studio in a shopping area, you'll get occasional drop-in business on the lure of your window display. But that business is minimal. If you handle advertising and public relations work, there's no way that anyone will rush over and hire you. No one seeks out someone who's unknown to shower him with million-dollar contracts.

In other words, you're going to have to hustle business if you

want to become successful, or even if you want to meet your bills for food and shelter. And where do you find this business? You find it by making the rounds of advertising agencies and public relations firms, by calling newly engaged couples, by visiting churches and schools, by contacting new parents. You must be involved with the public, constantly querying, showing your portfolios, and generally doing everything you can to obtain new clients. You don't get business by being in your darkroom!

If your first studio is basically a one-person operation, you have no business having a darkroom in use on a regular basis. Every hour you spend slaving over the enlarger means wasted time that could have been used to gain new clients.

The Equipment

Another drawback to handling your own darkroom work is the equipment cost. A professional must have his darkroom established in such a way that he can provide quality and speed. This means expensive equipment, and often specialized apparatus that can be far more involved than originally anticipated.

For black-and-white work you'll need multi-reel developing tanks, a dust-free drying system, a quality enlarger capable of printing a wide range of negative sizes, and enlarging lenses the equal of your camera's lenses. You'll also be likely to need a stabilization processor in addition to your standard processing methods. The stabilization processor produces black-and-white prints very quickly, though they are not well fixed and will fade after a year. They're great for short-term newspaper and advertising needs but aren't meant for file or wall display.

Another requirement is elaborate washing and drying equipment. The latter generally involves a rotary dryer to dry the greatest number of prints in the shortest time.

With color you run into special enlarger color heads and computer analyzers. You'll need careful temperature control for all your chemicals. And so the list grows and grows. A quality professional studio darkroom can probably not be assembled for less than $1,000, and many cost several times that figure.

The result is that the darkroom is a tremendous financial drain. Consider the fact that you're paying two ways; one is for the cost of the equipment and the other is the lost income that

results from your not being behind the camera, where you can charge high rates.

Using Custom Labs

For all these reasons I feel that it's essential for you to locate custom labs that can handle your needs and meet your print specifications. This can be a fairly involved process, and a rather expensive one, but it will save you money in the long run.

With few exceptions, most labs specialize in either black-and-white or color processing and printing. Of those which handle both, only a few have truly efficient workers in both areas. Generally their best people are in one division and people with lesser skill handle the other work, though there are exceptions.

Another aspect of color labs is that each one tends to handle different procedures in inconsistent ways. For example, one of the color labs I use can provide low-cost prints from slides that are gems of perfection. The lab's technicians make machine prints that are the equal of other labs' custom, hand-made work, and for a fraction of the price. Their prints are equally good from negatives, but whoever handles the negative printing doesn't bother to replace the negatives in the protective sleeves used for storage. The negatives are returned loose, pressed together in a way that can result in scratching. It would be foolish to risk negative damage by sending them such material, so I use them for slides and nothing else.

Another lab near me has very expensive machine-made prints, which I don't feel are good. But its custom printing of portraits, industrial photos, and other critical work is perfection itself at highly competitive rates. When custom negative printing is demanded, I would go nowhere else.

Yet a third lab makes magnificent 4 × 5 internegatives from my Kodachrome transparencies, then blows them up to the size of a wall, all for prices that are unbelievably low. Unfortunately, their skills are countered by a disdain for service that results in my negatives being retained in the lab for periods of three to four weeks. Since a maximum of five working days is normal for a lab serving professional needs, you can see why I don't dare use this lab when the client is in any sort of a hurry.

For black-and-white work, one lab provides twenty-four-hour

service for everything I send to them. However, their rates are high, and they refuse to use unusual developers when I want to experiment.

A second lab charges considerably less but takes an additional day or two. However, this lab will do anything I want done. If I want to solarize part of a print while having the other section handled normally, the lab will do it. If I want to use a film that requires a special developer, the lab personnel will buy it and charge me only a minimal fee for doing so. And the owner tends to experiment with film-developer combinations, letting me know the results and sending me prints at no charge so I can see if I might like to use the effect on an assignment.

And so it goes. Every lab has its strengths and its weaknesses. You might find that one particular lab can supply you with the quality and service you require for the work you do. Or you might find, as I have, that the wide range of assignments you handle requires you to use several different labs you know and trust.

How to Choose a Lab

How do you find a custom lab? Start with your Yellow Pages and see what kind of work is available where you live. The closer the lab, theoretically, the faster the service. Certainly you won't have to add mailing time to a rush order when telling the client how early you can provide finished work.

Quality. What should you check? Have film processed to see how it's returned. Are the negatives scratched, streaked, or otherwise not as good as they might be? Are they returned in individual holders so the strips don't touch each other?

Speed. What's the *maximum* in-lab time? Some labs brag that they try to get all work completed within twenty-four hours of receiving it. Others say to allow forty-eight hours. But when they get pressed, as they often are during the holiday seasons, it may take anywhere from five days to three weeks before the work is ready. Can the lab handle rush orders? What's the charge? It doesn't matter what the best service they can give might be. You want to

know their worst service so you can anticipate problems before they arise.

Services. What type of printing services does the lab offer? Some labs provide only proof-sized prints, which are great for portraits and weddings but a nuisance for many other assignments. Proof-sized prints are expensive when you could get away with a cheaper contact sheet and use a magnifying glass to study the contacts before having anything enlarged. But some labs don't make contact sheets, so be sure you know what can be done locally.

Some labs are basically machine printers, and can't or won't adjust to any special needs of your negative. If your work is consistently exposed and of even quality, you may never need anything better. However, most professionals feel it's essential that their labs offer both machine printing and custom work done by hand.

What about special processing? One lab near me does an adequate job of processing when film is exposed normally, but let someone push the film an extra stop or two and the processing is terrible. The right time, temperature, and chemicals are used but the elephant hired to do the work tramps on the negatives while they're drying to show his disdain for my having caused him extra work. The negatives are returned scratched and oddly bent.

What special services are available? If you handle weddings, you may want to use a lab that's equipped to use overlays. Thus a bridal couple might be shown in a heart or surrounded by their favorite music. If you do advertising photography, there may be some sandwich printing or other special manipulations you want the lab to do. Will they handle it?

Can the lab make archival prints? When you sell a portrait for a client's wall, you don't want the image fading or discoloring within a couple of years. If it does, you'll be out at least the cost of replacing it; at worst, you will have lost a customer.

Can the lab process and print transparencies? What's the charge? Does the lab do Cibachrome printing—which can give the richest, most stable colors possible—or is it tied to more

traditional approaches? Some labs have the "little yellow box" syndrome. If something isn't made by Eastman Kodak, they can't or won't handle it. Unfortunately, no matter how good Eastman products might be, and I use them almost exclusively, there are many specialty items Eastman doesn't make, without which I would be lost. If the lab can't work with them, I may not be able to use it.

Charges. Does the lab have a regularly updated list of prices? Some labs list their charges for amateur work but quote a price to professionals at the time the order is placed. There is no way of knowing your costs in advance. Thus there is no way to figure expenses in advance—an intolerable situation if you have to make an estimate for a client.

Out-of-Town Labs

After you've completed your check of the local labs, you will have spent money for processing and prints of different types and sizes. You will have used black-and-white and color, assuming they handle both, and will have a price sheet. Your next step is to try out-of-town labs reasonably close to your home. This might mean several states away, such as an Arizona photographer using a lab in Washington state or a Michigan photographer using a New York lab. But a photographer in California shouldn't bother checking labs in Florida unless some of his assignments don't have to be turned in to his client for two or three weeks.

Run the same type of tests, and ask the same questions.

Where do you find out-of-town labs? One approach is to see if the reference section of your library has the Yellow Pages for nearby major cities. If such books are available, that's a good way to start. If not, you'll have to rely on advertising in the photography magazines.

As a general rule of thumb, work with a lab you can contact in a hurry. If a lab lists a post office box but no telephone number, you won't be able to contact them in an emergency. If it lists an address, check with the telephone operator in that city to be certain there's a phone listed for the lab. You may never need to call, but there can come a day when an order is unusually late or a client wants to know what sort of rush service he can get and

you'll need to contact them. If there's no telephone number readily available, you'd be better off trying another lab.

You'll have to accept and reject assignments according to the services your lab can provide, as I had to reject that department store work when I was first in business because my labs couldn't deliver. However, to have done such work myself would have cost me far more than I could have hoped to recover from the assignments I realistically hoped to obtain.

It helps to have your studio equipped for packaging and mailing exposed film, slides, negatives, and prints. I always keep a large supply of envelopes of different sizes on hand, as well as cardboard inserts to act as protective stiffeners. I also maintain a supply of Mail-Lite Envelopes, which have air-bubble plastic liners that act as waterproof shock absorbers when I send off rolls of film. I keep a good five-pound postal scale and a large supply of stamps of different denominations. Thus, I have to go to the post office only every four to six weeks, instead of wasting time by making a trip every time I have something to mail.

Many custom labs supply mailers free of charge. Unfortunately, these are not always heavy-duty, and I once had a roll of film slip through a hole torn in the side of a mailer when it went through the post office. Only the fact that I wrap each exposed roll with a small name and address sticker saved me from losing important negatives.

Credit

It's a wise idea to open a credit account with the custom labs you use, providing they offer this service. Whenever you have a rush order or an order of unknown cost, a credit account can save you valuable time. For example, I recently gave a rush order to a lab with which I didn't have an account. Despite the fact that I had used them for months, the lab policy was to always wait for a personal check to clear before shipping the prints. This usually meant a week or ten days, and my client didn't have that much time. I had to go to the bank and get a cashier's check to ensure the rush. This took half an hour's time, during the middle of the day when I had the least time to spare. That never would have happened had I had a credit account.

Many labs accept BankAmericard or Master Charge, and this

is a convenience. However, watch your orders and monthly credit card statements closely if you use them. Although almost every lab is completely honest, I once dealt with one that provided fast service and quality work when I charged items on my card—and, when I got my statement, there were indications that the lab had charged me twice for the same order. Identical bills were listed with the charges marked a week apart from each other.

Did the lab make a mistake? Did someone slip up and make the same notation twice? I assumed so when I called the Master Charge people to straighten the account. But after talking with them I realized that the lab was apparently dishonest. Not only did I have that double charge, but so did several other people in the immediate area who also used the lab. This pattern indicated that there was probably a deliberate attempt to gain extra money through double billing. Master Charge wiped the duplicate bill from my account, and I never used that lab again.

The custom lab is like a junior partner in your studio. You are interdependent upon each other, and you must be able to work together quickly, efficiently, and at a reasonable cost. Locate the ones you feel can meet your needs, then stick with them as long as their service is maintained at the level you desire.

15

Income and Insurance

Few aspects of running a professional photography studio are so important yet so little understood as insurance. Without the protection of insurance an accident, injury, illness, or theft can be a devastating financial blow from which you may never recover.

Camera Insurance

Camera insurance is one of the most basic types of insurance you'll need. If your equipment is damaged or stolen you must be able to replace it as quickly as possible. This means you'll need cash from either savings or insurance. Since few beginning professionals have much in the way of savings, insurance is the proper way to protect yourself.

Cameras must usually be insured separately from the other contents of your home and/or studio. This is because most companies don't provide adequate protection for your equipment in the typical home or business policy. For example, when my camera equipment was kept at home I had an insurance policy that covered the entire contents of our home. This protected us from theft, fire, and similar calamities. In addition we had a

$1,000 "floater." The floater protected $1,000 worth of possessions when we took them with us on a trip. In theory, both the home policy and the floater protected the camera equipment as well. In reality, a check with the insurance company revealed that only *hobby* equipment was covered. Since my cameras were used professionally, damage or theft was *not* covered in our tenant's policy! I had to obtain a separate policy that protected only the cameras and was designed specifically for professional use.

Professional photographers are often ignored by many "name" insurance companies. If an agent is willing to handle policies like camera insurance, usually the price he must charge is exorbitant. The policy is written specially, and the volume of such insurance handled by the company is so small that the charge is out of line with what it should be for the risks involved. In my case, my agent could offer me standard home and business coverage, life insurance, and health insurance all at reasonable rates. But coverage for my camera insurance ran double what I am currently paying.

My answer to the insurance hassle was to go with an independent agent who was willing to hunt for the best possible policy rather than being limited to one particular company. Not only is every camera and accessory I own protected in my home and studio, it is also protected when I go on location. The floater is not limited to just $1,000.

What It Should Cover

Camera insurance should cover cameras, lenses, lighting equipment, and other expensive items. There should also be a coverage for miscellaneous items—filters, inexpensive gadget bags, and other low-cost necessities. None of these items is likely to cost more than a few dollars by itself, but if several are taken, the total can run to several hundred dollars—quite a shock if you have to replace it yourself. Some agents require you to list the minor items, others don't. But you should have a miscellaneous items section that covers the odds and ends you use in your business.

Another vital aspect of your policy is the coverage of newly purchased equipment from the time it's acquired to the time you

can notify your agent to increase your coverage. If I buy a camera or similar item, it's automatically covered for a set number of days from the date of purchase. This gives me adequate time to notify the agent. Of course, if I wait too long the item is uninsured, so I must remember to act reasonably quickly.

The Annual Update

The changing economy and the fluctuation of the dollar on the world market make it imperative that you update your insurance on an annual basis. In many cases it can cost considerably more to replace your used equipment than the price you paid originally.

For example, a few years ago I made an extensive purchase of 35mm equipment, buying both used and new items. Six months later it would have cost me an additional $500 to buy the identical equipment from the same source. Today it would cost more than $1,000 additional to replace the cameras and lenses. My used cameras are worth more on a resale today than the price I originally paid for them. It's a rather frightening commentary on the economy, but one of which you must be aware when analyzing your insurance needs.

Evaluating the Service

Be sure you understand just what your policy covers and how you'll be paid if you make a claim. Will the adjuster arbitrarily assign a value to your loss regardless of the actual price of replacement? Or are you covered to whatever extent is necessary to replace your equipment, up to a dollar maximum equal to the limit of your policy? Be sure you understand what's involved before committing yourself.

Get competitive bids for your insurance. Different companies have different rates, and you want to go with the lowest bid that still assures quality coverage.

Finding an agent can be difficult. There are some general guides to insurance companies, such as the information put out by the Consumer's Union, Mount Vernon, NY 10550. This is the organization that publishes the highly rated magazine *Consumer Reports*. It periodically reviews the larger national insurance companies, and its ratings can be most helpful.

Before using any company or agency, check out the firm with your local Better Business Bureau. No matter how good a company may be on a national basis, be sure the local office also gives quality service.

The amount of information the Better Business Bureau will provide varies with each city's office. However, all of them should be able to tell you whether there are legitimate, unresolved complaints against the firm. If such problems do exist, you'd probably be better off avoiding that particular company.

Covering Your Studio

A second insurance policy you'll need is one to protect the contents of your studio, other than camera equipment, from fire and theft. This means coverage for desks, file drawers, chairs, shelving, and similar items. If you're working from home all this can be included in your standard home owner or tenant's policy. Otherwise you'll need a separate policy for your place of business.

Liability Insurance

If you'll be working on location or will have people coming to your studio, you'll have to have liability insurance. This is to protect you in case someone is accidentally injured by your equipment or while on your premises.

How much liability insurance you need depends on the type of assignments you handle. Keep in mind that if you work with professional models their potential earnings are extremely high. Should a model be disabled as a result of your negligence, the resultant damage suit could easily reach a minimum of several hundred thousand dollars.

You can sometimes keep the cost of liability insurance fairly low by buying it as one of several policies from the same agent. The more insurance you buy from a company, the more likely you are to get a break in rates. However, be sure to compare costs among several companies to get the best deal possible.

If you'll be transporting models in your car, check your automobile insurance liability coverage. Remember that you may need special liability coverage for your studio, your car, and

location work. This is expensive, I admit, but it's protection you can't safely do without.

Covering Yourself

Life Insurance

Life insurance is another form of protection you must consider. There are basically two types of life insurance. The less expensive is term insurance, death insurance that protects your family for a set period of time—the "term" mentioned. Term insurance can be purchased as a renewable policy, which you must renew for the same amount every few years, or as a decreasing policy. The latter provides for less and less protection as you get older.

The idea behind decreasing term is that the largest amount of money is needed when your children are small. As they get older you will theoretically need less and less money to see your family through. However, this theory doesn't hold up well, especially when you consider the rising cost of living and the fact that your children may want to go to college. The major drawback to term insurance is that you have to die to benefit from it. It has no cash value, and if you live to the end of the term you get none of your money back.

A better but more expensive type of life insurance is known by several names, including "cash value" life insurance and "whole life" insurance. The money you pay creates a cash value, which grows with each year that you meet your premium. You can borrow against this money at rates that are generally more favorable than bank loans, and you can convert your insurance to a regular monthly retirement income at age sixty-five.

Whole life insurance has a few drawbacks. First, it is expensive compared with term. Some experts feel that you're better off buying decreasing term insurance and putting the difference between your term insurance payments and what you'd pay for an equal amount of whole life into a savings account. Your savings will grow, offsetting the decreasing term, so after perhaps twenty-five years you'll have savings equal to the amount of term insurance you originally purchased, and can stop buying the term. However, such a plan assumes you have

the discipline to pay yourself at the same time you pay the insurance company without touching that growing savings account.

Whole life insurance is not a very good savings plan when compared with putting the premium payments directly into the bank. The first year's premium goes almost entirely for the agent's commission and the cost for setting up the policy records. Even after that first year you don't get the cash benefit of your entire premium. However, what you do get is an instant estate should you die young. If you put the premium payments into a savings account, your family is left with just that account, no matter how small. When you buy whole life insurance, your equity grows very slowly but your estate is always equal to the maximum benefit stated on the policy.

Most insurance companies offer special family plans for couples with children. You can buy whole life insurance for yourself and your wife, and some small term policies for your children for less than the policies would cost when purchased individually. This can be an excellent way to purchase your insurance.

Talk with your insurance agent to find out what plans are available within your budget. For a slight additional premium you can arrange to buy additional whole life policies at specific times in your life without taking a physical examination. Generally the option to buy more comes every five to ten years, as well as each time you have a child. You can buy the insurance even if you have a terminal illness, but you must arrange for this feature when you take out your first policy. It's well worth the small additional cost.

Health Insurance

Health insurance is another necessity, and the more coverage you have the better. Beware of buying health insurance through the mail; more frauds are perpetrated through mail order insurance than for any other type of product. States that strictly regulate insurance companies maintaining offices within their boundaries often don't regulate the practices of companies in other areas selling through the mail. Mail-order policies are carefully worded to avoid violating postal ordinances, but what

they offer is generally worthless, either because you're unlikely ever to collect or because the benefits are so slight as to be of almost no value.

Health insurance should cover hospital stays as well as visits to the doctor and prescription drugs. Some people like to save on hospital insurance by having a high deductible—up to $400 or $500. But when your family is young your hospital needs are liable to involve such matters as pregnancy, broken bones, and tonsillectomies. These things can get expensive, and with a high deductible you must meet the total cost from your own pocket. High deductibles are of no practical value in this field.

The only way to save on health insurance is through a group insurance plan. See if your local or state photographers' association has a group plan in which you can participate. If not, try to arrange to start one. Such a program can save you thousands of dollars during your career. In fact, you might go so far as to see if area insurance companies will offer group plans for liability coverage and equipment theft protection. The more policies the company can sell at one time, the better the break you'll get on your rates.

Disability Income Insurance

It seems as though the types of insurance you might need are endless, but protection is important. Yet another type of policy covers disability. If you become disabled, this insurance pays you a percentage of your normal income until you're back on your feet. If you start on a freelance basis, it may be difficult to get this type of coverage; however, it's something to consider. This is not as important as the other types of protection, though, because you can get disability income from your Social Security after several months of disability.

Many life insurance policies have an option specifying that the company makes your insurance payments after a period-usually six months-of disability. The payments stop when you're no longer disabled but are made all your life if you're unable to return to work. This option is well worth the slight additional expense, regardless of whether you decide to take any additional insurance.

If you enter into a partnership or a corporation, you might

consider a form of life insurance known as a "Key Man" policy. This policy makes each person the beneficiary of a life insurance policy held by his or her partner. If one partner (the "key man") dies, the other partner has the insurance payment to help meet bills and keep the studio operating while a new partner is sought. This is a wise investment for a new studio.

Ensuring Your Retirement Income

As a self-employed individual, you must plan for your retirement income as best you can. Social Security will, of course, supply some benefits for your nonworking years. But Social Security is not likely to prove adequate to maintain a life style remotely resembling what you want to enjoy.

Life insurance can also be used for retirement income when you convert your whole life policies for a monthly retirement income. Annuities are also of value. However, there are two plans which offer far greater benefits.

The first plan is called the Keogh retirement plan, in honor of the senator who devised it. The second, made possible by recent legislation, is known as the Individual Retirement Account. Both of these plans offer steady retirement income as well as excellent tax breaks.

Both the Keogh and the Individual Retirement Account (IRA) are changing periodically in the way they work. Keogh plans generally allow a greater income contribution than the IRA, but there are a few drawbacks. The most important problem is that if you select the Keogh and eventually hire a staff, each employee must be given a benefit in the form of a Keogh pension contribution equal to the amount you set aside for yourself. This may be more money than you can afford or want to spend.

The IRA allows a smaller contribution, but at this writing it doesn't require you to cover your employees. If you're working with your spouse, both of you can contribute the maximum, thus doubling your eventual benefits.

Money contributed to Keogh and IRA pension programs is deductible before you pay taxes. Thus, these plans give you a pension program and a tax savings all rolled into one.

Information about the Keogh plan and the IRA are available

from many sources. The most aggressive sales people are insurance agents. However, the best person to talk with is a trust officer of your local bank.

When people put money into Keogh and IRA they can do it in a variety of ways. If it's administered by an insurance company, you're generally limited to life insurance purchases or investment in a mutual fund, neither of which offers much of a return. Banks are far more flexible. In addition to the insurance and mutual funds most offer, you can also put money into high-interest Certificates of Deposit or almost any other investment of which the bank approves. Thus, if you're an expert in an investment field, such as rare coins, rare stamps, art masterpieces, or so on, the bank can allow you to invest in those rather unusual fields. Whether such investment will be permitted depends upon the individual bank's policy. The federal government does not restrict them in determining how you may set your money aside.

Keogh and IRA will probably not be considered when you first start into business. But once your income is fairly steady and your business is reasonably sound, it's well worth your while to investigate these retirement plans. When you're your own boss, you've got to be the person who keeps an eye on your own best interests.

Any way you look at it, insurance is a major expense. When you go into business for yourself you no longer have the protection of company benefits: you must be your own protector. By investigating your options thoroughly and enlisting the aid of your local and/or state professional society, you should be able to make the best arrangements possible for the money you can afford to spend.

16

Pricing

No area of professional photography causes so much controversy and confusion as that of pricing one's work. Trying to determine what to charge for a given assignment can be difficult even for the established studio. For the person starting in the field it can seem an insurmountable task.

This chapter does not tell you exactly what to charge for your work. Such a guideline would probably be outdated by the time this book was off the press. Instead, it discusses what's involved in pricing your work and provides you with regularly updated sources for pricing your work and provides you with regularly updated sources for price information that will prove invaluable to you.

What's Involved
A major factor in setting your prices is an intangible—what do you think you're worth? This involves your self-image and your evaluation of your skills. If you feel you're the best person for a particular assignment and can handle it better than anyone you might be competing with, your price might be considerably higher than others would charge. More important, if the client

views you the same way you view yourself, that charge will be met without hesitation. If the client doesn't feel that you're the best for the job, or if his budget is just too limited to allow for such a high charge, the work will be given elsewhere.

Raising Your Rates

As a general rule, always keep in mind that it's easier to start with a slightly higher price than you think you're worth than to try to raise your fees a few months after you go into business. Once you give your clients a fee schedule, there will be a certain amount of hostility toward any changes you might make. This means that though labs raise their rates, film prices go up, and other areas of overhead are on the rise, people will expect you to operate on the same schedule.

The problem of raising rates without losing customers is so serious that many portrait photographers never tell their clients when they're raising rates. Instead they change their list of services, hiding the increased charges in different package promotions. For example, suppose a studio offered one 8 × 10 and two 5 × 7 prints for $35. Instead of raising the price, the package might be dropped, and in its place the studio might start offering one 11 × 14 and two 5 × 7's for $55. This is a new package, not an increased charge. If the established customers say something, the owner explains that this package was more popular with clients and so the other one was dropped. 8 × 10's are available in addition, of course, but the special package rate is no longer being offered. This is much easier for a client to accept than the fact that you raised your rates.

Most advertising and public relations assignments are different each time they're handled, so small raises in your rates are not always noticed. Occasionally you'll find yourself doing the same work for a client again and again so a variation in charge becomes quite obvious. All you can do is explain that due to rising costs your prices have had to be increased 5 percent, 10 percent, or whatever figure applies.

An alternative is to keep your hourly fee the same but to start charging separately for services once included with the hourly. For example, at one time the hourly rate I quoted covered time,

film, processing, and contact sheets. Today my hourly rate covers only time; all expenses are billed separately to the client. My cost increases are passed right along. Since my hourly has been unchanged for quite some time, my clients don't feel that I am trying to get rich off them. Of course, the fact that expenses are no longer coming from the hourly means that I've given myself a nice raise, but no one has ever noticed this fact.

What the Price Includes

Your price must include overhead and materials. These might be billed separately or quoted in the total price. With portraits and weddings, the fee you charge includes all these items. Your client doesn't get a price breakdown, as might be given for advertising and public relations work.

The price you charge will vary with the time you spend on the assignment. The portrait sitting fee should be based on a certain maximum time of fifteen minutes, thirty minutes, or whatever you find works best. Start with your hourly rate and divide it by the actual time you plan to spend with each client.

Your hourly rate does not reflect just your skills, nor will your expenses cover all your overhead. There are some very real expenses you must recover that can't be listed with those charged to clients. You have to pay for wear and tear on equipment, the cost of rent, electricity, telephone service, and other "hidden" items. All that insurance discussed in the previous chapter has to be considered as yet another expense. A percentage of your hourly rate must be used to meet these items, which you might otherwise overlook.

Obviously, your hourly rate does not directly relate to your *profit* per hour. When a photographer charges $50 an hour plus expenses, for example, overhead might erode two-thirds of that figure. And if you have a staff payroll to meet, the profit percentage might be reduced even more. Suddenly your "high" fees no longer seem so high, do they?

How to Set the Price

Generally, the longer you've been in business, the more you can charge for your work, assuming your experience is reflected in

constantly improving quality. However, at all times you must be aware that you're in price competition with other photographers. You can set rates that are the highest in your community and still have customers. But they can't be too much higher than those of others or you'll price yourself out of the market.

Rate Information Sources

How do you learn what everyone else is charging? Try asking around; some photographers might be happy to tell you their prices. Others feel threatened by such a question. They will be extremely hostile to you, a situation which should be avoided.

There are two excellent sources for rate information applicable anywhere in the country. Perhaps the best is the *Blue Book of Photography Prices,* by Thomas Perrett, published by Photography Research Institute Carson Endowment, 21237 South Moneta Avenue, Carson, CA 90745. This is a monthly service for studio owners; it covers the average fees and the highest fees charged by professional photographers for a variety of services. The book covers everything from "Advertising Illustration" and "Aerial Photography" to "Portrait Photography" and "Candid Weddings."

The *Blue Book* is a thick loose-leaf notebook filled with sample information relating to costs, charges made, prices for prints, negatives, and just about everything else relating to the subject covered. Updated material is mailed out every thirty days, so you're kept current on how others are charging. The book serves as a guide showing the range of prices and expenses encountered around the country; it is not meant to fix prices but to show you what others are doing.

For example, under Public Relations Photography in Black-and-White, you learn that if a photographer is asked to deliver work the same day it's taken, various professionals charge from 100 percent to 200 percent additional for the services. A twenty-four-hour delivery means a markup of half that amount, or 50 percent to 100 percent.

Other notations indicate standard service times for straight charges, cancellation or postponement fees charged against a client, charges for pickup and delivery of work, charges for

Polaroid prints, charges for prints of various sizes, hourly rates, day rates, travel time charges, and numerous other items.

The price of the *Blue Book* is relatively high, but it's worth every cent. Since the price varies, you should write for the current subscription rate. But whatever it is at the moment, it's well worth your money. It can help you compete favorably from the start while insuring that the charge you decide on leaves ample room for profit.

The same company offers a second service, which is fascinating though not quite so valuable. Once a month an assignment in a specific field is created. For example, one assignment stated:

"The LNM Company has a requirement for 8 × 10 Black-and-White Construction Progress Photographs on part of a construction project they are bidding on in your area. The construction site will be located exactly one mile from your place of business. The photography is to be done once a month, starting in June 1975, on a monthly basis between the 15th and 20th of each month for a period not less than 9 months and not exceeding 15 months. You can pick the date and time within the above limitations convenient to your schedule. It is anticipated that you can complete the necessary photography (12 to 18 different views each month) with one trip to the site and within an average time of 2.5 hours portal to portal from your place of business.

"All negatives printed are to be permanently captioned with the project name, a negative identification number, and date of photography in such a manner that this information will be printed on all photographs made from these negatives. These captions shall not obscure important subject matter in the prints.

"You will be required to deliver the photographs within 3 working days after photography to the project engineer. You will present a monthly bill to the project engineer for all services rendered during the month. The project engineer will be located at construction site office. You have been told that you will then be paid by the 15th of the following month after you have presented your bill to the project engineer.

"You know you can get this job if you can come up with the 'RIGHT PRICE'. What will be your Per Photograph Price to provide LNM Construction Company with the photographic services outlined above?

"Do not include Sales Tax in your answers. It will be understood that all prices are plus all applicable Sales Taxes."

With the assignment is an in-depth questionnaire regarding all aspects of handling the project. This material is sent to a cross section of photographers around the country; these photographers provide information on how they charge and what they charge, and some insight into how they work. The results are compiled and sent to the subscribers. This isn't as valuable as the *Blue Book,* but it is a way of getting inside the heads of photographers with whom you would otherwise have no contact.

A second pricing manual is the periodically updated *Estimating Manual for Professional Photography,* published by Professional Photographers West, Inc., 1665½ Veteran Avenue, Los Angeles, CA 90024. This guide defines the various services a professional studio might offer and discusses the range of prices currently being charged. It is far less expensive than the *Blue Book,* but it also lacks some of the depth. Both guides should be considered a must for your new studio.

Setting Goals

Although every studio is unique, you can make a few assumptions regarding your first year in business. One is that your expenses are going to be very high. You'll be lucky if your net profit begins to approach a third of your gross. You'll find yourself adding equipment as you go and not being certain what to buy, what to rent, and which assignments to refuse for lack of proper tools.

Services and supplies like film and flood bulbs will rise steadily in cost during the first year. Suppliers are raising their rates, and you're going to have to meet higher and higher prices to stay in business.

When business is good, many people are slow in paying their bills. When the economy is in a slump, the time you have to wait for payment gets longer and longer. If you don't have the cash reserve necessary to sustain your business without profit for the first year, you may find yourself snowed under by bills. There is no instant success in this field.

Ideally, you should set goals for your studio in terms of the amount of business you intend to generate each month. Start by

figuring the time you're going to work. There are 365 days in a year. Two weeks will be vacation time, though you may decide to skip that luxury the first year. Another 100 days are lost with time off, assuming you take two days off each week. Then subtract holidays; the result is roughly 240 days of actual working time.

Next, set your goals by the week, the month, and the year. Keep in mind that most new studios report that they get business from only one out of every six or seven contacts they make, and some only get business from 10 percent of their contacts. You should have regular growth goals in terms of both potential clients contacted and billing amounts. These goals should increase as you gain experience and begin to make a reputation for yourself that results in repeat business.

As mentioned, your profits will probably be no more than a third of your first year's gross. Taking this third as an example, suppose you want to earn $10,000 that first year. This means that you must have a gross billing of $30,000 in collectible business. You may actually need to bill a little more to cover any losses from deadbeats.

Based on that fifty-week work year, you must take in $600 a week, or roughly $2,500 a month. For each week that you gross less money, you'll have to hustle all the harder the next few weeks to exceed your goal enough to cover the loss.

Always remember that the harder and more efficiently you work, the faster your business will grow. Talent is only one factor in gaining success. Start with a good cash reserve, set goals for yourself, and price your work both realistically and competitively—your business will soon become sound and prosperous.

17

Selling from File

Your photographic files can be counted as one of the greatest assets of your business. They're more valuable than your cameras, your lights, or your studio—for many photographers, those files represent income that equals or exceeds what they earn from day-to-day assignments. Thus, it's important to examine the best way to utilize the potential of this buried "treasure."

There are many ways to resell prints from file. Some involve contacting trade journals. Others involve general-interest magazines. But the simplest methods involve resale to original clients.

Portraits: The Family Album
Portrait photographs are a good area to start. As your business begins to grow, you'll find yourself accumulating quite a file on some of your customers. You might have taken the portraits of a middle-aged couple and their children. Then, when the son or daughter got married, you covered the wedding. Later there was the first grandchild, and perhaps another wedding. Additional portraits of the original couple might show an increase in gray

hair or, perhaps, a decrease in the amount of hair of any color on the husband's head. In other words, your files show the growth and changes in the lives of the family.

What value is such a record to you? After all, hasn't the family already paid for all the photographs they might ever want?

Not at all! Each time a member of that family had a picture taken it was for a specific purpose. The wedding photographs went into a special wedding album which the bridal couple purchased. The portraits were custom-framed and mounted on the wall. The picture of the entire family was used both for Christmas cards and for mounting in the father's office. The senior portrait of the son went into the school yearbook, with additional prints given to friends. But at no time did the family ever coordinate that diverse group of photographs into anything cohesive.

Why not put together a special album of prints covering the many periods in the family's life? This album can be the sales sample for all your customers, so you can justify the expense even if that family isn't interested.

You might start with the latest family portrait, then show flashbacks to different scenes in the family's life—portraits of each family member, photographs of the baby or babies, scenes from the children's weddings, and anything else that's in your files. Don't use duplicate wedding photographs, but show the couple being married, perhaps kissing after the ceremony, the posed picture with the family, and perhaps a photograph at the reception. If the bride danced with her father or the groom with his mother-in-law, include this print. Add pictures of family pets if you've taken any, especially pets that may have died over the years. You want an album that tugs at the heartstrings: the reasons for this purchase are more emotional than practical.

A nice added touch is the family's name printed on the outside of the album. Many luggage shops can handle this task if you don't know of another source for such work. The size of the album is a matter of personal choice, though it should be either 8 × 10 or 11 × 14. Anything smaller is not effective and anything larger becomes both cumbersome and expensive.

Make an appointment to show the family the sample album. If they're interested, set the price somewhat below your normal per-print basis, for there is little work involved in creating the album. All it takes is a trip to your organized files and the sending of the selected negatives to your printer. With a slight sales effort, you might convince the family to have yet another sitting for an up-to-date portrait for the front of the album—and perhaps a framed enlargement for the wall?

Once you've sold such a family album, you must naturally keep it up to date. Are there new grandchildren or pets? Add their portraits to the album, and likewise any pictures of grandchildren taken as they're growing. You might even suggest an annual portrait session for the entire family as a family Christmas present to themselves.

Has part of the family moved out of town? Suggest to the others that when the wandering members return for a visit they might want to stop by your studio for a portrait. And when they do, not only will you have the additional business, you might be able to make a second Family Album sale; the wanderers might like an album of their own rather than just looking at their parents' when they return for a visit.

Occasionally you can sell family albums to every member of the family. This isn't something you can count on, though; the oldest members of the family are usually the only ones with the money to purchase such a sentimental item. While the grandchildren are young, the children are strapped for money just making ends meet. It's the grandparents, with their reduced financial obligations, who are most likely to be your customers.

Wedding Follow-Ups

Wedding pictures need not vanish forever in your files after the couple has purchased their album. Contact family members each anniversary and near Christmas; suggest that wedding prints would make the ideal remembrance. Perhaps previously unsold pictures can be sold to expand the album; perhaps super enlargements can be made from some of the more meaningful images so the couple or their parents can mount them on the

wall; or perhaps the parents and relatives might like a proof-sized mini-album that matches the images in the album of the bridal couple.

Business Sales

When you photograph stores, businesses, and industries, keep alert to changes in their circumstances. A move or expansion marks the time to begin reselling the customer on your work: not only can you photograph the new location or the enlarged interior, you can also sell framed prints from file. These are used to show the public "how far we've come," in the case of the expanded firm.

Sometimes a company enlarges by opening additional operations in other parts of the city, state, or country. When this happens, your photographs of the original locations can be enlarged, framed, and sold for hanging in the branches to give the public an idea of the size of the firm.

Although it's always wrong to take an assignment on speculation, when you decide to sell file prints to businesses and industries, it's best to make up a sample of the size print you have in mind. Do you feel a 30 × 40 would be ideal? Then make a dry-mounted sample you can use again and again so the company can envision the size you're discussing. Remember, such prints are your idea, not the company's. The final effect may not be something the staff can visualize without your samples.

Trade Journals

Another area for the sale of business and industrial photographs is through magazines known as trade journals. These are periodicals devoted to a particular business or industry, as *Engineering News-Record, Office World News, Business Insurance, Boot & Shoe Workers Journal,* and countless others. The photographic equivalents include *The Rangefinder* magazine, *Photographic Business and Product News,* and *Industrial Photography,* among others.

Each trade journal publishes information of interest to a limited audience. Many of these magazines pay token fees for the work sold to them; others compete with major markets in terms of dollars spent on photographs and articles.

To learn which trade journals might relate to the businesses you've photographed, you can check any number of publications the reference department of your local library is likely to have on hand. Two of the better-known ones are the annual *Writer's Market,* put out by *Writer's Digest,* and the *Gebbie Directory of House Organs,* which is regularly updated.

Once you've found trade journals relating to the areas you've photographed, send for sample copies. Explain that you're a photographer who might have material of interest to the magazine's readers. Ask to see a sample and offer to remit any cost involved. Generally you'll get a free sample, though rising mailing costs may force the editor to charge you a small fee. Whichever proves to be the case, the cost is well worth it.

Client Permission. There's a moral side to selling to trade journals that you must always consider. In theory, all photographs taken for a client belong to the client, regardless of the fact that you retain the negatives. Thus, if you sell some of the photographs to a magazine, the client may rightfully feel that any money you receive is his. If this is the case, there is little you can do about it. Fortunately, this is seldom a problem.

When you're ready to submit material to a publication, talk to the person who originally hired you and ask permission to do so. Explain the fact that there might be payment involved and ask whether the company would mind if you submitted the work. In almost every case the company will be delighted to let you keep whatever money is paid; those photographs will bring the firm invaluable publicity, which no amount of money could buy.

As an example of the situation you can find yourself in, I once photographed the construction of a high-rise apartment built with a new type of precast concrete. The builder's PR firm used the photographs to illustrate an article that appeared as the cover story of *Engineering News-Record.* This article was the main reason I was hired to do the work.

After the story appeared, when the company was using my other photos for general publicity, I found that there was another aspect to the story. The building was meant for low-income housing, and the methods used to enlist neighborhood

aid seemed perfect for a photo story for *Nation's Cities* magazine. *Nation's Cities* is a magazine that goes to mayors, city managers, and other urban leaders around the country, a city government trade journal rather than one meant for business or industry.

The photographs I wanted to use had not appeared in the *Engineering News-Record* article, so there was no copyright problem. My client told me to go right ahead and submit the material if I wanted to; I could keep any money that resulted. The result was an additional check for $300 from the magazine and, in effect, thousands of dollars in priceless publicity for the client. Since all illustrations were from file, my costs were next to nothing, and that $300 represented almost pure profit.

What You Can Sell. What types of photographs will trade journals buy? As many different types as there are trade journals. Some publications use captioned photographs of important industry executives doing almost anything. Some go so far as to run pictures captioned: "Here's Joe Parlferburg, President of the Parlferburg Widget Works, smiling as he misses his 87th attempt to get his golf ball out of the sand trap on the first hole of the beautiful Quicksand Country Club in Alligator Bay, Florida." Others use this type of boring "news" item only when it's taken at an industry convention.

Some publications use photographs of expanding businesses, new offices, or even unusual display windows. Others want photographs that provide real value for their readers. Often these must be accompanied by an article describing in depth what is being shown. The *Engineering News-Record* photographs accompanied an article describing the precast concrete construction technique for engineers who would genuinely be interested in using the method.

If an article is needed, there are two ways you can provide it. One way is to write it yourself, as I did for the story in *Nation's Cities*. Another way, if writing is not one of your skills, is to team with either the company public relations person or a reporter on your local paper. If there's a weekly paper near your home, a staff member might be eager to pick up extra money by writing the article. Weeklies are notorious for low pay, and their reporters are happy to freelance.

When you work with someone on a sale, agree in advance how the money will be split. If the magazine pays separately for the article and the photographs there's no problem. If it doesn't, I generally work on a fifty-fifty basis, figuring that the cost of making the prints and mailing the illustrated article offsets the time the writer spends doing the manuscript.

The Rules to Follow. Whenever you submit material to a magazine of any type, your work stands no chance of being returned unless you follow several rules. First, be certain your material is properly packaged in a heavy-duty envelope with adequate postage. It's best to send everything first class, not so much for the handling it will receive but because it looks more impressive and it gets there much faster. Some editors don't care how it's sent; others have told me that if the envelope doesn't arrive with first-class postage, they have the impression that the photographer is not particularly proud of his work. This reasoning seems silly, but if that's the way the buyer thinks then you must plan accordingly.

Always include a return envelope and protective corrugated cardboard with your submission. The return envelope should have proper postage for the total weight of the envelope, photographs, manuscript, if any, and protective cardboard, but need not use first-class postage. The envelope must also be properly addressed to your home, studio, or post office box.

Never clip the postage to the envelope on the theory that the magazine will attach it. The postage might fall off or be stolen or the entire package thrown away. Affix it properly for mailing.

Never expect the magazine to type your name and address on the return envelope. If you don't bother to self-address it, chances are the publication staff won't either.

National Markets

Some of your photographs may have national demand. Poster companies, calendar companies, greeting card companies, and similar businesses might have an interest in unusual portraits, scenics, and other photographs. If you have work that's unusual or sentimental, these companies are worth checking. *Writer's Market*, previously mentioned, is one source for locating such

firms; another is the annual *Artist's Market,* also published by *Writer's Digest.* Yet another is the periodically updated *Where and How to Sell Your Photographs,* published by *Amphoto.*

If you aren't sure your work would be right for such companies, take a look in card and gift shops to see the type of work being published. Keep in mind that radically different approaches might also meet with a receptive market; many companies, especially greeting card manufacturers, work a year or two in advance.

National magazines are yet another market, especially the special-interest publications. If you've photographed area tourist attractions, for example, one possible market might be the airline in-flight magazines for companies that use the major airport nearest your city. Study the newsstands and read through some of the market guides, like *Writer's Market* or *Where and How to Sell Your Photographs,* for ideas on whom to query.

When you write to an editor your letter should be short, to the point, and neatly typed. Always ask to submit material on speculation; no editor will commit himself to photographs sight unseen. Keep in mind that it can take four to six weeks to get a reply, and may take as long as three months. Editors are occasionally notoriously slow, so have patience. If you're concerned about whether your work arrived safely, use a "reply requested" card from your post office.

Insuring photographs is wasted effort unless you insure the work only for the price of lab replacement of the prints. The value of a photograph is very difficult to determine, and collecting more than the price of making new prints is next to impossible. It's not worth the higher insurance cost.

Always keep possible markets for unusual photographs in mind. For example, I periodically send portraits of attractive women to romance magazine editors; these are then sold for use as covers. Since magazines often buy only two or three times a year, I usually tell the editors to feel free to file them until such time as they can be considered. I enclose a self-addressed stamped postcard with space for the editor to indicate that work is being held for possible use. The card lists what's being held and has blanks to be filled in. For example, it might read: "We are holding ten of your 8 × 10 color prints for possible future

purchase as covers for _____ (name of magazine or magazines)." Leave a space for the date and the editor's name. This card should be included *in addition* to the self-addressed, stamped return envelope.

Even the unconventional may have a market. For example, I've recently been illustrating a book on home, business, and self-protection. Some of the illustrations involve "damsels in distress." Others involve the proper use of locks and related safety equipment. Those prints that aren't selected for the book are being sent to various true detective magazines for both cover and interior use. They're selling quite well, and may one day net me more than the book for which they were originally taken.

Eventually you may find yourself specializing in a certain type of subject matter. Peter Gowland, for instance, is known for his glamour work. Other photographers have built reputations in the fields of wildlife, architecture, and numerous other areas. When this occurs you may find that publications automatically turn to you rather than your having to solicit their business. Some photographers do more business this way than they initiate for their studios.

Stock Photo Agencies

There are firms known as stock photo agencies located in several major cities; perhaps the largest number are found in New York, with many others located in Chicago and Los Angeles. These agencies specialize in selling stock photographs to clients around the world. Their files are bulging with prints and slides, and their sales staff is constantly in contact with magazines, newspapers, book publishers, ad agencies, and others who might have use for their work. When they make a sale they generally split with the photographer on a fifty-fifty basis for black-and-white and a sixty-forty basis for color.

Should you work through a stock agency? On the plus side is the fact that few, if any, legitimate stock agencies charge a fee for looking at or handling your work. They only take a commission at the time of a sale. The agencies are experts in marketing, and can get your work before far more people than you could contact.

The bad side of stock agencies includes the fact that their

commission is quite high. And there's the problem of size. The stock agency I've occasionally used in New York bragged about the fact that they had more than four and a half million prints and slides on file the last time I was up there, and since that was a couple of years ago, the number of prints may have increased dramatically. My work is obviously being diluted by the large number of photos taken by others that are on file.

If you decide to go with a stock agency, keep in mind that you should place a minimum of 1,000 photographs if at all possible. These should cover a broad range of subjects unless you're a specialist in a field for which the agency gets many requests.

Before sending file material to an agency, check with the staff to learn their needs. Often the agency is overstocked in one area, such as photographs of children, and is looking desperately for industrial pictures, for example. By learning where there's a need, you can select prints that will offer the greatest chance of being sold.

Be certain your material is in a usable form. Some agencies can't use 35mm slides; others can't use black-and-white prints.

Finally, keep the agency apprised of your location. Each time you move be certain to notify the agency of that fact. File prints can sell for years after they've been placed, but there's no way you can get your money if the agency doesn't know where you are.

Local Sales

What are some other markets for file prints? Your local Chamber of Commerce might be in the market for community photographs that can be used for promotion. Tourist areas like Tucson, Miami, and Los Angeles often use photographs in promotional literature sent around the world. When budgets become too tight to hire a photographer to take pictures to order, Chambers of Commerce often turn to the files of area professionals. It's cheaper to buy individual file prints than to have to pay for time and materials when hiring on assignment.

City magazines can be another market. Many cities, like Cleveland, Philadelphia, Chicago, Atlanta, San Francisco, and New York, have magazines dealing with the local scene. Some are

Chamber of Commerce publications; others are independent. Each has different needs and budgets. The ones with the highest incomes are likely to hire you to illustrate articles, and the ones with less money will be more likely to buy from your files. However they work, it's worth your time to talk with them.

Have you done work for churches and schools? Every time they have an anniversary approaching, such as twenty-five years in the building, some of your photographs can be resold for displays. Businesses occasionally put out special reports every five to ten years to show their growth; if you took photographs shortly after the last report went out, your work is old enough to be used in the new publication as an example of how far the company has come. Naturally, this also gives you the inside track to getting the job of taking pictures of the current operations as well. Keep in touch with the public relations staff to learn if such publications are planned.

18

Hiring Help

There will come a time when you'll need assistance in your studio. This might mean a darkroom technician, a receptionist, or someone who does a little of everything. This additional expense is a serious consideration, and deserves to be discussed in some depth.

When to Hire Help

You should never add a second person to your staff until it makes financial sense to do so. This second person should either be doing work that produces his or her salary in addition to putting extra profits into your pocket, or should be freeing you for financially productive tasks. In the former situation, the person you hire might be a second photographer or a darkroom technician who handles outside work in addition to your assignments. In the latter case, the person might take over booking, billing, and a certain amount of selling so you can spend more time behind the camera, where the bulk of your income is produced.

The Receptionist

The portrait and wedding studio owner is most likely to need a

receptionist before anyone else is hired. This person can greet the public, arrange sittings, promote enlargements, framing services, and other profit-making items, and, perhaps, keep the books. The receptionist might also do double duty as a retoucher if he or she has the necessary skill.

A receptionist can be found in several ways. You might try a "Help Wanted" sign and an advertisement in the Classified section of your newspaper. You might go through both state and private employment agencies. Or you might contact local business schools, explain your needs, and see if they have any recent graduates who could fill your requirements.

A receptionist should be hired on the basis of neatness, ability to meet with the public, and ability to handle the tasks you assign. Appearance need not fit any particular clothing style, but he or she should be clean and dressed in a manner that befits a business; this is usually slightly conservative but still stylish. Since public contact is the major part of the job, such qualities as poise and friendliness are also important.

As to the duties of the receptionist, these must be decided on in advance. Your receptionist will have to do a certain amount of record keeping, but will he or she be responsible for keeping all the books? If so, someone with bookkeeping training is essential.

Is the receptionist position a dead-end job or do you want to gradually train the person to handle camera work? Receptionists are occasionally trained to do wedding photography, children's photography, and other assignments. If you want to work your receptionist into a better-paying, more highly skilled job, be sure the person you hire is interested in a career, not just in interim employment before going elsewhere. Obviously an enthusiasm for the field of professional photography is a must under such circumstances.

Darkroom Assistance

There are several ways to get darkroom assistance. Some photographers make do, at first, with a part-timer, generally a high school or college student with well-developed skills. Usually these people are enthusiastic hobbyists, and may eventually go into photography on a full-time basis.

If you use a part-timer, he or she must have set hours so you know how much work can be turned out. His work load will most likely be limited to your client's needs.

A full-time darkroom technician can usually handle more work than a one-person photography studio can generate. As a result, it may pay you to accept custom darkroom work from amateurs and area professionals who lack darkroom space. Have your technician do the work for fees that are competitive with those of custom labs. In some instances, handling such work can meet salary and expenses for both the technician and the lab.

If you decide to accept outside work, be sure to limit your promotion of the service. You might place a sign in your display window and you might want to talk up the service at meetings of your local professional society. You should also talk with the owners of camera stores, perhaps working out an arrangement where the sales people take orders and pass them to you in exchange for the store's taking a small percentage of the bill.

The most enthusiastic darkroom workers can generally be found in two ways. The first is by talking with local art schools. Many of them have students who are interested in photography, skilled in the darkroom, and in need of a job. Another method is by going to local camera stores and asking them to refer skilled young customers to you. The person who regularly buys darkroom supplies might be interested in taking a job in the field.

Camera clubs are another source for darkroom workers. You can also advertise, of course, but this may not be necessary if you try the other procedures first.

Employee Security

Whenever there's a second person involved with your business, strict record keeping and accounting procedures are essential. Employee theft and employee waste can cost you a small fortune.

Before someone starts to work for you, take inventory of all your supplies. Make record sheets listing the number of rolls and sheets of film you have, the number of exposures on each, and the type (for example, 10 rolls of 12-exposure 120 Vericolor film). Then, each time you take film for an assignment, mark down what you take and the quantity. When you return, mark exactly how much was used and what you're returning to cold

storage. Cross check this with the processing lab statement. In this way you'll know not only what you have on hand but the average amount of film used for each type of assignment.

An assistant who's hired with such a procedure in force will have a difficult time trying to take anything. He or she can't pocket film that went unused and claim it was part of the assignment. You'll always know what you should have on hand.

Strict controls should be maintained in the darkroom. It's a good idea to use order sheets after your inventory to keep a close check on all supplies. When an order is given to the darkroom technician, it should include a piece of paper with the name of the client and the details of processing and printing to be done. Each time a new sheet of paper is used, whether for test strips or printing, a notation must be made on the order form. Every piece of paper must be accounted for.

Obviously it would be possible for someone to make personal prints and charge the sheets used to testing procedures for legitimate orders. However, such test sheets would soon add up, and the only conclusions you could draw would be either that paper was being used for personal work or the technician was testing so frequently because he or she was incompetent or overly cautious. Either way it would be time to get a new employee.

Chemicals and other items used should also be carefully noted. What dry-mounting materials were utilized, for example? How much film developer?

Cash should be deposited in the bank regularly, though not at a set time each day. Money should never be allowed to accumulate; it's a temptation both to the crooked employee and to the outside thief.

Contrary to what you must be thinking, I am not down on the world, nor do I feel that everyone is dishonest. I have great faith in people and feel that the overwhelming majority deserve your trust. However, there are exceptions, and you'll be hiring with little knowledge of a person's character. If you institute procedures that make it impossible for employee theft to exist, you'll never have to concern yourself with just how honest that employee might really be.

For further information about setting up your business to

reduce the risk of internal dishonesty, check with your local police department for advice. Many police departments have officers assigned to help small businessmen establish procedures that reduce the likelihood of internal or outside crime. A second source for information is The International Association of Chiefs of Police, Eleven Firstfield Road, Gaithersburg, MD 20760. The Executive Director can refer you to sources of reading material relating to this problem.

Training Your Employees

You can get help training your staff from a rather unusual source. The telephone company in most cities has a speaker's bureau; these personnel will teach business office staffs the proper use of the telephone. Since voice contact may be the only chance your receptionist has of getting someone into the studio, knowing the proper way to use the instrument for best effect is extremely important.

Depending on your location, the phone company may not be willing to send someone to talk with just one employee. If this is the case where you are, see if you can work a schedule with other photographers in your area so that you can each send staff members to a central spot for the lecture.

You can save money by taking an advanced photographer into your studio as an apprentice. This person can be trained to handle everything from weddings to portraits to advertising. He or she can be given a small salary to start, with regular raises for increasing proficiency. Of course, you'd better plan to bring the person into a well-paying position when fully trained, or you'll lose him or her to another studio.

Employee benefits are another expense you must plan for. As I mentioned earlier, if you can get a group insurance plan established through your local or state professional photographers' society, you can add your employee to the group. This will greatly reduce your benefit costs.

19

Equipping the Studio

One major problem for professionals is equipment. I have tried to provide an idea of what equipment will be needed for different types of assignments. Since this book deals with business aspects of your studio, I leave in-depth equipment studies to other books and magazines. However, I would like to offer some money-saving suggestions that could help boost your profits.

Lenses

There is more nonsense written about lenses than almost any other piece of equipment. What you pay for a *new* lens does not usually relate entirely to its optical quality. A few years ago the higher the price, the better the optics. Today, while expensive lenses are better, even the cheapest lenses are capable of remarkable resolution and contrast. The change has resulted primarily from computer technology and new materials.

What makes an expensive lens? Sometimes the advertising budget of the manufacturer and/or importer. The greater the promotion, the more the products have to cost, so that advertising expenses can be recovered. However, with most companies this is not a major factor.

247

Most likely when you buy a high-priced lens you're paying for quality construction as well as outstanding optical quality. Expensive optics have the finest cases and mechanical systems money can buy. They work smoothly and may last a lifetime. Inexpensive lenses, on the other hand, often work smoothly only because of a liberal application of grease, which can dry out in a few years. They can't take much abuse without screws loosening and the entire unit falling apart.

Should you buy expensive lenses for your cameras? That depends on how you're going to use them. When I made a major investment in 35mm equipment a few years back, I bought the best optics I could find. I knew that the lenses would be subjected to hard use under conditions that were far from optimum. They've been dangled from high buildings, bumped innumerable times, rattled and shaken during cross-country drives and plane flights, and bounced along desert trails through the mountains. They've been exposed to extremes of temperature and humidity, and still these lenses function smoothly. Less expensive equipment might have given me the same photographs, but the lenses would have had to be replaced two or three times during the period that I've had the quality equipment.

My needs and demands are unusual. Some lenses are used only under controlled studio conditions; they won't be abused by travel, climate, or carelessness. These lenses don't have to be heavy-duty to last; all that's required is that they take excellent photographs. If your equipment will be used in this manner, by all means investigate cheaper lenses by independent manufacturers. You can save yourself hundreds or thousands of dollars over the years.

If you decide to buy a used lens for an even greater savings, stick with only the finest optics. Less expensive lenses are seldom traded in while they're in good shape, and they also have a more limited life. Used equipment is too great a risk if it isn't of the highest quality.

Check the screw heads on all used lenses. Make certain the screws are tight and show no signs of damage. Sometimes a lens is traded in after an amateur repair job has failed, and whenever a lens is taken apart by someone other than an expert, there's a

good chance that it won't be reassembled properly. If elements are out of line, focus will also be incorrect.

Examine the glass carefully. Fingermarks and other damage are indicators that the lens should be rejected. If the store didn't remove the marks before placing the lens for resale, chances are that the marks are permanent. If the marks appear to be between the elements, the implication is that an amateur repair was made.

Be sure to test lenses before buying them. You might have to do this by running a roll of film through your camera while using the lens in the store. Other dealers will give you a seven-day return privilege. However you do it, test the lens before you must keep it, regardless of its apparent condition.

Keep in mind that a guarantee must be in writing to be valid. If the dealer grants you a return privilege, get it written on the sales slip. And be certain you can get your money back. Some dealers only let you trade for equipment of similar value.

Cameras

Used equipment is often the best way to go when buying high-quality merchandise. Most large cities have one or more dealers whose stock is fairly extensive. If you're planning to buy two or more bodies at the same time, it may pay you to travel some distance to a major dealer. This is especially true if your purchase will be sizable, perhaps including lenses and other items.

A recent problem for those of us who buy used equipment is the increase in camera collectors. At one time I used secondhand screw-mount Leicas because they could be bought for a fraction of the cost of the new M series with bayonet mount. Lenses were readily available, and I had an adequate amount of equipment, including two bodies, for the price of a new M-series unit without a lens.

Today some screw-mount bodies are available at low cost, but most are in the hands of collectors, and their prices are rising. Lenses for this series are almost impossible to find, and those that are available often cost more than new lenses. Too many people are bidding on equipment and holding it for an investment; its purchase by a working professional is no longer practical.

Buy your camera bodies according to your needs, not what the advertisements and your friends say is "best." For example, my work is such that any 35mm equipment I might buy today would have to be able to take a motor drive and a perspective-control lens. I don't need behind-the-lens light meters, electronic shutters, or any of a number of other "essential" features. But I do need the two items mentioned, and I couldn't work with any system that didn't have them.

I love single-lens reflex equipment, but if I were buying 2¼ × 2¼ cameras they'd be used for theatrical photography and other places where quiet is essential. I couldn't have the noise of the mirror bounce interrupting everyone. The only practical line for me would be an interchangeable-lens twin-lens reflex, though this isn't the type of equipment I would most enjoy owning. Nor is it "status" equipment. It is simply the best for my needs—the only sensible consideration when making a purchase.

View cameras and many types of press cameras have been around for years, so used buys are easy to find in larger cities. There is little to go mechanically wrong with these bodies, since shutters are added separately. Just be certain that the bellows is in good shape, light-tight and without pinhole leaks.

Check screw heads on used cameras as you would on lenses. If there's evidence of an amateur repair job, you're better off not buying the camera than risking owning a faulty piece of equipment. Do all the controls work smoothly? The camera should advance from frame to frame without slipping, grinding, or sticking. The rewind action should be smooth.

Hold the camera to your ear and listen to the shutter speeds. As you progress from the slowest to the fastest, each speed should be roughly double the length of the one that preceded it. If you listen carefully, perhaps running through the speeds a few times, you'll be able to hear the difference. If the speeds sound right, they're probably within reasonable tolerances and won't need repair.

If a dealer has a spotless *used* camera that he brags about being "practically brand new," *do not* purchase it, regardless of price. Cameras should be used regularly to stay in good shape. Shutter speed accuracy is maintained only when the shutter is regularly

exercised; a camera that's been sitting idle for most of its life is likely to be badly in need of repair. On the other hand, a battered-looking piece of equipment that was in use daily until sold to the dealer is liable to be in perfect mechanical condition.

Check the interior of 35mm and roll film equipment. Be sure that it's clean and that gears are not damaged. Is the pressure plate spotless and flat? A plate covered with scratches or one that seems to be at an odd angle means potential problems.

Lighting Equipment

Floodlighting is the least expensive equipment you can buy, the cost varies with the quality of the stand rather than with the amount of light the unit is capable of handling. The best units use bulbs that maintain the same color temperature for their entire life. Inexpensive flood bulbs darken with age, the color temperature changing as they darken.

Floodlighting equipment can occasionally be found used. If you buy used equipment, be certain it's heavy-duty or it may not last long enough to warrant the purchase. Be sure you test it before buying it. There's a chance it was traded in because it no longer works properly.

Electronic flash equipment should always be purchased new. The life of a flash head is too limited to risk buying equipment that might stop working for you when you most need it.

Electronic flash units are preferred for working with models, as they're cool and not tiring. You must have modeling lights so you can preview your final effect. An electronic flash meter is also a wise investment, as it assures more accurate exposures.

If you don't plan on carting your electronic flash equipment on location on a regular basis, you may not need the heavy-duty units. Many companies offer inexpensive systems, including barn doors and umbrella reflectors, which might be ideal for your needs. These are low-power, generally 60 watt seconds, but they may suit you perfectly. If your local dealers have nothing in this line, check with Spiratone, Inc., 135-06 Northern Boulevard, Dept. P6, Flushing, NY 11354. This is one of several companies that can supply your needs by mail.

Heavy-duty electronic flash units for studios generally run

$500 and above. They can take years of abuse and offer such extras as variable power and variable recycling times. However, if you don't need them, it's wise to place your money elsewhere.

Electronic flash units need "exercise" just as camera shutters do. A flash tube that's not charged and discharged several times each month will gradually diminish its light-producing capacity. It will give off less and less light, reducing its effectiveness and forcing you to run test exposures periodically to determine its exact current rating.

Portable electronic flash equipment should utilize heavy, high-voltage batteries. These ensure rapid recycling so you can take photographs almost as rapidly as you advance from frame to frame. A one- to 1½-second recycling time is ideal, especially for fast-moving events like weddings and some types of school photography.

Film

Film should be purchased in quantity whenever possible. Generally a minimum of twenty rolls is needed to get you a good price break from your dealer. There are two philosophies about film purchases. One is that you should patronize the same dealer every time, giving him all your business and letting him cater to your needs. You thus have a right to expect good service and help in emergencies, as when one of your cameras breaks down.

The other philosophy is that you should keep your overhead low. This means spreading your business, making purchases according to who has the items you need at the lowest cost. Film might be bought through a discount store, cameras through a major dealer with a large used selection, and so on. I prefer the latter approach where I live, because I have yet to find a dealer who gives me good service regardless of how much money I spend. Thus my last major camera purchase was from a large New York dealer, and I buy film from the discount stores that give me the best price.

Make sure the film you buy is fresh and has been stored in a cool place. Ideally it should have been refrigerated. No matter what, it should not have been exposed to heat, including the rays of the sun passing through the store window.

Store unneeded film in a refrigerator or freezer. This will prolong its life by many years. Expiration dates are meaningless for film frozen in its original package. Just be certain you remove the film twenty-four hours in advance of use so it can thaw.

You may find that you'll get objections from a spouse who feels that refrigerators were meant for food. This is a delusion. There are even businesses selling large quantities of meat that you're supposed to put in your freezer, thus taking up the space that was meant for film.

If your spouse complains that there's no room for leftovers with all your film, be kind. If reasoning doesn't work, do what I did. Get your mate interested in photography, and buy him or her a camera and several rolls of film. Explain how to keep the film fresh; suddenly the refrigerator will be returned to its proper role of film storehouse.

Bulk film, generally sold in 100-foot lengths, is the cheapest available but should be shunned for many reasons. The first is the danger of scratching. Only a few loaders are so designed that nothing ever touches the film and there is no danger of scratching. But even when the loaders are excellent, the reusable cartridges you must have can get dirty. Often almost microscopic grit will settle on the felt light trap. Normal cleaning does no good, and the film passing through the felt is damaged.

Another drawback to bulk film purchases is the fact that you must have your own darkroom to salvage the disposable cartridges, and, as discussed, this is financially impractical. Some custom labs will ship the containers back to you, but the cost for postage generally wipes out the savings advantage over the purchase of a large number of prepackaged rolls.

Background Materials

There are several sources for background materials. Seamless paper is the easiest to use, and the most readily available from photography stores. It comes in varying lengths and widths, providing an even color that does not detract from your subject. Generally several different rolls are needed, one black, another white, and one or two others in colors of your choosing.

Another approach some photographers have taken is the use

of wallpaper. This can be less expensive than seamless paper, but must be carefully chosen. If the eye is drawn to a pattern rather than to your subject, the portrait or advertisement you're taking won't be effective.

Check fabric stores for cloth that can be used for backdrops and for small-object photography. You can save quite a bit of money when you adapt items for use as backgrounds rather than buying commercial backdrops.

20

Obtaining Capital

Financing is a problem with any business, but in professional photography the bills sometimes seem unusually high. Camera equipment alone can run several thousand dollars for bare essentials when your studio is in full-time operation. Then there are furnishings, rent, utilities, and numerous other expenses. Sometimes these come over a long enough period to present no problem; other times they seem to arise overnight. Getting the cash to meet your needs and obligations can become a nightmare.

Before we explore how to get additional money, I again stress an important fact for every studio: you should not consider going full-time as a professional photographer until you have enough money to meet your needs for a full year, and two years would be even better. A working spouse whose income can meet family expenses will also suffice.

Nothing destroys photography studios quicker than undercapitalization. Borrowing money should be done only when you're doing the volume of business that allows you to expect that you can meet the installment payments from current profits. Never borrow on the basis of what you might earn; borrow on the basis of the income you've been earning regularly in the past.

How to Get a Loan

Bank Loans

The most logical place to turn for a loan is a bank. You walk in, see a loan officer, explain your need, and walk out—usually, unfortunately, without your money. Banks have never been generous with loans to small businesses, and professional photography studios are low on their list of priorities. When money is tight, as it is in my area at this writing, even well-established, financially sound businesses go begging. Any loan you can get will be personal, based on your assets, not the studio's. The rate will be high, and the monthly payments will prove most unsettling.

New photography studios are not noted for their business wisdom, which is why so many of them fail during their first two years in operation. Often they're run by photographers who plan to "do their thing" and let the world beat a path to their doors. The trouble is that the client expects the photographer to do the client's "thing." And as to that mad rush of people seeking the photographer's talent, it simply does not happen.

A studio becomes well-established through the aggressive promotion of its owner: you go to the buyers; they don't come to you. Unfortunately, too many photographers refuse to face the realities of business, and end up folding. Usually they blame their problems on the banks that didn't lend them operating capital. Actually, the banks refused the loan because they could see that the studio was headed for disaster.

If banks turned down only those photographers who have poor business judgment, the majority of working photographers would be able to get the money they need. Unfortunately, banks don't work that way. They tend to turn down almost everyone starting out in our field rather than take even the slightest risk.

Personal Loans

There are alternative ways to raise the money. The simplest is to go out and rob the bank that refused you the loan. This is often the most enticing method, but it's the least sensible one. It's hard

to operate a photography business while doing twenty years in the federal penitentiary.

Another approach is to utilize your assets and take out a personal loan. If you own your own home you should have a relatively easy time borrowing money, though probably at fairly high rates. Other assets might be acceptable as well, but usually they aren't. Cars, for example, decrease in value during the life of the loan. Even if you owned the most expensive vehicle made, the loan would have to be for a fraction of its current worth to allow for depreciation.

The best source for seeking funds is through a credit union. If you or your spouse has the opportunity to join one, this is the ideal place to get a low-cost loan. If you have no connection with a credit union, explore what would be involved in having your professional photographers' association establish a state-wide credit union. Such an operation is of tremendous value to you. In fact, it was through my wife's credit union that we obtained the funds to purchase the 35mm equipment I bought a while back.

Generally the credit union's rate for a business equipment loan is fairly high compared with its rates for new-car loans. There's a greater risk involved, and the equipment may be more difficult to resell if you default on the loan. However, the charge is almost always well below the arrangement you could make with a bank.

Savings

If you have a savings account equal to the money you need, you might be hesitant to use it if you consider it a cushion for emergencies. Fortunately, there is a way to take advantage of those savings as collateral for your loan.

If you put your savings into Certificates of Deposit, you can then borrow up to the face amount of the certificates for a rate that, at this writing, is from 1 to 2 percent above the interest paid by the certificate. Savings and Loan Associations generally charge 1 percent above the interest rate, and banks charge 2 percent. This is regulated by law.

Whether you can touch the money in your Certificates of

Deposit during the period when you're paying back your loan is decided by the bank. Generally, in a real financial crisis, some arrangement can be made to help you. However, barring an unforseen, genuine emergency, the money will probably have to stay put.

Insurance

As discussed in the chapter on insurance, whole life insurance has an increasing cash value. This cash value is an asset against which you can take out a loan at extremely reasonable rates. Your personal solvency, the worth of your business, or even your reasons for wanting the loan are of little or no concern to the insurance company. It lends you what is yours, in effect, and if you fail to meet the payments you simply lose the cash value you had built. This cuts into your estate but not into the insurance company's profits.

Many agents discourage their customers from borrowing against their insurance. They feel that maintaining the full estate is more important than any use that could be made of borrowed money. However, this is simply not true. Borrowing money for reasons that will help you build your business is likely to be far better for your family in the long run than the temporary risk of a reduced estate. If your business is thriving, you'll have that much more money for buying additional life insurance or making other investments beneficial to your family.

If you've had a whole life policy for several years and the cash value is high, there are circumstances under which you might wish to cash it in. When you reach a point where you want to buy your own studio rather than just renting space, that policy can be traded in to pay off the mortgage. Trading in the policy results in the loss of all future benefits from it, but with the mortgage paid off, you have personal property that will probably prove more valuable than the insurance benefits.

Remember that life insurance is meant for family protection and retirement income. If investing the cash value in property can result in a greater benefit for your family, then by all means cancel the policy.

When to Get a Loan

Now that you have some alternative means of borrowing money, let's explore when you should take a loan. The less money you borrow when you're first starting into business, the better off you'll be. Equipment should be acquired slowly at first. You have a certain amount of equipment accumulated during your years as an amateur, and you'd be wise to seek assignments only where it can be utilized. As you begin making profits, you can spend some of this money for your business, adding equipment that will enable you to take a broader range of assignments.

The first time you might run into the need for a loan is in handling wedding photography. Weddings require double the equipment you normally need so you have spares in case of camera or flash failure. Weddings are once-in-a-lifetime events; they won't be repeated for you if your camera fails. If you don't have backup equipment, you're unfairly jeopardizing your clients' coverage. This means that you may have to buy a second body and electronic flash, at the very least, an expenditure of $300 or slightly higher on the used market to over $1,000 for new and/or unusually sophisticated equipment.

Equipment costing $1,000 or more will almost certainly require your taking a loan. At the lower end, however, it would be wise to pay cash if at all possible. If you can't pay cash, try to take a loan at the cheapest rate you can find. Banks and camera stores will probably try to encourage you to use your bank credit card. This is ideal for them but will cost you 18 percent per year in interest, a steep price to pay for the money.

Some camera stores will charge an item on a sixty-day or ninety-day "same as cash" basis. This means that if you pay off the equipment in the specified time, after first making a down payment of at least a third, there is no carrying charge. Such an arrangement is in your best interest and should be established if at all possible.

If you can wait to take a loan until your business is well-established, you'll be better off. When your business is solvent and you've had a steadily rising stream of customers for three or four years, banks will look more kindly on you. At that time you

can get financial help for such major expenses as buying a studio or adding expensive equipment for a darkroom.

Even when money is fairly easy to obtain, borrow with caution. It's better to have a limited amount of equipment constantly in use than to have everything you might ever want but not enough clients to meet your debts. The less money you have to use for interest payments, the greater your profits, and the sooner you'll reach your goal of successful self-sufficiency.

21

Your Rights and the Law

Photography is a strange business. It's the only field I know of where the client pays money for a product that's seldom given to him. When a company hires you to take pictures of its installations, for example, the most important part of the work—the negatives—is retained by your studio. The company receives only prints made from those negatives, and for a far greater fee than would be involved if the company took the negatives and made its own prints.

Retaining Negatives

Traditionally, professional photographers doing industrial, advertising, and other forms of general commercial work have always kept their negatives. The client is provided with prints, but must pay for each new order. Thus the photographer can profit from his or her files for many years to come.

When you go to work as a professional your policy must always be that the client gets only prints or slides. You keep all negatives and a duplicate set of contact sheets on file. If the client insists on buying the negatives, charge him an extra fee; you'll be losing the profit that could have been made by selling additional prints.

For example, I once did some work for a branch of IBM. The assignment involved photographing both computer equipment and some new types of circuitry boards that were revolutionizing the field of electronic miniaturization. I quoted my normal hourly fee, which, at the time, was $25 per hour plus expenses, and the company agreed to it.

"Come have lunch with us first," one of the executives said, and I readily accepted the offer. I was told to meet him in one of the city's most expensive restaurants, a place I normally could not afford.

Lunch was delicious, and I was pleased to be so well feted before the assignment. Then came my first shock. The executive asked for separate checks.

I paid my bill, which I considered excessively high, though it was the smallest of the four brought to us. Then, in a somewhat less jovial mood, I went to the location to do the photography.

The session went beautifully. In three hours I was finished, and I was personally quite satisfied with what I had accomplished. As I made arrangements for delivering the work I received my second shock. "It's our policy to always buy the contacts *and* the negatives from the photographer," the executive told me. "You see, we make from 2,000 to 4,000 prints of selected negatives for distribution around the world. It's much cheaper for us to do the work ourselves rather than having the photographer do it."

Much cheaper, indeed! First they soaked me for a lunch I never would have bought on my own. Then they wanted my negatives! I was furious, but there was nothing I could do. I agreed to their request, but explained that my original charge was based on a normal working arrangement, which would not have included giving them the negatives. Since they wanted the negatives, I would have to charge extra.

In the end we agreed on triple time for the hours worked. I also included the price of my lunch in the bill, hiding the fact by increasing my expenses a few cents each so no one would notice. What made me even madder was that since they agreed to triple time so readily, I'm sure I could have charged even more without upsetting any of them.

I had a similar experience only one other time. I was doing some work for the manufacturer of a business security system. I had been hired to do the annual report, though the company planned to have an extensive number of prints made for distribution to their sales force. They were on a tight budget and felt it was financially more sensible to buy the negatives than to order the prints from me. Fortunately, this was discussed at the time I was hired. We agreed to terms that I felt were excessive enough to cover any lost profit.

If you must supply the negatives, charge your client for them, and make copies of the best photographs for your files. If you feel the work is of high quality, others will too. By making a few prints for yourself before turning over the negatives, you can use them in your portfolio and for other means of self-promotion.

The same thing holds true with transparencies. Your client will always receive any transparencies you take, because the nature of the medium is such that you normally don't produce negatives. To have samples for personal use, I always have 4 × 5 internegatives made of the best slides. Then I can have prints made at my leisure. Anything smaller than the 4 × 5 would not necessarily reproduce as well as the original image. Kodachrome, for example, at this writing is capable of enlargements greater than any negative film other than 4 × 5 or larger. If I had a 35mm or 2¼ × 2¼ internegative made, I couldn't get blowups equal to the potential inherent in the original slide; 4 × 5 is a must for me.

Resale Limitations and the Model Release

Even though you retain negatives under normal circumstances, what you can do with those negatives may be severely restricted. Let's explore some typical situations.

Suppose you take a portrait of an attractive model. She buys prints from you and you file away the negative. A couple of years pass and you decide to try your hand at freelancing from file. One of your targets is the publisher of a romance magazine that regularly uses stock photographs of women for their covers. You happen to come across the photo of the woman whose portrait you took, and want to include it in your offering. Can you do it?

Although the law varies from state to state, certain general interpretations seem to hold true almost everywhere and any time. In the case of our example, a model release must be obtained before the picture can be printed. The use of the photograph on a magazine cover of this type is totally foreign to the original purpose of the posing, and the model must approve or disapprove this new action.

What's the solution? In the case of our example, the photographer should contact his client, tell her he found her portrait so attractive that he wants to sell it elsewhere, and ask for a release. In the majority of cases she will be so flattered that she'll be delighted to sign.

A better approach, one I follow, is to get the model release signed at the time of the sitting if there seems to be the slightest chance I might one day wish to sell the photograph elsewhere. The same holds true with pet photographs, since pet owners can legally sue you for publishing the pictures unless they've signed a release. The pets, by the way, have never been known to sue.

Technically you should pay at least a token sum of $1 when the release is signed to make everything legal and binding. However, I don't feel that it's honorable to pay a token fee and then make perhaps $50, $100, or more through the sale of the picture. Instead of paying the token, I add a clause to the release form I use to guarantee my models 25 percent of my gross for the picture(s). They thus have a far greater potential for income from resale, and often encourage me to seek new markets.

There are some exceptions to the matter of releases. For example, in the case of magazines, a photograph may be used editorially provided it does not hold the subject up to unfounded ridicule. You can label someone a crook if he's been convicted of the crime under discussion in the text. But if you use a photograph of a couple kissing innocently in your studio and then print it with text implying that they're typical of today's "swinging singles," the lawsuit against you could cost you everything you own.

Good examples of editorial uses for which no releases are necessary are the illustrations for articles I write for photography magazines. I often show photos of models as examples of my work. The pictures illustrate technical points, and so no

release is necessary. However, I still insist on a release, because it protects the subject by ensuring that he or she will be paid when I use the photograph.

You can also display portraits as examples of your work. You can enlarge the image of a model and place it in your display window or include it in an exhibition. Again, no permission is needed.

There is one exception, however. You may not say or imply that the person shown endorses your studio or your abilities. You may only say that the photograph represents your skill.

Even when a model poses for advertising and illustration work, knows the image may be distorted, and willingly signs a release, he or she retains certain rights. It has been generally held that a photograph of this type can't be used in an unexpected manner.

A good example of this situation was a photograph taken of a woman reclining on a bed. The original photograph was meant for an advertisement for bed linens, and was perfectly innocent. It was in no way derogatory of the character of the model.

The photograph was used in the advertisement and forgotten. A few years later, the photographer received permission from his original client to resell it from the file. This time it went to a magazine, where the staff artist combined it with a photograph of an old man, making it appear that the two were in bed together. The composite was meant to promote an article on May-December romances, and gave the public a very different impression of the woman than did the original advertisement for which she posed.

The model sued the magazine, the photographer, and the advertising agency that was the original client. She won judgments against all three, despite the fact that the photographer was proved to have no prior knowledge of how the magazine would use his photograph. The jury seemed to feel that he should have exercised more caution and control in the matter.

Another photographer illustrated articles on the problems of crime and what people can do to protect themselves. Some of the pictures were of a bound and gagged "damsel in distress" posed by a professional model.

Later the photographs that weren't used for the magazine

articles were sold separately. A detective magazine bought one of the woman, combined it with a photograph of a lurking figure, and used it to indicate that she was about to be raped. It was a different use than the original pose, but the photographer had discussed possible additional sales with the model at the time the work was first taken. She knew the ways the work might be submitted and used and had no objection. She even found the composite rather amusing. There was no lawsuit.

The important point of these examples is that the model must have an understanding of the possible uses of his or her photograph at the time the work is taken and the release signed. Many release forms say that the image may be distorted in one manner or another, and when the model signs the form he or she is agreeing to such a possibility. However, the courts have generally held that when the model objects to a picture used in a way that's radically different from the purpose of the original posing, he or she can collect damages.

If there is ever any question in your mind as to what sales might be permissible for a specific photograph, you should consult a lawyer. However, there is one in-depth general guide to this procedure, and I strongly advise buying a copy—*Photography and the Law,* by George Chernoff and Hershel Sarbin. The book is periodically updated, and gives comprehensive information, including the wording for different types of model releases.

Selling and Retaining Rights

When you sell a picture you don't have to give away all rights to it. For example, suppose a greeting card company is interested in your work. The company might offer you a flat fee for all rights even though it only publishes cards. This should always be unacceptable.

Instead of selling all rights to the card company, sell only the exclusive right to use the photograph on greeting cards. You should retain the right to resell the photograph as a poster, magazine illustration, book illustration, or whatever, agreeing only not to sell the picture to a competing business. In this manner you'll get the greatest mileage from your work.

Some magazines stamp the back of their checks so that an endorsement results in your granting them exclusive rights to your pictures. This can happen even when you've stated in your letter to them that only magazine rights are being offered. There are two choices you can make in such a situation. You can endorse the check or you can return it and ask the publisher to issue a new one. This latter action could result in a subsequent rejection of the work.

To protect yourself, have a stamp made up stating the rights available for the photograph. Then stamp the back of each print in the same way you'd stamp your name and address. For example, one photographer I know stamps his prints with the message, "For one-time use only. Payment must be made for each subsequent reproduction." This has given him all the protection he needs.

Caution! Whenever you stamp the back of a print, place the print face-down on a hard, smooth surface and use the stamp lightly. Some photographers use so much ink and so much pressure that the wording shows through on the front of the prints. This destroys their usefulness.

Obtaining Permissions

Reselling Photos
Work done for a client should not be reused without the permission of the client. If I wanted to illustrate an article for an electronics magazine, I might want to use some of the IBM photographs I retained for personal promotion. However, before I could legitimately offer them for publication, I would have to request permission from IBM.

Most stock agencies require you to have model releases available for every photograph you submit to them. This gives them a far greater potential market than would otherwise be possible. However, if you don't have a release, send the photographs anyway, with a note explaining that a release is not available. Legitimate stock agencies can be depended to market the work accordingly, so you need have no worries.

Taking Photos

There are some legal hassles you can encounter when you're taking photographs. Many so-called public areas are not public at all in terms of your rights. While people usually cannot legally object to your taking pictures on the streets, they can object to your photographing in a shopping mall, department store, or other location. Even museums may have restrictions for photographers.

If you plan on doing location photography, especially with models, check with the management of the building you'll be using. I've never heard of a store or shopping mall refusing a photographer permission to use the facilities when he or she made a request in advance of the work day. However, I have known many photographers who have been expelled from such places when they failed to get advance permission.

Occasionally you might find that while taking a picture for pleasure someone stops you and demands the film. For example, I once did some work for the fashion department of a large store. As I was leaving I glanced down from a balcony at the floor below. The pattern of people and merchandise intrigued me, so I put my camera to my eye and took a couple of photographs. Then, as I started to leave, a big, burly man grabbed my arm and demanded that I give him my film.

It turned out that he was a store detective (later fired for incompetence). After countless arguments and threats, I still refused to give him my film. The reason was that though he could stop me from reproducing the pictures I'd taken, he couldn't make me give up my film just for taking them. The fact that a store can't make you yield your film is true in every state at this writing.

After several minutes my detective threatened to call the police. I thought that was a fine idea, which upset him greatly. He eventually called the department head for whom I was working, and then let me leave with my film.

Whenever someone demands that you yield film, assuming it's a representative of a business and not a person you just recorded murdering his wife, do not give up the negatives. You may not be allowed to sell the pictures you've taken, but you shouldn't have

to give up your film. If the person is insistent, call the police to make sure you're not violating some new city ordinance.

Some locations may charge you for taking photographs, a very different matter from challenging your right to take them. Some zoos, museums, and other popular places levy a fee against anyone who uses a camera. Generally this fact is posted at the entrance. However, sometimes there's no way of knowing about it until you're stopped by a guard or other employee. Such fees are perfectly legitimate, though annoying, and should be paid if you're going to photograph anything.

Photographers have wide latitude in what they may and may not do. With a little caution and a good supply of model releases you should be able to avoid legal problems throughout your entire career.

Getting Help

While this book attempts to be a comprehensive guide for the photographer starting into business, you may be faced with unique problems. In addition to your local area's branch of the Service Corps of Retired Executives (SCORE) and the Better Business Bureau, here are some places to turn for help.

The Society of Photographers in Communications, 60 East 42nd Street, New York, NY 10017. This used to be the American Society of Magazine Photographers. The group offers guidelines for prices, day rates, stock sales, general ethics, and so on.

Professional Photographers of America, 1090 Executive Way, Des Plaines, IL 60018. This is considered the major association of studio owners, and has branches in every state.

The Social Security Administration; The Internal Revenue Service; The Small Business Administration—all of these agencies offer individual help to businessmen. A local number for your area can be found in the White Pages under United States Government.

Eastman Kodak Company, Professional Division, Rochester, NY 14650.

GAF Corporation, 140 West 51st Street, New York, NY 10020.

Blue Book of Photography Prices, Photography Research Institute Carson Endowment, 21237 South Moneta Avenue, Carson, CA 90745.

Everyday Credit Checking, by Sol Barzman. This book is available from the National Association of Credit Management, 475 Park Avenue South, New York, NY 10016; or from the publisher, Thomas Y. Crowell Company, 666 Fifth Avenue, New York, NY 10019. The author has been connected with the mercantile industry, but most of the information in the book is applicable to photographers interested in commercial credit.

Index